On This Day In

FLORIDA
HISTORY

NICK WYNNE

THE
History
PRESS

Published by The History Press
Charleston, SC 29403
www.historypress.net

Front cover, top left: Courtesy of Indian River County Historical Society; *second row, right*: Cassius Clay/Mohammad Ali, courtesy of Arva Moore Parks Collection; *bottom right*: Public domain/NASA.

First published 2014

Manufactured in the United States

ISBN 978.1.62619.646.9

Library of Congress Control Number: 2014953167

CONTENTS

INTRODUCTION

The history of Florida is long and often follows a distinctly different path from that of the history of other states in the Union. Florida has had a number of nicknames attached to it, including such well-known names as the "Sunshine State" or the "Land of Dreams." One recent book by a Florida historian labels Florida as the *Land of Sunshine, State of Dreams*. Whatever can be said about a state has been said about Florida. It is everything to everybody, and it has been home to dreamers, schemers, crooks, shysters, goodly priests, pious preachers, hardworking commoners, royalty, movie stars, athletes and the ultra rich. It is a state with sandy beaches, lonesome prairies, fertile farms, isolated wildernesses and bustling cities. Sometimes called the "most southern of states," it has also been referred to as the "most southern of northern states" because of the large number of Yankees who choose to make Florida their home. Florida is a land of brilliant sunshine and clear skies,

but it is also often the target for destructive hurricanes, tropical storms and extended droughts. It is, above all, a contradiction. In 1926, a convocation of advertising men in New York, financed by Governor John W. Martin, finally became so exasperated trying to come up with a single brief description of the Sunshine State that they threw up their hands and agreed on this one phrase to describe it—"Everything you can say about Florida is a damned lie!" Welcome to life in the Sunshine State!

JANUARY

January 1

1885—Florida Has a New Constitution: Florida's fifth constitution, created by a Constitutional Convention that met in Tallahassee on June 9, 1885, went into effect today and remained the basic law of the Sunshine State until 1968. The 1885 constitution replaced the "carpetbag" constitution of 1868. In the 1920s, the 1885 constitution was amended to include a prohibition on the imposition and collection of a state income tax, a provision to encourage investment in land development.

1914—First Scheduled Commercial Air Flight: The first scheduled commercial airplane flight was made today from St. Petersburg to Tampa. Tony Jannus, a pioneering aviator, opened the service with his flying boat, the *Benoist*, which

could haul one passenger and a small amount of freight. A.C. Pheil, former mayor of St. Petersburg, purchased the first passenger ticket for $500. Jay Dee Smith was Jannus's mechanic. Two daily round trips were flown for twenty-eight consecutive days.

January 2

1830—Henry Morrison Flagler, Railroad and Hotel Magnate, Is Born: Henry Morrison Flagler, founder of the Florida East Coast Railway and developer of the Florida east coast tourist industry, was born today in Hopewell, New York. Flagler, whose interest in Florida stemmed from visits to St. Augustine, combined his railroad interests with hotels and steamships. An early partner with John D. Rockefeller in Standard Oil, Flagler spent millions on his Florida projects, eventually constructing the longest railroad over water with his Florida Overseas Railroad, which connected the mainland to Key West.

1979—Popular Governor Bob Graham Inaugurated: On this day, "Bob" (D. Robert) Graham was inaugurated as the Sunshine State's thirty-eighth governor. Graham was born on November 9, 1936, in Coral Gables. He graduated from the University of Florida in 1959 and received a law degree from Harvard Law School in 1962.

Henry Flagler's hotel and railroad empires stretched the length of the Sunshine State's east coast from Jacksonville to Key West. He visited St. Augustine in 1878 and became enchanted with the prospects of making money on Florida tourism, land sales and his railroads. In the 1880s, he started construction on the Ponce de Leon Hotel in St. Augustine, and by 1896, his enterprises stretched as far south as Miami. By 1912, Key West was added to the Flagler empire. *Richard Moorhead Private Collection.*

January 3

1861—Secession Convention Meets in Tallahassee: Delegates to the Florida Secession Convention met in Tallahassee to take up the question of secession. Edmund Ruffin of Virginia arrived to confer with Governor Madison Starke Perry and members of the convention.

1967—First Republican Governor Since Reconstruction Inaugurated: Claude Roy Kirk Jr. was installed as Florida's thirty-sixth governor today. Kirk was born on January 7, 1926, in San Bernardino, California. He lived in a variety of locales during his youth and graduated from high school in Montgomery, Alabama, when he was seventeen. He enlisted in the Marine Corps and, after officer training at Quantico, Virginia, was commissioned as a second lieutenant. He left the marines in 1946 and entered law school. He received his law degree in 1949. Kirk returned to active duty in 1950 and served in combat in Korea. After the war, he entered the insurance and investment business in Jacksonville, eventually heading up the Kirk Investments Company. A former Democrat, he was successful in his 1966 campaign for the governorship and became the first Republican to hold this position since the end of Reconstruction. In 1978, he ran an unsuccessful campaign for governor as a Democrat. In 1988, he failed in his bid for the U.S. Senate as the Democratic nominee.

January 4

1863—First Governor of Florida Dies: William Dunn Moseley, Florida's first governor under statehood (1845–49), died on this day. Moseley was born at Moseley Hall, Lenoir County, North Carolina, on February 1, 1795. He attended the University of North Carolina with James K. Polk, later president of the United States. After college, he practiced law in Wilmington, North Carolina, and entered public service as a state senator. In 1835, Moseley purchased a plantation in Jefferson County, Florida, and resided there until 1851. A member of the territorial legislature, Moseley defeated Richard Keith Call, the third and fifth territorial governor of Florida, in a contest to become the first governor of the new state of Florida. In 1851, Moseley moved to Palatka, where he was a planter and fruit grower.

1961—Florida's Governor During Civil Rights Turbulence Inaugurated: Thomas LeRoy Collins, the thirty-third governor of Florida, took the oath of office today. Collins was born on March 10, 1909, in Tallahassee. A graduate of Leon High School, Collins attended the Eastman School of Business at Poughkeepsie, New York, and received a law degree from Cumberland University. He married Mary Call Darby, the great-granddaughter of two-time territorial governor Richard Keith Call. Collins's terms were marked by the rise of the civil

rights movement in Florida, and through his leadership, Florida avoided much of the violence and turmoil that marked desegregation in other southern states.

January 5

1929—Sarazen Wins Miami Open Golf Tournament: Gene Sarazen won the $750 first prize at the Miami Open Golf Tournament, played at the Bayshore/LaGorce course. His score was 294 for 72 holes. This was his third consecutive win.

1965—Democrat Hayden Burns Enters Governor's Office: William Hayden Burns took the oath of office today to become Florida's thirty-fifth governor (1965–67). Burns was born on March 17, 1912, in Chicago, Illinois. He attended Jacksonville public schools and Babson College. During World War II, Burns served in the U.S. Navy. Although eligible for a second two-year term, he was defeated by Claude Roy Kirk Jr., a Republican, in 1966.

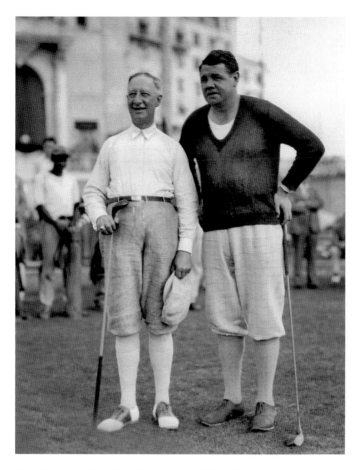

When Flagler's railroad and hotels opened Miami to development, the area boomed. Soon, anyone who was anyone could be found on the beaches or playing golf at the luxury hotels that were in abundance. Governor Al Smith (left) and baseball hero George "Babe" Ruth pose in front of the Miami Biltmore in 1931. *Historical Association of South Florida, Miami.*

January 6, 1925

Governor to Preside Over Florida Land Boom: John Wellborn Martin took the oath of office today as Florida's twenty-fourth governor with high expectations that the boom in Florida property sales would continue indefinitely. Martin was born on June 21, 1884, in Marion County. Admitted to the bar in 1914, he began to practice law in Jacksonville. From 1917 until 1924, Martin was the mayor

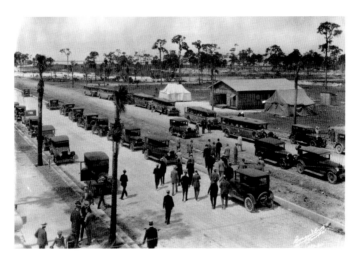

During the land boom of the 1920s, developers sent free buses as far away as Kansas and Iowa to bring prospective buyers to the Sunshine State. Buyers were housed and fed while they toured prospective new town sites. Of course, some people saw the eagerness of developers to get them to come to Florida as an opportunity for an "all expenses paid vacation!" *Burgert Brothers Collection, Tampa Public Library.*

of Jacksonville. Unfortunately, Martin's expectations of continued prosperity were soon dashed, and he presided over the beginning of the Florida "bust." During his administration, Florida began an expansive program of highway construction, direct state appropriations to finance public schools and the distribution of free textbooks to students in grades one through six. In 1928, he was defeated in his bid for a U.S. Senate seat. In 1932, he lost a bid to regain the governor's office.

January 7

1903—Zora Neale Hurston, Noted Author, Born: Florida author Zora Neale Hurston was born today. Some controversy exists as to the actual place of her birth. Some authorities claim it was in Eatonville (east of Orlando), but the latest scholarship places her birthplace in Alabama. Regardless of where she was born, Hurston certainly considered Eatonville her home and centered many of her stories there.

1911—Popular Actress Thelma "Butterfly" McQueen Born in Tampa: Thelma "Butterfly" McQueen was born today in Tampa. McQueen gained enduring fame for her portrayal of Prissy in the 1939 epic *Gone with the Wind*. McQueen hated her given name, Thelma, and legally changed her first name to Butterfly. An accomplished screen and

Broadway actress, McQueen's first role would become her most identifiable, along with the famous words: "I don't know nothin' 'bout birthin' babies!"

January 8

1853—New Railroad Company Created: David Levy Yulee and his financial partners incorporated the Florida Railroad Company today. The railroad ran between Fernandina and Cedar Key and was completed in 1860, just a few months before the outbreak of the Civil War. After the war, the railroad enjoyed a few years of prosperity, but it eventually fell on hard times and was purchased. It was later abandoned.

1965—"Murph the Surf" Arrested for Burglary: Jack "Murph the Surf" Murphy and a companion were arrested today in Miami. They were suspects in the American Museum of Natural History robbery of October 1964, in which the fabled "Star of India," the world's largest sapphire, was stolen.

January 9

1861—Convention Agrees to Postpone Final Vote: In Tallahassee, the final debate on the Ordinance of Secession concluded

in late afternoon. Delegates agreed to postpone a final vote until January 10. Governor Madison Starke Perry and governor-elect John Milton were both strong supporters of secession. In a minority opinion, former territorial governor Richard Keith Call, acting as a private citizen, argued that secession would bring only ruin to the state.

1990—Shuttle Columbia *Launched Successfully*: Shuttle STS-32, *Columbia*, was launched today from Cape Canaveral. The launch was NASA's thirty-third successful mission and the ninth mission for the *Columbia*. Astronauts on board were Daniel C. Brandenstein, the commander, and crew members James D. Wetherbee, Bonnie J. Dunbar, Marsha S. Ivins and G. David Low. Crew members were tasked with deploying the Syncom IV-F5 defense communications satellite and with retrieving NASA's Long Duration Exposure Facility. *Columbia* landed safely on January 20, 1990, at 1:35:37 a.m. Pacific standard time on Runway 22 of Edwards Air Force Base in California.

January 10

1861—Secession!: Governor Madison Starke Perry read a telegram to the delegates at the Florida convention from Florida's congressional delegation, informing them that "Federal troops are said to be moving or about to move on Pensacola forts." This warning, given just before the

final debate on the state's secession ordinance, created a sense of urgency among the delegates. After two hours of debate, the secession convention approved the measure by a vote of 62–7. Florida thus became the third state to leave the Union. In Tallahassee, crowds danced in the street. Fireworks, a large parade and the ringing of church bells created an atmosphere of celebration and joy. In Pensacola, the commanding officer of Federal forces consolidated his men in Fort Pickens. Later that evening, Union lieutenant H. Erben led a raiding party that battered in the gates of Fort McRee. The Union raiding party spiked the guns of the fort and dumped about a dozen barrels of gunpowder into the sea.

1888—Luxury Hotel Opens in St. Augustine: Construction on Henry Flagler's famous Ponce de Leon Hotel, one of the earliest luxury resorts in Florida, was completed today in St. Augustine. The hotel is now the main building of Flagler College, a private institution of higher learning. It is currently open to the public for guided tours.

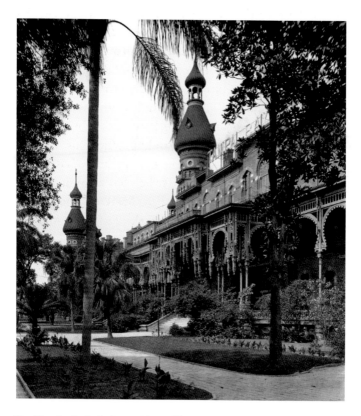

The friendly rivalry between Henry Plant and Henry Flagler stimulated Florida's economy during the late 1800s. Flagler pressed southward along the Atlantic coast while Plant pursued his interests in central Florida and along the Gulf coast. *Henry Plant Museum, Tampa.*

January 11

1839—Delegates Approve New Constitution in St. Joseph's: Florida's first constitution was signed by members of the constitutional convention meeting in St. Joseph's today. Although the document would not become the law of the land in 1839, as Florida was still only a federal territory, it provided the basic framework for the first state constitution in 1845.

1861—The Independent Nation of Florida: The Ordinance of Secession, approved by the secession convention on January 10, 1861, was signed today. Florida became an "independent nation" until it joined the Confederate States of America on January 28. Soon-to-be governor John Milton unfurled the new flag of Florida, a white silk banner with three stars. The stars represented the three southern states that had seceded—South Carolina, Mississippi and Florida. An official Florida flag was adopted later, although a number of flags were used by Floridians.

January 12

1888—Florida's Newest Attraction: The Ponce de Leon Hotel in St. Augustine, the first of what eventually would be a twelve-hotel chain owned by the Florida East Coast Hotel Company (part of the Flagler System), officially opened today. Upon their arrival in St. Augustine, guests were

astounded when the generators were turned on and one million light bulbs lit up the hotel. Guests were invited to a sumptuous feast and an elaborate program of entertainment as the celebration of the opening got underway.

1942—Floridian Wins Medal of Honor: Lieutenant Alexander (Sandy) Nininger Jr. of Fort Lauderdale was killed in action today in Bataan, Philippine Islands. He became the first U.S. soldier to be awarded the Congressional Medal of Honor in World War II.

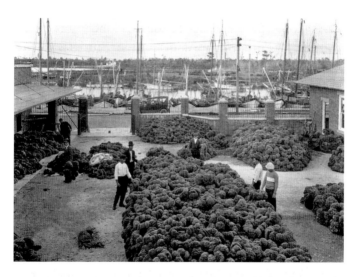

The sponge docks of Tarpon Springs and the lively Greek community of shops and restaurants drew hordes of tourists to this village on Florida's Gulf coast. Even today, tourists seeking the colorful and unusual in the Sunshine State find their way to Tarpon Springs. *The Richard Moorhead Private Collection.*

January 13

1982—Air Florida Plane Crashes into the Potomac River: A twin-engine Air Florida jet (Air Florida Flight 90), bound for Tampa, crashed into the Potomac River today immediately after takeoff from Washington's national airport. Some seventy-eight persons were killed. The jet, encumbered by ice on the wings, crashed into the Fourteenth Street Bridge and struck a truck and at least four cars. Horrified commuters and emergency personnel worked to rescue the passengers from the icy waters of the river. Traffic was so snarled that emergency vehicles were forced to resort to using the sidewalks to reach the crash scene. Some investigators suspected that the mass firing of the air controllers by the Reagan administration five months earlier contributed to the disaster, although the final report of the national Transportation Safety Board did not place any blame on this occurrence.

1993—Another Successful Shuttle Launch: Space Shuttle *Endeavour* (STS-54) was sent into space today from Cape Canaveral. Its primary mission was to deploy a tracking and data-relay satellite and carry out a number of scientific experiments on X-ray radiation and microgravity. The mission was under the command of John H. Casper, and crew members included Donald R. McMonagle, Mario Runco Jr., Gregory J. Harbaugh

and Susan J. Helms. Mission specialists Runco and Harbaugh carried out a five-hour spacewalk, conducting experiments to test the limits of movement.

January 14

1861—Florida Senators Notified of Secession: The U.S. senators from Florida, David Levy Yulee and Stephen F. Mallory, were officially informed today of Florida's secession from the Union. They, along with U.S. representative George S. Hawkins, would formally resign their offices on January 21.

1941—Florida Luminaries Celebrate Common Birthdays: Oscar-winning actress Faye Dunaway was born today in Bascom, Florida. Award-winning screenwriter Lawrence Kasdan was born on the same date in 1949. Dunaway won the Oscar for Best Actress for the 1976 film *Network*. Kasdan, best known for his work in co-writing such films as *Raiders of the Lost Ark* and *Star Wars: The Empire Strikes Back*, has been nominated for four Oscars: twice for Best Original Screenplay for *The Big Chill* and *Grand Canyon* and once for both Best Adapted Screenplay and Best Picture for *The Accidental Tourist*.

January 15

1897—Royal Palm Hotel Opens in Miami: The Royal Palm, Henry Flagler's luxury hotel, opened today in Miami. Five stories tall, it boasted the city's first electric lights, elevators and swimming pool. The hotel featured 450 guest rooms and suites and had a dining room that could seat 500 persons, as well as a second dining room for maids, nannies and children. With a staff of 300, including almost twenty cooks, the hotel provided first-class amenities for its guests. Although the deed to the land on which the hotel was situated contained a clause prohibiting the sale of alcoholic drinks (placed in the deed at the insistence of Julia Tuttle, the land's original owner), a special exemption to this restriction was granted during the four months of the high tourist season. The hotel was severely damaged by the 1926 hurricane, and in 1930, it was condemned and torn down.

1949—*Ronnie Van Zant Born*: Ronnie Van Zant, the leader of the Jacksonville rock band Lynyrd Skynyrd, was born in Jacksonville today and died in a plane crash in 1977. Originally formed in 1964 in Jacksonville, Florida, the band rose to worldwide recognition on the basis of its driving live performances and signature tunes "Sweet Home Alabama" and "Free Bird." Lynyrd Skynyrd was inducted into the Rock and Roll Hall of Fame on March 13, 2006.

January 16, 1792

Indian Raiding Party Captures Trading Post: William Augustus Bowles and a band of Creek warriors captured the Panton, Leslie and Company trading post near St. Marks on this day. Bowles was a former British officer, who resigned his commission in Pensacola to set out through the Florida wilds. He was captured by Creek Indians in 1781 and persuaded them to support the British. Eventually, Bowles left Florida for the Bahamas. The British governor Lord Dunmore sent Bowles back among the Creeks with orders to establish a trading house, which he did along the Chattahoochee River. One of his wives was a daughter of the Hitchiti Muscogee chieftain William Perryman, and Bowles used this union to exert political influence among the Creeks, later styling himself "Director General of the Muskogee Nation." In 1795, along with the Seminoles, he formed the "State of Muskogee" in northern Florida. In 1800, equipped with two schooners and a force of four hundred frontiersmen, former slaves and warriors, he declared war on Spain. Spain placed a bounty on his head, and he was captured and transported to Spain. He managed to escape and return to Florida, but in 1803, he was recaptured, turned over to the Spanish and imprisoned in Morro Castle in Havana, Cuba. He died two years later.

January 17

1821—First Native-Born Florida Governor: Ossian Bingley Hart, the first Florida-born governor of the state, was born today in Jacksonville. Hart's father, Isaiah David Hart, was a founder of Jacksonville. Ossian Hart was an attorney who initially practiced law in Jacksonville but eventually moved to Fort Pierce to become a farmer. In 1845, he represented St. Lucie County in the Florida House of Representatives. Although the son of a slave owner, Hart was opposed to Florida's secession and actively opposed it. His opposition earned him a great deal of trouble during the Civil War. In 1868, Hart was appointed an associate justice of the Florida Supreme Court. In 1870, he was defeated in a bid for Congress. He was elected governor as a Republican in 1872, but his term was cut short when he died of pneumonia in 1874.

1861—Florida Delegates to Southern Convention: Jackson Morton of Santa Rosa County, Patton Anderson of Jefferson County and James B. Owens of Marion County were appointed as Florida's delegates to the Southern Convention scheduled to meet in Montgomery, Alabama, on February 4. The purpose of the convention was to bring a new central government for southern slave-owning states into existence. The convention also elected Jefferson Davis of Mississippi the provisional president of the Confederate States of America.

January 18

1861—Confederate and Union Forces Face Off in Pensacola: Despite demands by Confederate forces in Pensacola, Union lieutenant Adam Slemmer refused to surrender Fort Pickens. Slemmer held Fort Pickens until additional Union troops arrived on Union transport ships. The fort remained in Union hands throughout the war. He was promoted to major in May 1861 and assigned to General Don Carlos Buell's command. In 1862, he was promoted to brigadier general and fought in the Stones River campaign, where he was wounded. Slemmer continued on duty but was relegated to administrative duties. In 1865, he was brevetted a brigadier general in the regular army and served as the commander of Fort Laramie, Wyoming, until his death in 1868.

1941—Singer Bobby Goldsboro Is Born: Singer Bobby Goldsboro was born today in Marianna. A student at Auburn University, Goldsboro left school during his second year to become a guitar player in singer Roy Orbison's band from 1962 to 1964. Goldsboro left that band and became a solo singer. Over his career, he put out sixteen Top 40 hits that made the Billboard Hot 100 and twelve that made the country chart. In the 1990s, Goldsboro became a music composer for television programs, a television actor and a scriptwriter.

January 19

1863—Union Naval Blockade of Florida Effective: Florida was effectively blockaded by the Union navy, seriously hampering the efforts of Confederates to use the state's 1,500-mile coastline to bring in critical supplies to relieve the shortages experienced by the Southern population and army. This letter from Nassau reveals how effective the blockade was:

> *There are men here who are making immense fortunes by shipping goods to Dixie…Salt, for example, is one of the most paying things to send in. Here in Nassau it is only worth 60 cents a bushel, but in Charleston brings at auction from $80 to $100 in Confederate money.*

1957—Ottis "O.J." Anderson, NFL Star Born Today: Running back Ottis "O.J." Anderson, a National Football League 1979 first-round draft pick, was born today in West Palm Beach. Anderson attended the University of Miami and was the first player for that team that amassed more than one thousand yards in a single season. Drafted by the St. Louis Cardinals, he also played for the New York Giants. Anderson was known for his ability to hold on the ball and seldom fumbled.

January 20

1920—Sam Gibbons, War Hero and Congressman: Today is the birthday of former U.S. congressman Sam M. Gibbons of Tampa. A highly decorated combat veteran in World War II, Gibbons was a captain in the 101st Airborne, an American parachute group, and landed behind the German lines on D day. He was also part of the force sent to relieve American troops besieged at Bastogne during the Battle of the Bulge. He had a distinguished career in the Florida House of Representatives and the Florida Senate and was first elected to the U.S. House of Representatives in November 1962. He served until 1996.

1924—Noted International Music Star Born in Tampa: Country and western singer Ottis Dewey Whitman Jr., known professionally as "Slim" Whitman, was born today in Tampa. During his music career, Whitman sold more than 120 million records, achieving his greatest popularity in Europe. In the 1950s, he toured with Elvis Presley, and in the 1960s, he produced a string of hit records, most notably *Indian Love Call*.

January 21

1912—Key West Reached by Train: The first train (a construction engineers') to make the complete trip between Homestead and Key West using the newly completed Key

West Extension of the Florida East Coast Railway ran today. Having extended the FEC as far south as Miami, Henry Flagler became interested in extending his railway to Key West after the United States announced the construction of the Panama Canal in 1905. Some four thousand workers were employed by the FEC to construct the tracks, bridging miles of open water, braving hurricanes and enduring other hardships. After seven years, the job was completed, and Key West had a solid transportation link with the mainland.

1927—Florida to Have a Canal That Stretches from Coast to Coast: President Calvin Coolidge signed the Act to "Survey A Waterway from Cumberland Sound, Georgia, and Florida to the Mississippi River." This act was the forerunner of the later Cross-Florida Barge Canal legislation enacted under the administration of Franklin Roosevelt. After several fitful stops and starts, the construction of the canal was ordered stopped by President Richard Nixon. It was officially ended in 1991 and the right of way turned over to the state, which created the Marjorie Carr Greenway, an environmentally protected area.

January 22

1912—First Passenger Train Arrives in Key West: The first passenger train arrived in Key West today, marking the official completion of the Florida East Coast Railway.

Henry Flagler arrived in his private car. The Key West Extension of the Florida East Coast system spanned 127.84 miles from Homestead to Key West and cost more than $50 million. Seventy-five miles were over marsh or water. The longest viaduct of the system, between Knights Key and Bahia Honda Key, covered seven miles.

1963—Railroad Unions Halt Train Service on Florida's East Coast: FEC Railway passenger and freight train service ended due to a strike by nonoperating unions. The operating unions, though not on strike, would not cross the picket line. Freight service, utilizing supervisory personnel, resumed on February 10, 1963, but Florida Supreme Court–mandated passenger train service did not begin again until August 2, 1965.

January 23

1837—Seminole War Leader Killed: The Seminole leader Osuchee and his son were killed by U.S. Army troops near Lake Apopka today. When he was killed, Osuchee, also known as Cooper, was the most important Indian leader to have died in the war between the Seminole Indians and American settlers and army troops. Osuchee was one of the leaders at the Battle of Wahoo Swamp, an Indian victory made possible by military mistakes. Although a significant loss in Seminole leadership, Osuchee's death did little to shorten the ongoing war.

1923—Prize-Winning Author Born in New Smyrna Beach: Hugo Award–winning science fiction writer Walter M. Miller Jr. was born on this day in New Smyrna Beach. Educated at the University of Tennessee and the University of Texas, Miller served in the army air corps in World War II as a radio operator and tail gunner on bombers. The author of more than three dozen science fiction stories, he won the Hugo Award in 1955 for "The Darfsteller." His only novel, *A Canticle for Leibowitz*, won the 1961 Hugo Award for Best Novel and has become a cult favorite. A recluse with a troubled personal life, he committed suicide on January 9, 1996.

January 24

1884—First Train Arrives in Tampa: The first train arrived in Tampa today via the Plant System, controlled by Henry Plant, who made his fortune in the railroad freight business prior to, during and after the Civil War. Plant was a specialist in acquiring small, financially troubled railroads and merging them into a single entity. The South Florida Railroad, strapped for cash, sold a 60 percent interest to Plant's investment company. When Plant found out that the railroad's charter to build a line to Tampa was due to expire at the end of January 1884, he sped up the South Florida's construction of the line to Tampa via Lakeland and Plant City. The line opened just

days before the charter expiration. The South Florida Railroad was merged into the Plant System in 1893.

1989—Serial Killer Ted Bundy Executed: Convicted serial killer Theodore Bundy was executed today in Starke's Raiford Prison. Bundy died in "Old Smokey," the prison's famous electric chair. On July 23, 1979, Bundy was convicted of the murder of two co-eds at Florida State University. During a period of fifteen years, Bundy was thought to have killed more than thirty young women in Washington, Utah, Colorado and Florida.

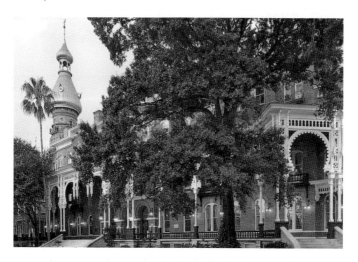

Henry Plant's luxurious Tampa Bay Hotel was headquarters for General William Shafter and the staff officers of the U.S. Army during the weeks it took to assemble and train soldiers before the invasion of Cuba in 1898. Other, less fancy, camps were in Fernandina, Miami, Lakeland and smaller towns near Tampa. *Henry Plant Museum, Tampa.*

January 25

1814—Petitioners in Fernandina Request Admission to the Union: Petitioners representing the "Republic of East Florida" asked Congress to admit their republic, with its capital at Fernandina, into the Union. The republic was the product of the Patriot War of 1812, a covert military action approved by the administration of President James Madison. The goals of the operation were to seize Florida from the Spanish, recapture and enslave runaway slaves from the southern American states, destroy the free black militias that worked in cooperation with Spanish authorities and eliminate the Seminoles. After seizing Fernandina and the surrounding area, the American adventurers thought the new territory would be annexed by the United States, but Congress refused to approve their request.

1895—Heavyweight Title Match Held in Jacksonville: James J. Corbett, who won the title a year earlier by defeating John L. Sullivan, knocked out Charley Mitchell, the English champion, to retain his heavyweight boxing title in a bout fought in Jacksonville today. Corbett's fans were worried that the champion, who had been partying and drinking heavily since he won the championship, might not be able to fight an extended battle against Mitchell, who had recently won a fifty-one-round fight against the former champion Sullivan. The fight lasted three rounds, and Corbett won this bout by a knockout in the third round.

January 26

1767—Rollestown Colony Established on Banks of the St. Johns: Denys Rolles, an English philanthropist, established an agricultural colony in present-day Putnam County on this day. Great Britain, which had acquired Florida as a result of the Seven Years' War, had opened the Florida peninsula to colonization. Rolles, who was granted land by the British Crown, gathered two hundred indentured servants—vagrants, beggars, debtors and prostitutes from the streets of London—and settled them on his plantation. Unfortunately, none of the settlers knew anything about farming or subsisting in the wilderness, and the plantation failed.

1943—Frogmen Open Training Base in Fort Pierce: The formal commissioning of the Amphibious Training Base and Underwater Demolitions Training School (UDTS) at Fort Pierce took place today at 10:00 a.m. The UDTS eventually evolved into today's SEAL program. Fort Pierce is home to the National Seal Museum.

Following page: Camp Gordon Johnston, located near Carrabelle, was considered the worst possible place to train. General Omar Bradley, who trained there briefly, declared that whoever was responsible for selecting that site as a base "should be court-martialed for stupidity." The soldiers at Camp Gordon Johnston were in training for amphibious operations in the Pacific. The amphibious training program was later transferred to Fort Pierce. *Camp Gordon Johnston Museum, Carrabelle.*

January 27

1967—Astronauts Perish in Flash Fire at Cape Canaveral: Astronauts Gus Grissom, Ed White and Roger Chaffee were killed in a fire during a test of the first version of the Apollo spacecraft. NASA officials said an electrical spark ignited the pure oxygen inside the cabin of the Apollo spacecraft while the three astronauts were inside. The fire broke out at 6:31 p.m. as the Saturn rocket, which was to carry the spacecraft, sat on Launching Pad 34. Because the entire procedure was a test, the gantry remained in place and blocked the emergency escape system. Although the ignition source could not be conclusively identified, the astronauts' deaths were attributed to a

wide range of lethal design and construction flaws in the early Apollo command module.

1992—Female Serial Killer Aileen Wournos Convicted: Aileen Wournos was convicted of killing three male motorists along Florida highways in 1990 while she was working as a prostitute. She was eventually accused of killing a total of seven men between 1989 and 1990, who, according to her, had either raped or attempted to rape her. She was convicted and was executed by the State of Florida on October 9, 2002.

January 28

1958—Air Force Successfully Launches Thor Missile: The U.S. Air Force launched a Thor missile today at Cape Canaveral. The Thor became the first operational missile deployed by the United States and the United Kingdom. It could carry thermonuclear warheads and had a range of 1,500 miles. Its period of service was short-lived, and in 1963, it was replaced by longer-range intercontinental ballistic missiles. The Thor, modified for use with other missile launches, continues in use today.

1986—Challenger *Shuttle Explodes, Killing Crew*: The shuttle *Challenger* exploded after its launch from Cape Canaveral on this day, killing all seven astronauts on

board. The *Challenger*, which was scheduled to lift off at 9:38 a.m., was kept on the launch pad for two hours because unusually low temperatures caused ice to form on the shuttle and ground support system. At 11:38 a.m., the shuttle lifted off flawlessly from the pad. When the space vehicle had achieved an altitude of ten miles and immediately prior to the full ignition of the main engines, the shuttle exploded in a ball of fire that was visible throughout the state of Florida. Killed in the explosion were Francis R. Scobee, Michael J. Smith, Judith A. Resnick, Ronald E. McNair, Ellison S. Onizuka, Gregory B. Jarvis and Christa McAuliffe.

January 29

1864—Confederate Deserters Roaming Florida Countryside: Governor John Milton informed General Pierre Beauregard, commander of the Department of South Carolina, Georgia and Florida, that Confederate army deserters were organizing themselves into bands in the state. The areas of the strongest groups were in LaFayette, Washington, Walton, Taylor and Levy Counties in West Florida. The deserters were also operating in strong bands from Tampa to Fort Myers in Southwest Florida.

1885—English Composer Visited Florida: Frederick Delius celebrated his twenty-third birthday at Solano Groves in

St. Johns County during a short stay in Florida (1884–86) as the manager of a citrus plantation near St. Augustine. Influenced by African American music he heard during his Florida sojourn, Delius began composing his own music. From Florida, he made his way to Germany, where he briefly studied musical composition. His *Florida Suite*, inspired by his visit, premiered in 1887. Delius then made his way to Paris, where he married and settled down to a career of full-time composing. He enjoyed his initial success in Germany in the 1890s but later enjoyed success in England and the United States. Syphilis, which he had contracted during his stay in Paris, took its toll in later life, although he managed to continue working until 1932.

January 30

1917—Snow Blankets St. Augustine: On this day, one newspaper reported that a child urged his mother to "come and see all the grits all over the roofs and ground." Snow was also a novelty for many of the older residents "who have never wintered north," the *St. Augustine Record* informed its readers. The mercury dropped to a reported twenty degrees, which had residents and farmers concerned about possible damage. As the *Record* reported, "Vegetables in the city gardens look as if they had been laundered and hung out to dry." Growers had greater concerns because the area

still contained numerous citrus groves, but the hope was that some of the hardiest varieties would recover.

1964—NASA Plans for Manned Moon Launch: A Ranger spacecraft was launched today from Cape Canaveral carrying six television cameras and aimed at the moon. It was hoped that the spacecraft would transmit valuable pictures back to Earth to help with the American manned moon-landing attempt later in the decade. The mission was not a success, however. It struck the moon's *Mare Tranquillitatis*—the Sea of Tranquility—within a few kilometers of its target on February 2, 1964. The cameras aboard the spacecraft never switched on. The failure led to an independent review board, new program management, a congressional investigation and calls for the program's cancellation.

January 31

1891—Grand Hotel Opened in Tampa: Henry Plant's Tampa Bay Hotel covered six acres and was a quarter mile long. The 511 rooms and suites were the first in Florida to have electric lights and telephones. Most also included private baths. The price for a room ranged from five to fifteen dollars a night. Guests could hunt, play golf, bowl or swim on site. Unable to meet its debts during the Depression, the hotel shut its doors in 1930. It reopened in 1933, when a

junior college took it over, using the old suites as classrooms. Today it is the University of Tampa.

1958—Success as America Launches First Satellite: The first American satellite, Explorer I, was placed into orbit on this day by the Army Ballistic Missile Agency. Explorer I was launched from the Cape Canaveral Missile Annex and was the first spacecraft to detect the Van Allen radiation belt. Data from instruments in the satellite continued to be transmitted until its batteries were exhausted after nearly four months.

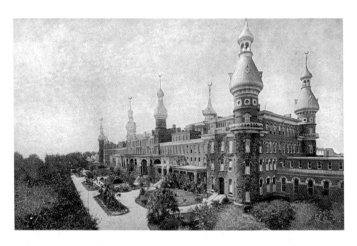

At Henry Bradley Plant's Tampa Bay Hotel, an exotic combination of Persian and Moorish architecture built of red bricks, guests could hunt wild birds, play a game of golf or stroll through luxurious gardens—all on the front lawn. The Tampa Bay Hotel served as the headquarters for the American Army on its way to fight in the Spanish-American War of 1898. *The Richard Moorhead Private Collection.*

FEBRUARY

February 1

1929—Unusual Attraction Is Dedicated by President Coolidge: The Edward W. Bok Singing Tower and Bird Sanctuary in Lake Wales was dedicated today by President and Mrs. Calvin Coolidge. Governor Doyle E. Carlton also participated. Edward W. Bok, the editor of *Ladies' Home Journal*, and his wife, Mary Curtis Bok, hired noted architect Frederick Law Olmsted Jr. to design a bird sanctuary for the Lake Wales Ridge where the couple had a winter home. Olmsted's tower, complete with a surrounding garden, has remained a favorite destination for Florida residents and tourists.

1939—Thoroughbred Racetrack Opens in Hallandale: The Gulfstream Park Race Track at Hallandale opened for its first Thoroughbred racing meeting on this day. The large crowd of eighteen thousand demonstrated the attraction of horse racing and parimutuel betting for tourists and

residents of the Sunshine State. In December 1944, James Donn Sr. inaugurated a program of twenty days of racing. Since that time, the track has been home to the Florida Derby and other notable races with large purses and famous horses. In 1955, Swaps, who won the Kentucky Derby that year, established a world record for the mile and seventy-yard track with a time of 1:39⅗ in the Broward Handicap.

February 2

1914—First Flight of Naval Aviators in Florida: Lieutenant J.H. Towers and Ensign G. Chevalier made the first flight from the Pensacola Aeronautical Station on this date. The twenty-minute flight covered the military reservation and Bayou Grande. Towers founded Pensacola NAS in January 1914, when he brought seven aircraft, forty-two men and portable hangars from Annapolis to use for training other aviators. Just months later, he led the first naval squadron into battle when he and two other pilots boarded the *Birmingham*, a cruiser headed for Tampico, Mexico. The squadron was part of an American force that responded to a confrontation between American sailors and Mexican soldiers from General Victoriano Huerta's army.

1946—Country Music Star Howard Bellamy Born Today: Guitarist Howard Bellamy was born in Darby, Florida. Along with his

brother, David, Howard Bellamy formed a musical group that had several major hits during the 1970s and 1980s. Their crossover hit, "Let Your Love Flow," topped the *Billboard Hot 100* in 1976. Eventually, the Bellamy Brothers had twenty singles that made it to number one.

February 3, 1768

Turnbull Colony Established at New Smyrna: Scottish physician and philanthropist Andrew Turnbull, who used his friendship with Governor James Grant to secure a land grant on Florida's east coast, established a plantation colony at New Smyrna. He recruited settlers from Minorca, Italy and Greece to come to Florida as indentured servants and laborers. The settlers were promised their freedom and tracts of land after their indentures were completed. His landholdings were dedicated to the production of hemp, sugarcane and indigo. Although the colonists enjoyed success in these endeavors, they were besieged by diseases (primarily malaria) and Native American raids. Continued mistreatment by Turnbull and his overseers fueled a growing discontent among the colonists, and in 1776 and early 1777, some of the colonists traveled north to St. Augustine to state their grievances and request sanctuary. A decision by the British courts released the colonists from their servitude and allowed them to settle in St. Augustine. In the summer of 1777, they left Turnbull's plantation and

journeyed to St. Augustine, where their descendants still live. In 1783, East and West Florida were returned to the Spanish, and Turnbull abandoned his colony to retire in Charleston, South Carolina.

February 4, 1861

Confederate States of America Formed; Davis Named President: Delegates from Florida joined with delegates from Mississippi, South Carolina, Alabama, Georgia and Louisiana today in Montgomery to organize the provisional government of the Confederate States of America. Jefferson Davis, a former U.S. senator from Mississippi and secretary of war, became the provisional (and later regular) president of the new nation. Davis was a hardworking, though divisive, chief executive, whose preoccupation with detail, reluctance to delegate responsibility, lack of popular appeal, feuds with powerful state governors, favoritism toward old friends, inability to get along with people who disagreed with him, neglect of civil matters in favor of military ones and resistance to public opinion all worked against him. Modern historians believe Davis to have been a less effective military leader than Abraham Lincoln. With the defeat of Confederate military forces, Davis, along with members of his cabinet and family, sought to escape capture by Union forces and fled south. He was taken prisoner in 1865. He was accused of treason against the United States but was

never tried. He was released after two years in prison. After the war, Davis restored some of his popularity during a tour of the South in 1886 and 1887.

February 5, 1926

Town of Miami Shores Incorporated: In 1856, American soldiers cut a narrow eight-foot-wide trail from Fort Lauderdale to Fort Dallas at the mouth of the Miami River, opening the territory between the forts for settlement. In 1891, a "Mr. Ihle" purchased eighty acres, erected a palmetto frond shelter and began to grow a variety of crops. A small community grew up around the Ihle farm, and in 1905, the Flagler railroad erected a depot at the site. By 1912, the community, called Arch Creek, boasted eighteen homes, a church, a general store, a blacksmith shop and several packinghouses. When the Florida land boom happened in the early 1920s, the area was ideally located for development. On February 5, 1926, developers E.C. Harner, Earl Irons and Arthur Griffing persuaded residents to incorporate the small town as the town of Miami Shores and to approve a bond issue for $287,000, which was used to build infrastructure projects. The prospects for further growth appeared bright, but in September 1926, a major hurricane destroyed the land boom, causing the town to experience hard times. In 1931, the town of Miami Shores lost the right to its name when the legislature awarded the

Shoreland Company the right to name its new development the "Village of Miami Shores." Residents then choose the name "Town of North Miami" as a replacement.

February 6

1897—Millard Fillmore Caldwell Born: Millard Fillmore Caldwell, the twenty-ninth governor of Florida (1945–49), attended Carson-Newman College, the University of Mississippi and the University of Virginia. Caldwell came to Florida in 1924 during the Florida land boom to practice law. He immediately became active in politics, and in 1929, he was elected to represent Santa Rosa County in the Florida House of Representatives. In 1933, he was elected to the U.S. House of Representatives. In 1941, he retired to private law practice but continued to be active in politics. In 1944, he was elected governor. His administration was considered very progressive. He left office in 1949 and returned to his law practice. In 1962, Caldwell was appointed a justice in the Supreme Court of Florida. He was elected for a full term that same year. In 1967, he was elected chief justice. Caldwell retired in 1969. He died in Tallahassee on October 23, 1984.

1907—Maas Brothers Incorporate Department Stores: Maas Brothers Department Stores were incorporated on this day. Originally founded by Abe Maas in Tampa in October 1886, Maas Brothers eventually grew from a

single store to a chain of thirty-nine located in cities across Florida. Although Maas Brothers sold its stores to the Hahn Department chain in 1929, the brothers continued to operate the franchise until the 1960s. In a series of corporate buyouts and mergers in the 1980s, the Maas Brothers brand disappeared.

February 7, 1979

Legislator Gwen Cherry Killed in Car Accident: Gwen Sawyer Cherry, the first African American woman to serve in the Florida legislature, was killed today in a one-car accident in Tallahassee. A native of Miami, Cherry was born in 1923. Cherry was a teacher in Miami for a number of years before being admitted to the Florida Bar in 1965. She was the first African American female lawyer in Dade County. She was also on the faculty of the FAMU law school. In 1970, she was elected to the Florida House of Representatives from Dade County and would serve four terms. She introduced several important pieces of legislation, including a bill to create a state holiday honoring Martin Luther King Jr. Cherry, along with Pauline Willis and Ruby Thomas, co-authored the book *Portraits in Color: The Lives of Colorful Negro Women*. She also served on a number of national committees for the Democratic Party. In 1986, she was posthumously inducted into the Florida Women's Hall of Fame, and FAMU's College of Law honored her by dedicating a lecture hall in her name.

February 8

1571—Jesuit Missionaries Killed: Father John Baptist Segura, vice-provincial of Jesuit Missions in Florida, and eleven companions were killed today at their mission on the Rappahannock River near the Chesapeake Bay. This was part of a plan of Pedro Menéndez de Avilés to explore the land north of present-day Florida to find the Northwest Passage to the Pacific Ocean and the Far East. As a result of this episode, the Jesuits abandoned their attempts to convert Florida Native Americans to Catholicism in 1572.

1837—U.S. Army Attacked by Seminoles: Lieutenant Colonel William S. Harney and a small force were attacked on this day at Camp Monroe by some two hundred Seminole Indians led by King Philip and Coacoochee. The U.S. Army lost one officer killed and eleven enlisted men wounded during the attack. Captain Charles Mellon was the officer killed, and the encampment's name was changed from Camp Monroe to Fort Mellon to honor him.

February 9, 1838

Army Commander Recommends an End to Indian Removal: General Thomas S. Jesup, the commander of U.S. troops in Florida, reported that in his opinion, "The prospect of terminating this [Seminole] war in any reasonable time is anything but

flattering. My decided opinion is that unless immediate emigration be abandoned, this war will continue for years to come, and at constantly accumulating expense." Jesup proposed that the area west of the Kissimmee River, Lake Okeechobee and Panai-Okee; east of Pease Creek; and south to the extreme end of Florida be set aside for the Seminoles. The secretary of war did not approve this plan, and some five hundred Seminoles, who had entered Jesup's camp on the strength of this recommendation, were seized and transported to Tampa for the purpose of removal to the West.

February 10, 1835

Tallahassee to Be Connected to the Gulf of Mexico by Railroad: The Tallahassee Railroad Company was incorporated on this date. Cotton planters, naval stores merchants and timber barons needed ready access to international and domestic markets, and a railroad to St. Marks, the nearest deep-water port, would provide it. To finance the railroad, a federal land grant was secured, and construction got under way. The railroad was primitive in construction, but it worked. After completion in 1837, the twenty-two miles between Tallahassee and St. Marks was an easy one-day journey. Over the years, the wooden rails were replaced by iron ones, and the mule-drawn cars gave way to steam engines. In March 1865, the railroad was used to transport

Confederate troops south to face a Union army moving from the coast toward Tallahassee. Confederate generals Samuel Jones and William Miller used the railroad to move enough troops to Natural Bridge, where on March 6, the much larger Union force, commanded by General John Newton, was defeated. The railroad continued to operate until 1983, when the Seaboard Railroad, which had gained ownership of the road, filed for permission to abandon the line. St. Marks was no longer a major port and shipments could be sent overland to most destinations. The railroad had operated continuously for 147 years.

February 11

1894—Flagler Opens Royal Poinciana Hotel: The Royal Poinciana Hotel in Palm Beach, which became the largest wooden structure in the world, could accommodate 2,000 guests at a time and employed about 1,700 individuals. Although long a favorite of many of the wealthiest Americans, other resort cities—such as Miami Beach and Miami—eventually replaced Palm Beach as a favored vacation destination. The Poinciana closed during the Great Depression.

1920—Daniel "Chappie" James: Daniel "Chappie" James Jr., the first African American to achieve four-star rank in the armed forces of the United States, was born in Pensacola

on this day. A 1942 graduate of Tuskegee University, James was an instructor in the army air force during World War II. He later served as a combat pilot in Korea and Vietnam, flying a total of 179 missions. On September 1, 1975, he was awarded his fourth star.

February 12

1899—BRRR!: Tallahassee recorded a temperature of negative two degrees Fahrenheit on this date. This is thought to be the lowest temperature ever reached in Florida. This was also the date of the greatest snowfall on record for the Sunshine State. Four inches were reported at Lake Butler, three and a half inches at Marianna, three inches at Lake City and trace amounts as far south as Fort Myers, Avon Park and Titusville.

1963—Plane Crashes in the Everglades; No Survivors: A Northwest Orient Airlines plane, Flight 705, crashed in stormy weather north of Miami. Forty-three persons were killed. The plane, a Boeing 720 aircraft, broke up in midair shortly after takeoff during a severe thunderstorm. The flight carried thirty-five passengers and had a crew of eight. There were no survivors when the plane crashed. An FAA investigation blamed the crash on extreme vertical displacements within the thunderstorm.

February 13

1831—City of Fernandina Reincorporates: The city of Fernandina Beach was reincorporated today. The city had first been incorporated on January 1, 1825. Fernandina is Florida's northernmost city on the east coast and was once a major port city because of its deep harbor and fishing industry. The city has also been a favorite target of freebooters and political adventurers. During its history, eight different national flags have flown over the city, although only those of Spain and the United States endured for any significant period of time. Fernandina, named in honor of King Ferdinand VII of Spain, has attracted a variety of pirates, privateers and patriots who have captured, lost and recaptured the city.

1864—Confederate Forces Await Battle at Olustee: Confederate forces under the command of General Joseph Finnegan concentrated at Camp Beauregard near Olustee on Ocean Pond. General Finnegan selected the position because of the protection offered by two small lakes. It was also the location of the major road and railroad into the interior of the state. Confederate soldiers started the task of building entrenchments and fortifications in anticipation of a major battle that would be fought on or near this spot.

February 14, 1839

New Fort Constructed in South Florida: Fort Lauderdale, now a major Florida city and vacation destination, came into being as a temporary fort built during the Second Seminole War. The scene of heavy fighting during the war, the fort was abandoned in 1842, and the area surrounding it remained largely uninhabited until the 1890s. The arrival of the Florida East Coast Railway revived interest in the area, and the frenetic land boom of the 1920s saw the development of large tracts of land. Following the 1926 hurricane, interest in Fort Lauderdale waned until the town became home to a major naval aviation training base

Small municipal airports like the ones at Vero Beach and Fort Lauderdale were quickly converted into pilot training bases in World War II. Across Florida, more than ninety pilot training bases were in operation, some nothing more than a landing strip and gasoline refueling pumps. *Indian River County Historical Society.*

during World War II. Many of the service personnel who had trained there returned after the war and settled in the city. The 1960 film *Where the Boys Are* made it a popular spring break destination.

February 15, 1898

American Warship Explodes in Havana Harbor: The explosion of the USS *Maine* set into motion the events leading up to the Spanish-American War. More than 250 men were killed and some 50 wounded. Although unproven, the accusation made by the American press that Spain, which was involved in fighting a war against Cuban revolutionaries, was responsible for the destruction of the *Maine* resonated with the American public, who demanded military action. Bowing to public pressure, President McKinley asked Congress for a declaration of war. Congress approved his request on April 25. Florida became the staging ground for the American military. The war, which lasted only three months, two weeks and four days, resulted in the defeat of the Spanish army and navy. American investigations into the sinking blamed poor ship design and unstable black powder for the disaster.

Ships line the docks of Port Tampa taking on supplies for an invasion of Cuba. Many Americans welcomed the war with Spain as a way to heal sectional wounds that remained from the Civil War. *Tampa Bay History Center.*

February 16

1933—Assassination Attempt on President Roosevelt: Floridians and the world were taken aback when early morning reports trumpeted the news that President Franklin Roosevelt and Chicago mayor Anton Cermak had been the targets of an assassin in Miami late the previous night. After delivering a speech in Bay Front Park, Roosevelt was sitting in his car surrounded by well-wishers and political allies when five pistol shots rang out. Roosevelt escaped harm, but Cermak

and four other persons were wounded. Cermak's wounds proved fatal. The would-be assassin, Guiseppe Zangara of Hackensack, New Jersey, was wrestled to the ground by a policeman and hustled off to jail. His only statement was "I'd kill every president." Hidden in his clothing was a newspaper clipping describing the assassination of President William McKinley in 1901.

1965—Pegasus Satellite Launched at Cape Canaveral: The first Pegasus satellite was launched from Cape Canaveral on this date. The purpose of the satellites was to study meteoroids and other potential hazards that might be encountered by the upcoming Apollo missions. The event inaugurated a program of three American satellites launched in 1965 to study the frequency of micrometeorite impacts on spacecraft. The Pegasus satellites were notable for their "wings," which were made of panels fitted with sensors to detect punctures by micrometeoroids at high altitudes. The information would help the Apollo Program in its preparations for manned lunar landing.

February 17

1919—Flu Outbreak Kills More Than 3,000 Floridians: The State of Florida Board of Health reported that 3,007 Floridians had perished in the first three months of the great influenza outbreak that swept the world immediately

following World War I. The earliest reports of a possible pandemic of influenza in the Sunshine State came in 1917 when outbreaks were reported in Key West, Tampa, Jacksonville, Miami and Pensacola—the common denominator being that these were the major ports. Within weeks, the flu outbreak had spread inland. Worldwide an estimated 20 to 40 million people died.

1959—Boys Ranch Program Inaugurated by Florida Sheriffs: The first boy was enrolled at Florida Sheriffs' Ranch near Live Oak on this day. The ranch, founded in 1957, was created to serve as a home for nondelinquent dependent, homeless and/or neglected boys between the ages of eight and seventeen. In 1971, ground was broken for a sister program—the Girls Villa—followed by a third youth ranch in 1975. In 1986, the youth fund changed its name to the Florida Sheriffs' Youth Ranches, Inc. The program now consists of six sites throughout the state and operates independently from the Florida Sheriffs' Association, though the sheriffs remain key supporters. Since its founding, the program has served more than 100,000 boys and girls and their families.

February 18, 1842

Colonel Recommends End to Second Seminole War: Colonel William J. Worth reported today that only 300 Seminole warriors

were left in Florida and that it was impossible for the U.S. Army to capture or kill them all. He recommended to his superiors that a peace treaty be made. They agreed, and Worth, on August 14, declared the Second Seminole War at an end. This war was the most expensive Indian war fought by the United States, and estimates of its final cost range from $30 to $40 million or roughly $93,300 a month, plus the monthly pay of regular soldiers, sailors and marines involved in the fighting. The war, which started in 1835, lasted seven years and involved 10,169 regular troops, plus an estimated 30,000 militiamen and volunteers. The number of American regular soldiers who died during the war is officially recorded as 1,466, although the majority of these deaths were caused by disease. The actual number of soldiers killed in action is variously listed as 269 to 328, while navy casualties from all causes are listed as being 41 to 69. An addition, 55 officers and men of volunteer forces were killed. No casualty figures are available for Seminole or civilian deaths.

February 19, 1821

Adams-Onís Treaty Approved: Under the terms of this transcontinental treaty, Spain ceded Florida to the United States in exchange for the elimination of about $5 million in outstanding debts. Although Spain had rejected previous U.S. attempts to buy Florida, international events had placed heavy demands on the Spanish treasury, forcing

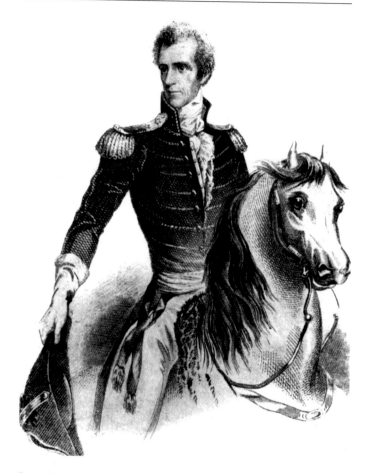

General Andrew Jackson led a successful invasion of Florida in pursuit of marauding Native Americans. As a result of his conquest, Spain agreed to turn the Florida Peninsula over to the United States in exchange for $5 million in claims against the Spanish government. *Florida Memory Project, Florida State Photographic Archives.*

Spain to consider the American proposal. Raids by Seminole Indians and their African American allies led General Andrew Jackson to invade Florida and capture the Spanish forts in a yearlong campaign against the Seminoles. Secretary of State John Quincy Adams justified the Americans' control of Florida, which was "open to the occupancy of every enemy, civilized or savage, of the United States, and serving no other earthly purpose than as a post of annoyance to them." When Spain asked for assistance from Great Britain, London declined to assist in the negotiations. While some of President James Monroe's cabinet demanded Jackson's immediate dismissal, Adams persuaded him that Jackson's success had given the United States a favorable diplomatic position.

February 20

1864—Union Forces Defeated at Olustee: The largest Civil War battle to take place in the state of Florida occurred today at Ocean Pond/Olustee. Union and Confederate forces were about evenly matched. The Confederates, under the command of General Joseph J. Finnegan, had prepared defenses in the area. The failure of the Union commander, General Truman Seymour, to commit his forces in concert gave the Confederates a strategic advantage. At the end of the day, the Confederates controlled the battlefield, and Federal forces were in a hasty retreat toward Jacksonville.

1962—Glenn Is the First American Astronaut to Orbit Earth: Lieutenant Colonel John H. Glenn Jr. became the first American to orbit the Earth in his Mercury spaceship, *Friendship 7*. Glenn, enclosed in the *Friendship 7* high atop an Atlas rocket, was hurled into space at 9:47 a.m. The rocket placed the Mercury capsule in orbit ninety-nine miles above the Earth's surface. The launch came after ten separate delays caused by bad weather conditions and technical glitches to equipment. The Mercury made three full orbits of the Earth and landed in the Atlantic at 2:43 p.m. Hundreds of thousands of Floridians lined the beaches of the east coast to catch a glimpse of this historic event.

February 21

1865—Battle for Fort Myers Ends with Confederate Withdrawal: On the morning of February 20, a force of between two and three hundred Rebel troops from Fort Meade, composed mostly of militia and cattle ranchers under the command of Colonel Charles Munnerlyn, ambushed Union pickets stationed outside the Fort Myers. Munnerlyn fired one warning shot from a field piece and demanded the fort's surrender. Captain James Doyle, commander of Fort Myers, declined and pushed out dismounted cavalry and artillery units from the fort's walls. During the day, there were dozens of skirmishes

and artillery exchanges in the area but no extensive fighting. Confederate troops withdrew back to Fort Meade the next day.

1949—Mary McLeod Bethune Awarded Degree by Rollins College: Mary McLeod Bethune was granted the first honorary degree by a southern white college to an African American woman on this date. Bethune's rise to prominence was a source of inspiration for generations of African American youths. Born to former slaves on July 10, 1875, in Mayesville, South Carolina, she graduated from Scotia Seminary for Girls in 1893. In 1904, she founded the Daytona Normal and Industrial Institute in Daytona, Florida, which later became Bethune-Cookman College. She died on May 18, 1955, in Daytona.

February 22, 1959

First Daytona 500 Race: The first Daytona 500 race, with a purse of $19,000, was won by Lee Petty of Randleman, North Carolina, on this day. Petty averaged 135.42 miles per hour in his 1959 Oldsmobile. Johnny Beauchamp of Harlan, Iowa, finished second in a 1959 Ford Thunderbird. Petty's win was disputed as the two men finished neck and neck in a photo finish. A crowd of 41,921 viewed the almost four-hour race, in which racers achieved an average speed of 135.21 miles per hour. Cotton Owens led qualifiers for

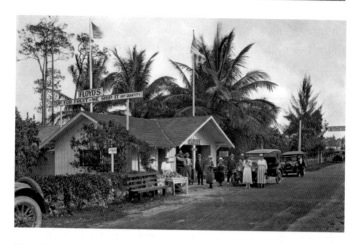

This photograph neatly captures two of the most important elements of the tourist trade in Florida—fresh citrus and automobile traffic. Such "mom-and-pop" operations as this one were common sights along highways in the Sunshine State until the late 1960s and 1970s when super-attractions like Disneyworld and Universal Studios began to dominate the industry. *The Lewis N. Wynne Private Collection.*

the race with a speed of 143.198 miles per hour. There were no delays during the race, a feat that earned that contest the sobriquet the "Perfect Race."

February 23

1865—Union Forces Seek to Capture Tallahassee: A Federal expedition under the command of General John Newton sailed from Key West today, believed to be headed for St.

Marks on the Gulf Coast. Once there, Newton marched his forces toward Tallahassee but suffered a defeat at the Battle of Natural Bridge in March 1865. On May 10, 1865, Union brigadier general Edward McCook and his staff entered Tallahassee. McCook and his occupation force had come from Macon, Georgia, to establish federal control and authority in Florida. Confederate troops signed parole documents and turned over military equipment to federal authorities. In a May 20 ceremony, Union troops raised a large U.S. flag over the state capitol. On the same day, General McCook read the Emancipation Proclamation, formally freeing slaves in Florida.

1958—Daytona Beach Road Course Hosts Last Race: The last races on the old Daytona Beach track were held this week. On Friday, Banjo Matthews won the 125-mile Sportsmen/ Modified race, and on Saturday Curtis Turner won the 160-mile Convertible race. On Sunday, Paul Goldsmith started from the pole to win the final event at the course. Curtis Turner finished second; Jack Smith, third; and Joe Weatherly, fourth. Lee Petty, Buck Baker, Fireball Roberts and Cotton Owens finished in the top ten.

February 24

1840—John Warren, President of the Territorial Council, Resigns: John Warren of Duval County submitted his resignation as

the first president of the territorial legislative council on this day. The council had a membership of eleven men and was charged with enacting the laws and approving budgets for the territory of Florida. Warren, a volunteer in Jackson's military campaigns against the Seminole Indians several years earlier, became a merchant in Cowford, a small town on the banks of the mouth of the St. Johns River, where herders could drive their cattle across the river. In 1822, Cowford was formally platted and named streets were created. Warren successfully urged Jacksonville's founders to name the young town in honor of Old Hickory. Warren, who became a prominent political force in the community, is one of the long-forgotten men in Jacksonville's history.

1862—Union Blockader Captures Ship: The USS *Harriet Lane* captured the Confederate schooner *Joanna Ward* off the coast of Florida on this date. The *Harriett Lane* was commanded by Lieutenant Jonathan M. Wainwright, the grandfather of General Jonathan M. Wainwright, who was forced to surrender Bataan to the Japanese in World War II.

February 25, 1964

Cassius Clay Defeats Sonny Liston: Cassius Clay (later Mohammed Ali) defeated heavyweight boxing champion Sonny Liston this day at Miami Beach in a controversial six-round match. This was Clay/Ali's first heavyweight

title. Liston and Clay/Ali would meet in a later rematch on May 25, 1965, that would also be a win for Clay/Ali and generate additional controversy when Ali delivered the famous "Phantom Punch" that knocked out Liston in the first round of the fight. Because of Liston's business relations with Frankie Carbo, a one-time Mafia hit man and senior member of the Lucchese crime family, the FBI investigated both fights as possible "fixed" fights. No criminal charges were ever brought forward.

February 26, 1946

Former Prime Minister Winston Church Awarded Honorary Degree: More than 17,500 persons watched as Winston Churchill received an honorary Doctor of Laws degree from the University of Miami today. According to the fall 2011 edition of *University of Miami Magazine*'s Alumni Digest column:

> *University of Miami President Bowman Foster Ashe and Sir Winston Churchill...led the long academic procession through the Orange Bowl...to a stage festooned with the flags of the Allied Nations and tropical palms for a Special Convocation to honor Churchill on February 26, 1946...the sun shone brightly as Churchill received an honorary Doctor of Laws degree from UM, confirms Frank Stokes, B.S. '49, who had*

helped plan the auspicious affair as freshman class president. "We all respected Churchill for what he did in the war," explains Stokes...Churchill had been in South Florida on an extended, long-overdue vacation...it was, in fact, an awkward time for the former prime minister. Just months after helping lead the Allies to victory, he lost a landslide election in July 1945...On the subject of education, Churchill observed wryly: "I am surprised that later in my life I should have become so experienced in taking degrees when, as a schoolboy, I was so bad at passing examinations. In fact one might almost say that no one ever passed so few examinations and received so many degrees."

February 27, 1964

Cross-Florida Barge Canal Excavations Restarted: In 1933, southern politicians lobbied the federal government to fund the construction of a canal across the Florida peninsula as an economic recovery program. Eager to keep his New Deal programs fuelling the regional economy, President Franklin D. Roosevelt allocated emergency funds for the project in 1935. Although construction of the canal would have added thousands of new jobs and millions of dollars to the Florida economy, Floridians were concerned that the canal would damage the state's aquifers and diminish the available water supply. As a result of their concerns,

work was stopped. The idea of a canal was revived in 1942 as a defense project; however, congressional support was lacking, and the project languished. While the idea got new life and some limited funding in the 1960s, opposition by environmentalists stopped the project before much in the way of construction could be done. The canal project officially died in 1991, and the land for the right of way was given to the state. It is now a greenway named for environmentalist Marjorie Harris Carr.

February 28, 1988

Daredevil Cyclist Sets Long Jump Record in Tampa: Daredevil Todd Seeley jumped his motorcycle 246 feet from ramp to ramp in a World of Wheels show. Seeley, a Tampa resident, considered himself to be a professional stuntman as opposed to other motorcycle jumpers. He performed stunts in a number of movies and during a variety of motorsports events. He was a member of the Screen Actors Guild, the Tampa Showmen's Association and the Eastern Museum of Motor Racing. Seeley died on July 26, 1998, when he attempted to jump a four-wheeled ATV a distance of 150 feet in Lancaster, Pennsylvania. He had previously recorded a jump of 160 feet on the same vehicle in Pontiac, Michigan. The Associate Press reporter covering the attempt explained what happened:

As the stunt began, Seeley revved up the squat red-and-white ATV to reach 65 mph, a shower of golden sparks from a firecracker trailing behind it. Ahead of him, he aimed for the 12-foot wide, 84-foot long landing ramp about 100 feet away. More than 4,000 spectators gasped and rose to their feet as Seeley came off the ramp—the ATV visibly pulling left. He shoved his vehicle away in mid-air, his body clipped the safety catcher along the ramp's side, and he hit the dirt face down beside the landing ramp. He didn't move as ambulance crews carried him away.

February 29, 1836

American Soldiers Forced to Eat Horses and Dogs During Siege: General Edmund P. Gaines and his troops were pinned down by more than 1,500 Seminole warriors during a ten-day siege at Camp Izard on the Withlacoochee River, near present-day Dunnellon. The siege eventually became so critical that the U.S. troops were forced to kill their horses and dogs for food. Camp Izard was an emergency fortification established when General Gains and his force, attempting to cross the Withlacoochee River, came under attack by Seminole Indians under Chiefs Osceola and Alligator. Lieutenant James F. Izard was the first casualty of the battle. The Seminoles surrounded soldiers and forced them into a 250-yard

quadrangle, which the soldiers fortified. General Gaines sent a request to General Clinch for reinforcements after the first day, but the siege lasted two weeks without any reply. The Seminoles requested a conference with Gaines, who sent representatives to talk with them. As the talks got underway, 500 American reinforcements arrived and opened fire on the Seminoles, who fled. The post was abandoned at the end of the war in 1842.

MARCH

March 1, 1861

Cross-Florida Railroad Completed: The first train of the cross-peninsula railroad from Fernandina to Cedar Key arrived in Cedar Key on this day. David Levy Yulee, U.S. senator from Florida, was the driving force behind this railroad. Construction of the railroad started in 1855. Although original plans called for the road to go to Tampa first and then to Cedar Key, Yulee opted to exercise the Cedar Key route after the road had connected Fernandina with Palatka in 1858. The Panic of 1857 had left the railroad in serious financial trouble, and the Cedar Key link offered the quickest way to rejuvenate the finances of the company. When the connection was completed, it stretched 156 miles, the longest railroad to be built in Florida before the Civil War. Immediately after completion, the war erupted, and both terminals were attacked by Union forces, which made them unusable. In 1864, the tracks were removed

and used to construct a new line from Live Oak, Florida, to Lawton, Georgia. Although Yulee sought to reopen the line after the war, he was unsuccessful, and the line was auctioned off. Nevertheless, the new owners managed to continue operations, and Cedar Key, the terminus on the Gulf, enjoyed a period of great prosperity in the 1870s.

March 2, 1900

Audubon Society Organized: The first organizational meeting of the Florida Audubon Society was held today in Maitland. The society's immediate purpose was to stop the slaughter of the hundreds of thousands of Florida's plume birds for the purpose of providing decorations to women's hats. As a result of this fashion craze, the Sunshine State's population of snowy egrets and other plumed birds was almost wiped out. The plumes were so valuable—bringing the same price per ounce as gold—and so easily gotten that hunting plumed birds was an activity shared by men, women and children in both pioneer and Seminole communities. So great was the demand for plumes that the trade in feathers soon became a worldwide business. The so-called Feather Wars were fought in the legislatures of states where bird populations were large. In 1911, New York banned the sale of native bird plumes and prohibited the domestic trade in feathers. In 1913, Congress passed the Underwood Tariff, which banned the importation of plumes, and in 1916,

the Migratory Bird Act was approved. This act ratified an agreement among the United States, Canada and Great Britain that afforded protection for migratory birds. Fashions changed after World War I, and the demand for bird plumes dried up.

March 3

1845—Florida Admitted into Union as Twenty-Seventh State: President John Tyler signed the act of admission. Although some members of Congress thought the Florida Territory should be divided and admitted as two states, it was finally approved as a single state. The debate over slavery in the United States, which had not been permitted in Congress since the imposition of the "gag rule" in 1836, was reopened when the question of Florida statehood was broached. American politics during the 1850s was dominated by the questions of slavery and emancipation, which eventually broke the Union apart. Sixteen years after it became a state, Florida seceded from the Union and joined the Confederate States of America. It was readmitted into the Union in 1868.

1969—NASA Successfully Tests Lunar Module: At Cape Canaveral, NASA launched Apollo 9 in its first manned test of the lunar module at 11:00 a.m. eastern standard time. The module, commanded by Russell Schweickart, made

152 orbits around the Earth. During the test, Schweickart performed a thirty-seven-minute spacewalk. The Apollo 9 launch was the first Saturn V/Apollo spacecraft in full lunar mission configuration and carried the largest payload ever placed in orbit.

March 4

1824—Tallahassee Becomes Florida Capital: Governor William Pope Duval, the first territorial governor, issued the proclamation. The selection of Tallahassee was largely a matter of convenience. In 1821, Florida was acquired by the United States from Spain as a result of the ratification of the Adams-Onís Treaty, and a territorial government was established. The long distance between Pensacola in extreme western Florida and St. Augustine on the eastern coast made a capital somewhere between the two cities highly desirable. Appointed by Governor William Pope Duval to find a suitable alternative, John Lee Williams of Pensacola and Dr. William Simmons of St. Augustine agreed on Tallahassee, which was roughly midway between the two towns.

1871—African American Josiah T. Walls Represents Florida in Congress: Josiah Thomas Walls, an African American born in Virginia on December 30, 1842, presented his credentials to the Speaker of the U.S. House of Representatives on this day. He served from March 1871 until January 1873,

when his election was successfully contested by Silas L. Niblack. Walls was elected for a second term and served from March 1873 until March 1875. Although reelected for another term, his tenure was cut short when his election was successfully challenged by Jesse J. Finley, who replaced him in the House in April 1876. Walls died in Tallahassee on May 15, 1905.

March 5

1865—Union General Moves to Capture Tallahassee: Federal forces occupied the left bank of the St. Mark's River as far inland as Newport. Federal commander General John Newton was expected to move his forces toward Natural Bridge. A Federal success here would mean that Tallahassee would fall. Confederate forces were moving to prevent the successful passage of the Union force.

1966—Professional Football Star Michael Irvin Born: Dallas Cowboys' receiver Michael Irvin was born on this date in Fort Lauderdale. A football star at St. Thomas Aquinas High School, he attended the University of Miami, where he set a variety of school records. Irvin was drafted by the Dallas Cowboys in the first round of the 1988 NFL Draft. He retired in 1999 after amassing a total of sixty-five touchdowns and 11,904 yards gained during his eleven-year career. Irvin's run-ins with law enforcement continued after

his retirement and included charges of drug use and sexual assault. Despite these problems, Irvin enjoyed a successful, though up-and-down, career in broadcasting and as an actor. In 2007, he was elected to the Texas Sports Hall of Fame and to the Professional Football Hall of Fame.

March 6, 1865

Union Effort to Capture Tallahassee Repulsed: The Union attempt to capture Tallahassee was thwarted on this date by a ragtag collection of Confederate troops, soldiers on leave or recuperating from medical problems and cadets from the West Florida Seminary (now Florida State University) at Natural Bridge, about twenty miles south of the city. Despite a considerable numerical advantage, the Federal troops could not overcome the Confederates' use of natural defenses to reach the city. Following the failure of this Union attempt, Federal troops withdrew to St. Marks. Tallahassee remained the only Confederate capital east of the Mississippi to escape capture and occupation by Union forces during the Civil War.

March 7, 1935

Speed Record Set on Daytona Beach: Sir Malcolm Campbell set a world speed record of 276.8 miles per hour on this

day on the sand at Daytona Beach. Campbell's car, the "Bluebird," could produce 2,500 horsepower and cost an estimated $200,000. He established a new speed record for the first time in 1924, when he drove a racer 146.16 miles per hour. Between 1924 and 1935, he broke eight additional records, five of which were at Daytona Beach. On September 3, 1935, Campbell set his final record by averaging 301.337 miles per hour in two passes at Bonneville Flats, Utah. In 1931, he was knighted by King George V of Great Britain. His achievements won him the Segrave Trophy in 1933 and again in 1939. The trophy recognizes the accomplishments of a British national who demonstrates the possibilities of transport by land, sea, air or water. Campbell died after a series of strokes in 1948 at age sixty-three, one of the few land speed record holders of his era to die of natural causes. In 1990, Campbell was posthumously inducted into the International Motorsports Hall of Fame, and in 1994, he was also inducted into the Motorsports Hall of Fame of America.

March 8, 1861

Florida Representatives Challenge Mallory's Appointment: The Charleston *Mercury* reported that Florida representatives in the Confederate Congress, James B. Owens and Jackson Morton, continued their attack on Florida's Stephen Russell Mallory, the newly appointed Confederate secretary of the

navy, for being a self-seeker and having shown "bad faith toward Florida, his native state." Mallory was still officially a member of the U.S. Senate, a position that he continued to occupy until the Senate officially accepted his resignation on March 11. He proved to be a capable administrator and innovator as head of the Confederate navy, and because most other officials in the Confederacy showed indifference to naval matters, he was able to make it into a modern fighting force. Constantly facing criticism for the failures of the Confederate navy against the larger Union navy, he nevertheless persisted until the war's end. He was captured by Union forces after the Confederate surrender and spent a year in a federal prison.

March 9, 1999

Famed Baseball Player Joe DiMaggio Dies: Joe DiMaggio, the famous "Yankee Clipper," died today at his home in Hollywood, Florida. DiMaggio's fifty-six-game hitting streak in 1941 is a major-league record that still stands. He played thirteen years for the New York Yankees. He was a three-time MVP of the American League and played in nine World Series, which were all won by the Yankees. He was also an All Star in each of his thirteen seasons in professional baseball, and during his time as a Yankee, the club won ten American League pennants. When he retired, he had compiled a record of 361 home runs and a slugging

percentage of .579. His statistics might have been better had he not served three years in the military during World War II. In 1955, he was inducted into the Baseball Hall of Fame. DiMaggio was married to actress Marilyn Monroe in 1954, but that union lasted for less than a year. After Monroe died in 1962, DiMaggio sent six roses to her crypt three times a week. He died in 1999.

March 10

1845—Levy County Created: Levy County, Florida's twenty-sixth county, was created today by the Florida legislature. The county is named in honor of David Levy Yulee, prominent politician, statesman and railroad entrepreneur. Levy owned a five-thousand-acre plantation on the Homosassa River, where he grew sugar cane and produced sugar. Levy was the first U.S. senator to represent the new state of Florida. Levy was also the driving force behind the Florida Railroad Company, which completed the first trans-Florida railroad between Fernandina and Cedar Key in 1860.

1862—St. Augustine Women Angered by Confederate Retreat: Confederate troops evacuated St. Augustine when faced with the arrival of the Union gunboat *Wabash* and a small force. Angry civilians were upset that the city had been abandoned without a fight. The women of St. Augustine

gathered at the front of the St. Francis Barracks that evening and, as a display of their anger, chopped down the flagstaff so that the Union flag could not be flown. St. Augustine became a rest center for Union troops and a haven for Unionist refugees and escaped slaves, a large number of whom joined the Federal army. Although Confederate forces under the command of Captain J.J. Dickinson periodically attacked Federal forces in the area, no concerted Rebel attempt was made to retake the city.

March 11, 1922

Bubonic Plague Declared Ended: The Florida State Board of Health concluded a "rat-proofing" campaign on this day in Pensacola to confine an outbreak of bubonic plague in the city. The plague outbreak began on June 11, 1920, when a patient—later described as having taken ill suddenly with a chill, followed by a high fever and delirium—was noticed by a federal quarantine officer at Pensacola. The patient later displayed symptoms of swelling in the femoral region of his body. Smears from the site revealed the presence of bubonic plague. The patient, who had lived in the city all his life, had not been in the port area, where rats carrying infected fleas, frequently came ashore from docked ships. So the answer to how he contracted the disease became critical to preventing a pandemic. Nine additional cases had surfaced by mid-August, and health officials instituted a

campaign to find and eliminate the sources of the infection. The Pensacola City Council approved an ordinance to "rat proof" buildings in the city, and an extensive campaign of fumigation, trapping, poisoning and eliminating the potential food supplies of rats and fleas was undertaken. In March 1922, seven months after the last infected rat was killed, the plague was officially declared over.

March 12

1869—Doctor Mudd Released from Prison: Dr. Samuel Mudd, who was imprisoned in Fort Jefferson in Florida's Dry Tortugas, was released today after being pardoned by President Andrew Johnson. Mudd had been convicted of being part of the conspiracy to kill Abraham Lincoln in 1865. Mudd set the broken leg of actor John Wilkes Booth. There were serious doubts about his participation in the conspiracy in 1865, and practically no one today believes that Mudd was in any way connected to the conspiracy.

1929—Segrave Becomes Fastest Man in the World: Major Henry O'Neil Segrave established a new land speed record on this day at Daytona Beach. Segrave was born on September 22, 1896 in Baltimore but grew up in Ireland. He was a fighter pilot with the Royal Flying Corps in 1914. After World War I ended, he began to race and set his first land speed record on March 21, 1926, at Southport, England, with a speed

of 152.33 miles per hour. The record lasted for just over a month. Segrave regained the land speed record on March 29, 1927, when he completed the Daytona Beach Road Course at a speed of 203.79 miles per hour, becoming the first person to travel over 200 miles per hour. Two years later, on March 11, 1929, he drove the same course at a record-setting speed of 231.45 miles per hour.

March 13, 1961

Floyd Patterson Knocks Out Ingemar Johansson: Floyd Patterson knocked out Ingemar Johansson in the sixth round of a heavyweight championship match in Miami Beach. Johansson, undefeated in twenty fights, with thirteen knockouts, was little known outside European boxing circles. Patterson's amateur career was spectacular, resulting in two New York and Eastern Golden Gloves championships in 1951 and 1952 and an Olympic gold medal in the middleweight division at the 1952 games in Helsinki. He turned pro on September 12, 1952. Patterson won twenty-nine of his first thirty pro fights. His next fight was a win against Tommy ("Hurricane") Jackson in 1956, which earned Floyd a match with world light-heavyweight champion Archie Moore for the newly vacant heavyweight title. On November 30, 1956, in Chicago, Floyd dropped the forty-three-year-old Moore with a leaping left hook in the fifth round and finished him

off with a right-left combination. At twenty-one, Patterson was the youngest man ever to wear the heavyweight crown, as well as the first Olympic medal winner to win the title.

March 14

1844—Brevard County Created by Legislature: Brevard County, Florida's twenty-fifth county, was created today by the Florida territorial legislature from the large area of land called Mosquito County, which extended from present-day Volusia County south to present-day Dade County. Brevard County was most probably named for Theodore Washington Brevard, a Florida politician who served from 1853 to 1861 as the state comptroller.

1903—Pelican Island Bird Preserve Created: Pelican Island National Wildlife Refuge, located in the Indian River Lagoon, became America's first national wildlife refuge on this date. President Theodore Roosevelt authorized the

Following page: One of the areas that was sparsely settled—even under the generous terms of the Armed Occupation Act—was along the Indian River Lagoon because of the marshy headwaters of the St. Johns River to the west and the absence of openings to the Atlantic Ocean to the east. Only after the end of the Civil War did this area experience any growth, and even then, it was slow until the coming of steamboats on the lagoon in the 1880s. Wildlife flourished in this region. *The Lewis N. Wynne Private Collection.*

creation of the refuge following a visit to the area. Rodney Kroegel became the first game warden for the refuge. The refuge is still in operation today and is a popular tourist site.

March 15

1831—Governor and Confederate General Edward A. Perry Born Today: Edward Aylsworth Perry, the fourteenth governor of Florida (1885–89), was born today in Richmond, Massachusetts. Perry attended Yale, taught school briefly in Alabama and took up residence in Pensacola, where he practiced law. Joining the Confederate army as a private, he rose to the rank of brigadier general. His administration as governor was marked by the adoption of a new state constitution and by the creation of the state board of education to advance public schools. After his tenure as governor, Perry returned to Pensacola, where he died on October 15, 1889.

1960—Coral Reef Preserve Established: The Key Largo Coral Reef Preserve was established today. In the 1930s, the Everglades National Park Commission proposed the creation of a large national park to protect the fragile ecology of the Everglades and reefs in the waters off the Florida Keys. In 1947, when the Everglades Park was created, the reefs were excluded, but a vigorous public campaign by Gilbert Voss of the Marine Institute of Miami and *Miami Herald* editor John D. Pennecamp in the late 1950s led to the creation of the Key Largo Preserve. The site is one of only two living coral reef sites in the United States.

March 16

1910—Barney Oldfield Sets Speed Record at Daytona Beach: Barney Oldfield established a new land speed record of 131.7 miles per hour at Daytona Beach today. Oldfield was driving the "Blitzen," a special car built in France specifically to challenge the Stanley Steamer driven by Fred Marriott. This car, with its 1,300-cubic-inch engine boasting eight-inch pistons, was difficult to drive. The driver was unable to control the car in the race. It was later purchased by Ernest Moross for $14,000 and brought to Daytona Beach. On March 16, 1910, Barney Oldfield flew through the Measured Mile time traps for a new world record of 131.72 miles per hour, although it was not recognized officially as a record since Oldfield did not complete the mandatory return lap.

1952—First Twelve-Hour Endurance Race Held in Sebring: The first twelve-hour endurance race at Sebring was won on this day at 1:00 a.m. by Larry Kulok and Harry Gray. The two men won by piloting a Frazier-Nash, built and owned by Duke Donaldson, for 145 laps. The twelve-hour race in Sebring, Florida, is part of the prestigious American Le Mans Series. Sebring is the oldest endurance racecourse in North America.

March 17

1812—American Patriots Capture Spanish Fernandina: Fernandina was surrendered on this day by Spanish soldiers to General John H. McIntosh's "patriots" of the Republic of Florida, who were accompanied by an American naval squadron and U.S. Army troops. The next day, a detachment of 250 regular U.S. troops were brought over from Point Peter, and the newly constituted patriot government surrendered the town to the Americans, who raised the U.S. flag immediately. President James Madison's plan to annex East Florida was not enacted for fear of causing a war with Spain.

1946—Jackie Robinson Makes Major League Baseball Debut: Jackie Robinson, newly acquired by the Brooklyn Dodgers, played his first exhibition game with the major-league team today in Daytona Beach. Robinson was called up to the majors and broke the baseball color line on April 15, 1947, which ended racial segregation in baseball. He was an outstanding player and won the Rookie of the Year award in 1947. In 1949, he won the National League's MVP award. During his playing days, he was selected to appear in six consecutive All Star games. He played in six World Series, including the 1955 World Series, which the Dodgers won. In 1962, he was inducted into the Baseball Hall of Fame, and in 1997, his "42" number was retired by all major-league teams.

March 18, 1874

Florida Governor Ossian B. Hart Dies in Office: Marcellus Lovejoy Stearns, who was only thirty-four, assumed the office of governor of Florida on this day following the death of Governor Ossian Bingley Hart. Stearns became the eleventh governor (1874–77) of the state. He was born in Lovell, Maine, and came to Florida as a member of the Freedman's Bureau after having lost an arm while on duty with the Union army. Stationed in Quincy in the panhandle, Stearns remained in Gadsden County following his release from military service. He served in the 1868 Constitutional Convention and as Gadsden County's representative in Florida's lower house from 1868 until 1872. From 1869 until 1872, he was Speaker of the House. In 1869, he was appointed by President U.S. Grant to the position of U.S. surveyor general of Florida, a position he held until 1873. Elected lieutenant governor in 1872, he succeeded to the chief executive's chair on the death of Hart. Stearns was defeated when he sought a regular term as governor in 1876. In 1877, he was appointed a U.S. commissioner in Hot Springs, Arkansas. He held that position until 1880. Stearns died on December 8, 1891, and is buried at Lovell, Maine.

March 19

1854—First Territorial Governor Dies: William Pope Duval, the first territorial governor of Florida (1822–34), died today in Washington, D.C. Duval was born in Virginia in 1784. His father was an associate of Patrick Henry and was active in the Revolutionary War. He served as a captain of mounted rangers in the War of 1812 and as a member of the U.S. House of Representatives from 1813 until 1815. In 1822, President James Monroe appointed him territorial governor of Florida. Presidents John Quincy Adams and Andrew Jackson reappointed him. Duval County is named in his honor.

1883—Joseph Stillwell, World War II General, Born Today: U.S. Army general Joseph Warren "Vinegar Joe" Stilwell was born today in Palatka. General Stillwell, who was not well liked by ordinary soldiers, served as the chief of staff for Chiang Kai-Shek and as the commander of the China Burma India Theater. He later served as the deputy commander of the South East Asia Command under Lord Mountbatten.

March 20, 1565

Pedro Menéndez de Avilés Named Governor of Florida: Pedro Menéndez de Avilés was named *adelantado*, governor and captain general of Florida on this day by the king of

Spain. Menéndez, who hailed from the Asturias region of Spain, was an important admiral who was credited with organizing the convoy system to transport treasure from the New World to Spain. He was also responsible for the founding of St. Augustine in 1565 and for eliminating the French as colonial competitors in the region around the St. Johns River when he ordered the massacre of French Huguenots who had established Fort Caroline under the leadership of René Goulaine de Laudonnière. St. Augustine became the center for the Spanish administration of Florida and played an important role in protecting Spanish treasure ships on their journey to Spain. He later became the governor of Cuba in 1567. Menéndez died in Spain in 1574.

March 21

1965—NASA Launches Last Ranger Moon Probe: NASA launched Ranger 9 today from Cape Kennedy (Cape Canaveral). This was the last of the Ranger series of lunar exploration space probes. The Ranger probe was aimed at Alphonsus, a large crater on the moon, which had shown evidence of possible volcanic activity, and was programmed to send back thousands of photographs of the moon's surface. The Ranger probes have been considered essential to the program to land men on the lunar surface.

1972—USAF B-52 Crashes in Orlando: An USAF B-52, with seven on board, crashed into a residential section of Orlando on this day. The plane plowed a 150-yard furrow in the ground within 50 to 100 yards of the houses of the Silver Beach residential section, spewing flaming fuel throughout the neighborhood. All seven crewmen died in the crash and eight civilians on the ground were hurt.

March 22

1941—University of Miami Teaches Navigation to British Pilots: Pan American Airways and the University of Miami began teaching a navigation course, sponsored by the U.S. Army, to 10 British pilots on this day. The course would eventually be taught to more than 1,200 British students during World War II. Civilian instructors allowed the United States to assist its ally Great Britain while maintaining the façade of neutrality. When former prime minister Winston Churchill was awarded an honorary degree by the university in February 1946, he acknowledged the positive impact the program had on Britain's war effort.

1982—Shuttle Columbia *Launched at Cape Canaveral*: The space shuttle *Columbia* was launched on its third flight today from Cape Canaveral. STS-3 was the only shuttle to land at the White Sands Space Harbor near Las Cruces,

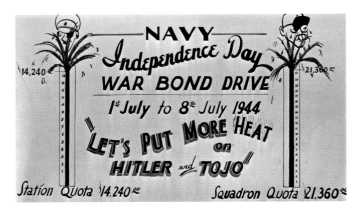

Not only were service personnel expected to do their jobs during World War II, but they also were encouraged to "Buy Bonds," or invest a portion of their monthly pay in savings bonds to fund the fight. *Florida Memory Project, Florida State Photographic Archives.*

New Mexico. This was necessitated because of flooding at Edwards Air Force Base, California, the original planned landing site.

March 23, 1964

Race Riots Sweep through Jacksonville: More than two hundred people were arrested in Jacksonville on this date as race riots swept through the city. One African American woman, Johnnie Mae Chappell, was killed and one white reporter severely beaten. On the night of March 23, rage

and resentment over racist treatment had escalated into violent confrontations between black and white—the worst episode of racial rioting the city had ever seen. That was the night Mrs. Chappell was killed, though she'd been far away from the racial protests. The investigation of the death of Ms. Chappell is a sordid story of deliberate police efforts to protect the murderers by hiding evidence and the persecution of detectives who solved the crime. Four men were eventually arrested and indicted for the murder, although only one, J.W. Rich, was convicted. Rich was convicted of manslaughter and served three years in prison. According to former sheriff's detective Lee Cody, who solved the crime, the sheriff's office was so tainted with racism that there was no interest in prosecuting the other men responsible. Cody and his partner were demoted and ultimately left the sheriff's department. Mayor Haydon Burns, who would become governor in 1965, refused to call in the National Guard or to instruct his police force to take drastic action to curtail the rioting.

March 24, 1899

First Presidential Visit to Tallahassee; First Lady Has Attack: Citizens of Tallahassee rolled out the red carpet for President and Mrs. William McKinley. It was the first presidential visit to Florida's capital city. The president and the First Lady, along with members of their entourage,

attended a luncheon at the famed Leon Hotel. The next day, thousands of Floridians were shocked when the president's wife apparently suffered an epileptic seizure as the couple descended the steps of the state capitol building. Prevented from falling by the quick response of the president, Mrs. McKinley was quickly taken to another building. An aide later reported to the crowd that the president was canceling the remainder of his visit in Tallahassee and the presidential party would return to Washington by train. Another anonymous aide explained that Mrs. McKinley suffered from periodic attacks of epilepsy that were so frequent the president and her doctors were no long alarmed:

> *The President has become so accustomed to these attacks; he appears casual and almost indifferent when one occurs. I remember one evening at a dinner party, Mrs. McKinley suddenly stiffened in the throes of an attack. The President simply covered her convulsed face with a napkin and, when she relaxed, he removed it. She, in turn, promptly picked up the conversation as if it never had been interrupted.*

March 25, 1822

Americans Claim Sovereignty over Key West: Naval officer lieutenant Matthew C. Perry today raised the American flag over Key West, officially declaring American sovereignty.

Key West was officially designated a "port of entry," which meant that salvaged cargoes could be brought to Key West instead of the distant port of St. Augustine. Perry recommended Key West as an excellent harbor for naval vessels, although he noted the presence of a large community of lawless desperadoes. In 1823, Captain David Porter was appointed commodore of the West Indies Anti-Pirate Squadron and given the job of establishing a naval base at Key West. In a short time, he had resolved the problem with the desperadoes but faced new problems. Mosquitoes, yellow fever, malaria and a lack of fresh water were difficulties that had to be overcome, and these problems persisted into the early twentieth century. Porter was not well liked by the residents of Key West; he assumed dictatorial powers in governing the island. His attitude that the needs and desires of the residents came second to the needs of the American navy and his arbitrary confiscation of firewood and cattle without compensation made him a despised person. Despite the tense relations between Porter and the residents, Key West became a major naval facility and the town prospered.

March 26

1958—American Satellite Discovers Radiation Belt: The U.S. Army launched its third satellite, the Explorer III, from Cape Canaveral on this day. The confirmation of the

existence of the Van Allen radiation belt was considered to be the highlight of the Explorer satellite program.

1961—President Kennedy and British Prime Minister Meet: President John F. Kennedy and British prime minister Harold Macmillan met today at the Key West Naval Base in Key West. It was the first meeting of the two men. Their talks concentrated on a serious dispute that had arisen between Britain and the United States over how to handle the Civil War in Laos. To develop a good working relationship with the new president, Macmillan went against long-standing foreign office policy and against the advice of the British chiefs of staff in agreeing to conduct joint planning with America on possible military intervention in Laos.

March 27, 1513

Ponce de León Sights Florida: Juan Ponce de León sighted the Florida peninsula on this day, although he would not go ashore until April 2. There is currently some dispute as to where the actual first landing of Ponce de León on the Florida peninsula was—some say St. Augustine while others say Melbourne Beach. The matter is still unresolved.

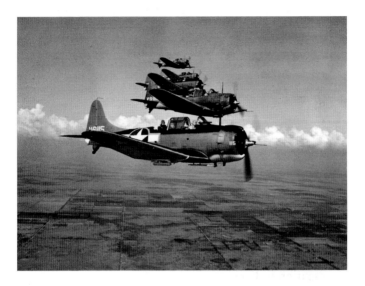

Many civilian airports built by government-operated "make work" programs during the Great Depression were immediately converted into military bases in 1942. Florida had mostly clear days and became a center for training pilots for service in the navy and the army. Some cities experienced a growth spurt that continued after the war was over in 1945, when many of the trainees returned to retire, vacation or find work in new industries. *The Lewis N. Wynne Private Collection.*

March 28

1833—Indian Removal from Florida Guaranteed by Treaty: The Treaty of Payne's Prairie/Landing, in which the Seminoles agreed to move west if land there was found suitable, was confirmed on this day. After an inspection of the western

lands, the chiefs were conflicted. Chief Charley-E-Mather agreed to the removal, but Arpeika (Sam Jones), Jumper, Black Dirt and Halpatter-Tustenuggee (Alligator) were opposed. The question of Seminole removal to western lands would trigger additional warfare between the United States and the Seminole people.

1893—General Edmund Kirby Smith Dies: Edmund Kirby Smith was the last surviving full general of the Confederate army. Smith, who was born in St. Augustine on May 16, 1824, was an 1845 graduate of West Point, a veteran of the Mexican-American War and an instructor of mathematics at West Point. His first task as a Confederate general was to organize the Army of the Shenandoah. He was severely wounded at the First Battle of Bull Run but went on to serve in Tennessee and Kentucky. He was appointed commander of the Confederate Department of the Trans-Mississippi West. When Vicksburg fell on July 4, 1863, Smith operated independently west of the Mississippi. A statue of Edmund Kirby Smith is one of two representing the Sunshine State in the United States Capitol in Washington.

March 29, 1863

Union Soldiers Burn Jacksonville: Federal army and naval forces evacuated Jacksonville today. As they evacuated, Union soldiers set fire to much of the town. Fires broke out in

the wake of the columns of the Sixth Connecticut, whose soldiers took advantage of the evacuation to set fire to the city. Rain and the arrival of Confederate troops combined to extinguish the fires but not before much of the city lay in ruins. While the Union's responsibility for the fire was clear enough, Confederate newspapers, as well as Northern ones critical of the use of black troops, denounced the black regiments as the agents of destruction, although most Northern papers placed the entire blame on the white soldiers of the Sixth Connecticut and Eighth Maine. There seems little doubt that white soldiers started the fires, but when it became clear that they were free to join in the torching, some black soldiers set fires as well. One Northern reporter who saw the burning city despaired that the war had taken a new and uglier turn from which there was no turning back: "Is this not war, vindictive, unrelenting war?"

March 30, 1950

President Truman Denounces Senator McCarthy: In Key West on this date, President Harry S. Truman denounced Senator Joseph McCarthy. His attack came just four days after McCarthy publicly denounced former State Department official Owen Lattimore as a Soviet spy. Truman also attacked the Republican party for trying to find an issue on which to take control of the Congress.

And in order to do that, they are perfectly willing to sabotage the bipartisan foreign policy of the United States. And this fiasco which has been going on in the Senate is the very best asset that the Kremlin could have in the operation of the cold war. And that is what I mean when I say that McCarthy's antics are the best asset that the Kremlin can have. Now, if anybody really felt that there were disloyal people in the employ of the Government, the proper and the honorable way to handle the situation would be to come to the President…and say, "This man is a disloyal person. He is in such and such a department." We will investigate him immediately, and if he were a disloyal person he would be immediately fired. That is not what they want. They are trying to create an issue, and it is going to be just as big a fiasco as the campaign in New York and other places on these other false and fatuous issues. With a little bit of intelligence they could find an issue at home without a bit of trouble!

March 31, 1832

City of St. Augustine Establishes Tax-Supported Schools: The St. Augustine City Council passed an ordinance on this date authorizing the creation of tax-supported free schools in the city. This is one of the earliest such ordinances in the American South and in the nation. According to the

website Dr. Bronson's Tours, the idea of free schools met serious opposition:

> *In 1832 the first English public school was conducted in this city in a building on Charlotte Street near King Street....The salaries of the teachers were paid out of the city treasury. Many of the wealthier taxpayers did not patronize the "free school" as they called it, and used their influence against its maintenance. In less than a year the school was abandoned...The opposition to "free schools" was so great that no money could be spent by the city to erect a suitable school house on this lot, until 1858. During this year a two-story building was constructed by the city, but at its completion, the feeling of hostility toward "free schools" had become so great again that the city council would not levy a tax for its support.*

APRIL

April 1

1864—Union Ship Maple Leaf *Hits Torpedo and Sinks*: This morning, the Federal transport steamer *Maple Leaf* struck a Confederate torpedo on the St. Johns River and sank immediately in three fathoms of water. A detachment of Confederate artillery and a company of infantry troops were dispatched to the area to ensure that the wreckage of the ship was complete.

1865—Florida Governor Commits Suicide: Governor John Milton, the fifth governor of Florida (1861–65), committed suicide today at his home near Marianna. Several days earlier, John Milton had, in complete despair, put down his executive duties and traveled to Sylvania. Tired and depressed, the governor shot himself on April 1, 1865. Floridians were left to ponder the words he

John Milton, the Civil War governor of Florida, was an ardent supporter of the Confederate cause. By April 1865, he was sure of Confederate defeat, so he went home to his plantation and committed suicide after assuring members of the legislature that "death was preferable to surrender." *Florida Memory Project, Florida State Photographic Archives.*

had uttered in his last address to the Florida legislature: "Death would be preferable to reunion." He was buried in the St. Luke's Episcopal Church cemetery.

April 2, 1513

Ponce de León Lands in North Florida: Juan Ponce de León landed on the Florida Peninsula on this day, reportedly near the mouth of the St. John's River. The exact location of Ponce de León's initial landing has been disputed by historians for years, and two additional sites have been offered as possibilities—Ponce de Leon Inlet to the south and Melbourne Beach, even farther south. Regardless of what the real site is, Ponce de León claimed the newly discovered land *La Florida*, named after the Spanish name for the Easter season, *Pascua Florida*, or the "Festival of Flowers." After staying in the area for about five days, the Spanish boarded their ships and headed south, although strong offshore currents impeded their journey. These currents, now known as the Gulf Stream, forced them to take safety at anchorage. One ship, the *San Cristóbal*, became separated for the fleet and was lost for two days. The Spanish resumed their voyage south, navigating around the Florida Keys, and made their way along the western coast of Florida, eventually landing near present-day Charlotte Harbor, although some historians suggest the actual site was Tampa Bay or even Pensacola, while other historians propose Cape Romano or Cape Sable as more likely sites. After replenishing his supply of fresh water and repairing his ships, Ponce de León, after several skirmishes with hostile Calusa Indians, left the coast to seek more islands in the Gulf of Mexico. After finding the Dry Tortugas, he returned to the Bahamas.

April 3

1856—Florida Indian Agent Puts Bounty on Seminoles: The newspaper, the *Florida Peninsula*, announced that Captain John Charles Casey, the agent for Indian Affairs in Florida, had authorized the payment of the following rates for the capture of Seminoles: $250–$500 for each warrior, $150-$200 for each woman and $100-$200 for each boy over the age of ten. The highest rates were to be paid for individuals in good condition, while those who were "infirm, bed-ridden and helpless" fetched only the lower rates. All captured Seminoles brought in for the bounty were to be "live and whole." Casey's proposal irked Floridians who thought that extermination of all Native Americans was the best way to resolve the conflict between Seminoles and whites. The only way to achieve this resolution was through unrelenting military action. The *Florida Peninsula*, which was published in Tampa, offered its readers advice on how to capture Seminoles, whom it deemed to be "Uncle Sam's pets." For individuals wanting to take advantage of the bounty offer, "We would advise them to set steel traps with the teeth filed off, baited with negro [*sic*] blankets! Whiskey would be an excellent bait but more white birds than red would be caught."

1861—Florida to Hold Convention to Ratify Confederate Constitution: Florida governor Madison Starke Perry on this day issued a formal call for a Florida State Convention to

meet in Tallahassee on April 18 to ratify the constitution of the newly formed Confederate States of America. Perry would leave the governor's office on October 7.

April 4, 1867

African American Elected to Office: Jonathan Clarkson Gibbs was elected to the executive board of the Union Republican Party of Florida on this day in Jacksonville. A Presbyterian minister, Gibbs was a free black man, born in Philadelphia and educated at Dartmouth College and Princeton Theological Seminary. After initially moving south to New Bern, North Carolina, Gibbs made his way to Charleston, South Carolina, as a missionary-educator. From there, he arrived in Jacksonville in 1867, where he started a private school. He rapidly moved away from his missionary efforts and into active political involvement in Reconstruction Florida. He was elected as a delegate to the Constitutional Convention of 1868, ran for Congress that same year and, failing election, was appointed Florida's secretary of state by Republican governor Harrison Reed. He served in that office until 1872. In 1873, he was appointed the state's superintendent of public instruction and a lieutenant colonel in the state militia and served as a city council member in Tallahassee. Gibbs died in office on August 14, 1874, in Tallahassee, Florida, reportedly of a stroke.

April 5

1865—Confederate Troops Disrupt Union Courier Line: Confederate captain J.J. Dickison reported that his troops had successfully intercepted the courier line between Jacksonville and St. Augustine. Four Federal troops were reported killed and a fifth wounded. Two horses and the mail pouches between the two towns were captured.

1993—Marlins Play in Home Stadium: The newly formed Florida Marlins baseball team played its first game in Joe Robbie Stadium on this day. Under the leadership of millionaire Wayne Huizenga, a major league baseball franchise was awarded to Miami in 1991, but the first game did not take place until two years later. The Marlins won their first game in the stadium with a 6-3 victory over the Los Angeles Dodgers. The Marlins have won the World Series twice since they were established—in 1997 and in 2003. In 2011, the Marlins changed their name from the "Florida" Marlins to the "Miami" Marlins.

April 6, 1856

American Casualties in Battle with Seminoles: American troops of the First and Second U.S. Artillery, commanded by Captain L.G. Arnold, fought a two-day battle with Seminole warriors at Big Cypress Swamp, near Billy's Town. Two enlisted

men were killed and one wounded. Located in southern Florida next to the Everglades, Big Cypress Swamp is today the site of a Seminole reservation, but in the mid-1800s, the swamp was the geographic center of Billy Bowleg's War, or the Third Seminole War. The war (1855–58) arose from issues unsettled since the end of the Second Seminole War of 1835–42. Since that time, the federal government had worked to encourage the migration of non-Indians to Florida. By 1855, the army was sending patrols regularly into the Everglades and Big Cypress Swamp. Soldiers and Indians, however, had little contact with one another. In late 1856, William S. Harney took command of the troops. His more determined efforts turned the tide of the conflict in the army's favor, and in March 1858, the Third Seminole War was declared by the army to be at an end. Most Seminoles moved to reservations in the Indian Territory, having been bribed to do so, although some three hundred remained in Florida.

April 7, 1890

Noted Environmentalist Born: Marjory Stoneman Douglas, whose 1947 book, *Everglades: River of Grass*, reshaped the public's perception of the Everglades from a useless swamp to a vital component of the world's ecosystem, was born. After her parents separated when she was 6, she lived with her mother and other relatives in Taunton,

Massachusetts. In 1908, she left her home for Wellesley College and graduated from that school in 1912. After her marriage to Kenneth Douglas ended, she joined her father in Miami, becoming a member of his paper's staff. By the early 1940s, she became interested in the ecology of the Everglades. In 1947, *Everglades: River of Grass* sold out within a month of the initial printing and has been in print since then, selling more than 500,000 copies. It is recognized as the primary source for readers wishing to understand the Everglades. Douglas also wrote about other topics, such as women's suffrage, poverty, urban planning and civil liberties. Her contributions to the cause of preserving the Everglades led to her receiving the Presidential Medal of Freedom from Bill Clinton in 1993. She was inducted into the National Wildlife Hall of Fame in 1999. She died in 1998 at age 108.

April 8, 1693

Spain Takes Control of Pensacola: Admiral Andrés de Pez, accompanied by Dr. Carlos de Sigüenza y Góngora and others, explored Pensacola Bay on this day. Pez, who had been a participant in expeditions to explore the coasts of the northern portion of the Gulf of Mexico between 1688 and 1689, was impressed with the possibilities of establishing a successful colony at Pensacola. He sailed to Spain, and after much opposition, he convince the

royal authorities that such a settlement was both possible and desirable. He was promoted to the rank of admiral and returned to Mexico in 1692. From there, he sailed for Pensacola on March 25, 1693; entered the bay on April 7; and began his explorations on April 8. Pez was convinced that the area offered great possibilities for Spanish settlement, and he left for Mexico fully expecting to return again with colonists. Events within Spain prevented his return, however, and the Pensacola area remained unsettled. In the late seventeenth century, with an eye out for more territory, the French began exploring the lower Mississippi River. To intimidate the French, the Spanish, in 1698, decided to establish a fortified town near what is now Fort Barrancas, laying the foundation for the modern city of Pensacola.

April 9

1876—Park Trammell, Florida Governor, Born Today: Park Trammell, the twenty-first governor of Florida, was born in Macon County, Alabama. Trammell attended school in Polk County as a youth. Trammell studied law at Vanderbilt University and Cumberland University, from which he graduated in 1899. Returning to his Polk County home, he practiced law, owned and operated citrus groves and ran a newspaper. After two terms as mayor of Lakeland, he was elected to the Florida House of Representatives and was

president of the Florida Senate in 1905. In 1912, he was elected governor. From 1916 until 1936, Trammell served as U.S. senator. He died in Washington on May 8, 1936.

1992—Former Ally of the United States Convicted in Miami Court: Former Panamanian dictator Manuel Noriega was convicted of drug dealing in Miami on this day. Following the death of dictator Omar Torrijos in 1981, Noriega, by 1983, had become dictator. Noriega used his position to create a safe haven for drug cartels in Panama. After several presidential elections that were nullified by Noriega by force, the United States invaded Panama in late 1989, and Noriega was captured and brought to Miami. He was indicted with a number of drug-related charges and convicted. He served his sentence in a federal prison but was extradited to France in 2010, put on trial and sentenced to ten years for money laundering. In 2011, he was extradited to Panama to face charges on human rights violations.

April 10, 1843

Church of Latter Day Saints Sends Missionaries to Florida: Two Mormon elders, William A. Brown and Daniel Cathcart, were assigned to Pensacola by the Illinois Conference of the Elders of the Church of Jesus Christ of Latter Day Saints. This is the first recorded instance of an LDS presence in the Sunshine State. By 1854, the LDS had an active a mission

program to the Native Americans in Florida. Throughout the late 1800s and the early 1900s, the Mormons established churches throughout the state, despite periodic outbreaks of violence against the members of the church, who were suspected of being members of a cult. In 1950, the LDS leadership purchased 50,000 acres of farm and ranch lands which became the Deseret Ranch. Currently, the Deseret Ranch now includes more than 300,000 acres of land and is one of the prime cattle producing ranches in the Sunshine State. The LDS has gained acceptance by most Americans, a fact that was demonstrated by the nomination of Mitt Romney as the Republican candidate for president of the United States in 2012.

April 11, 1861

Florida Men Subject to Duty in Confederate Army: As demands for more soldiers grew from Confederate generals, General Joseph J. Finnegan, commander of Rebel forces in Florida, issued a proclamation that put those persons who were enrolled through the Conscription Act of 1862 for active duty in Confederate forces but who had not reported for duty on notice that they would be rounded up and dealt with as deserters. Greatly outnumbered by the population of the Union states, the Confederacy had to maximize its available manpower. Although certain professions and occupations were exempt from the draft, the age limit was

expanded as Confederate military fortunes declined as the war dragged on. In Florida, salt makers were included in the exempt occupations because salt was critical to munitions manufacturing and the most commonly used method of food preservation. Men in other occupations, such as telegraph operators, railroad workers, druggists, and civil officials, were also exempt because they were deemed to be essential to the war effort.

April 12

1834—President Andrew Jackson Signs Treaty: President Andrew Jackson formally signed the Treaty of Payne's Prairie/Landing on this day. By the terms of this treaty, the Seminole peoples agreed to a conclusion of hostilities in Florida and the cession of lands in Florida. The Seminoles were to be transported to lands west of the Mississippi, be paid almost $100,000 and receive a large amount of blankets, dry goods and other services. The Treaty of Payne's Prairie/Landing did not end hostilities, since some Seminole leaders refused to accept the terms of the treaty.

1981—Shuttle Columbia *Launched*: The space shuttle *Columbia* rose from Pad 39A at the Kennedy Space Center a few seconds past 7:00 a.m. on this date. Astronauts John Young and Bob Crippen brought the shuttle to a safe landing at Edwards Air Force Base in California, after

making thirty-seven orbits of the Earth during their fifty-four-and-a-half-hour mission. It was the first American-manned space flight since the Apollo-Soyuz Test Project on July 15, 1975, and was also the only U.S.-manned maiden test flight of a new spacecraft system.

April 13, 1886

Apache Indians Held in Florida Forts: Seventy-seven Chiricahua Apache Indians arrived in St. Augustine today as prisoners in Fort Marion. Geronimo, the war chief of the Chiricahuas, was held in Fort Pickens in Pensacola. Born in 1829, Geronimo lived in western New Mexico where his mother, wife and children were murdered by Mexican soldiers in 1858. With a small band of followers, he raided across New Mexico, Arizona and northern Mexico. Geronimo and his band were eventually captured at Skeleton Canyon in 1886. The Apaches were to be sent to St. Augustine, but business leaders in Pensacola petitioned the government to have Geronimo sent to Fort

Following page: Prior to the coming of Mickey Mouse and Disneyworld in the early 1970s, tourists found great entertainment in visiting such low-tech attractions as alligator farms, petting zoos and natural attractions. Few such attractions even exist today, and those that do hang on are usually in financial trouble. *The Lewis N. Wynne Private Collection.*

Pickens. Local leaders wanted him as a tourist attraction for the city. In one day, he had over 459 visitors and an average of 20 a day during his imprisonment at Fort Pickens. He died in 1909 at Fort Sill, Oklahoma.

April 14, 1528

Pánfilo de Narváez Lands in Tampa Bay: Pánfilo de Narváez landed four hundred men and eighty horses at Tampa Bay and began his exploration northward on this date, although some scholars insist that the actual date was

April 15. From Tampa Bay, the expedition headed into the interior of Florida in search of gold and silver. Along the way, Narváez and his men encountered hostile Indians who exacted a heavy toll against the Spaniards. Narváez decided that his expedition was not going to be successful and ordered his surviving men to build rafts to attempt to reach Mexico. Although the raft carrying Narváez was lost at sea, two rafts with eighty-six men aboard them made it to Galveston Island, off the coast of Texas. The men were captured by Indians and only four managed to survive their capture and escape to the Spanish settlement of Sinaloa in Mexico. One of the survivors, Álvar Núñez Cabeza de Vaca, wrote an account of their escape.

April 15, 1896

Flagler's Railway Reaches Miami: Henry Flagler's railroad arrived in Miami today. The first train, a wood-burning steam engine, carried a load of building materials—certainly a harbinger of Miami's future. Passenger service started a week later. At the time, Miami was a small settlement of fewer than fifty inhabitants. When the town incorporated on July 28, 1896, its citizens wanted to honor the man responsible for the city's development by naming it Flagler. He declined the honor. Although Flagler is credited with

Before Henry Flagler's Florida East Coast Railway made its way down the east coast of Florida, the Indian River Lagoon served as the main inland thoroughfare as far south as Jupiter. A fleet of steamboats plied the lagoon on regular schedules, delivering passengers, mail and cargo. The Indian River Steamboat Company was the leading company in operation and eventually sold many of its steamboats to the railroad to serve as dormitories and supply boats for workers on the Key West Extension. *Florida Historical Society.*

the development of Florida's east coast, he saw little in the way of a prosperous future for Miami. Despite his willingness to invest in the construction of a large hotel and some infrastructure needs, he was already thinking about extending his railroad farther south to Key West. Miami's rapid development as a residential and vacation center would not come until the early 1920s.

April 16, 1934

Jacksonville University Opened: Jacksonville University (JU) was founded today. Originally known as William J. Porter University to honor its founder, Jacksonville University was

once known as Jacksonville Junior College. In 1958, the name was changed to Jacksonville University. It currently has a total student enrollment of about 3,500 students. Success in sports, particularly basketball, has raised the profile of JU considerably. In the 1970 NCAA basketball tournament, the JU Dolphins—coached by Joe Williams and Tom Wasdin and led by Artis Gilmore, who was seven feet, three inches tall, and Rex Morgan, who was an All-American guard—advanced to the title game before losing to UCLA 80–69. During the 1969–70 season, the team became the first NCAA basketball program to average 100 points per game in a season. Several JU basketball players, such as Gilmore, Morgan, Pembrook Burrows II and Otis Smith, have achieved success in the professional basketball ranks.

April 17, 1961

Bay of Pigs Invasion Fails: The Bay of Pigs invasion of Cuba failed today. Originated by the Eisenhower government but carried out by the Kennedy administration, the effort was for Cuban expatriates to overthrow the regime of Fidel Castro. In April 1960, the CIA began to recruit anti-Castro Cuban exiles in the Miami area and train them for the invasion at Useppa Island and various other facilities in South Florida. Specialized guerrilla training took place in Panama under CIA leadership. A series of costly mistakes and misjudgments by the CIA allowed Castro's militia to crush

the invasion within a few days and capture 1,200 of the 1,500 invaders. Cuban exiles in the United States arranged the return of 60 wounded prisoners soon afterward for $2.5 million, but the remaining exiles were put on trial and sentenced to prison. The Castro government indicated that the prisoners would be released for a ransom of $62 million. In December 1962, the United States secured the release of the prisoners by providing Cuba with more than $50 million in medical supplies and food. Allen Dulles, the longtime director of the CIA, was fired as a result of the failed invasion, although the CIA continued its intelligence operations against Cuba.

April 18

1925—*University of Miami Chartered*: The University of Miami was chartered today, just a year before the collapse of the Florida boom. George Merrick, the developer of Coral Gables, gave 160 acres of land and pledged $5 million to get the school started. With the collapse of the Florida boom, the university fell on hard times and filed for bankruptcy in 1932. It was reincorporated in 1934. The school continued to experience financial difficulties for a number of years but survived.

1962—*NFL Hall of Fame Football Star Born Today*: National Football League linebacker Wilber Marshall was born

James Deering, the bachelor son of William Deering, the chairman of Deering Harvester Company, followed his father's example and built Vizcaya, a luxurious mansion in Miami. His brother, Charles, also built a mansion in Miami. *Florida Historical Society.*

today in Titusville. Marshall, who played for the University of Florida and was a two-time All American, was drafted by the Chicago Bears in the first round of the NFL draft in 1984.

April 19, 1857

Controversial Florida Governor Born Today: Napoleon Bonaparte Broward, nineteenth governor of Florida (1905–09), was born today in Duval County. Broward worked as a tugboat captain, sheriff of Duval County and a gunrunner to Cuban revolutionaries fighting the Spanish. He was a member of the Florida legislature in 1901 and was the moving force behind the law that recognized insanity as a legitimate reason for divorce. This law was used by Henry Flagler to divorce his wife, Alice, who was slowly becoming insane, in order to marry Mary Lily Kenan, whom he met in 1891. A resident of New York, where insanity was not a basis for a divorce, Flagler moved his official residence to Florida, where, in 1901, a bill making "incurable insanity" grounds for divorce was introduced into the legislature and approved two weeks later. Although rumors persisted that Flagler had bribed members of the legislature to pass the law, nothing was proven at the time. Seventy years later, it was discovered that he had paid $125,000 to members. The law, used only once—by Flagler—was repealed in 1905.

April 20

1929—Noted Race Car Driver Phil Hill Born: Phil Hill was born today in Miami. He was raised in Santa Monica, California, where he lived until his death. He studied business administration at the University of Southern California from 1945 to 1947 but left college early. In 1956, he joined the Enzo Ferrari team and drove his first race, the French Grand Prix, in 1958. That same year, along with Belgian teammate Olivier Gendebien, Hill became the first American-born winner of the 24 Hours of Le Mans. He and Gendebien would go on to win the famous endurance race again in 1961 and 1962. In 1961, he became the first American to win the World Driving Championship. In 1959, Hill drove an experimental car at the Bonneville Salt Flats to a record speed of 255 miles per hour. After a successful career in business, he became an announcer for Wide World of Sports. He died in 2008.

1945—Steve Spurrier Born: Steve Spurrier, Heisman Trophy winner at the University of Florida in 1966, former University of Florida football coach, former coach of the Washington Redskins and current University of South Carolina football coach, was born today in Miami Beach.

April 21, 1956

Elvis Strikes Gold with Jacksonville Woman's Song: Elvis Presley scored his first *Billboard* number-one song today when "Heartbreak Hotel" topped the charts. Written by Mae Boren Axton, a Jacksonville schoolteacher, and Tommy Durden, a local musician, "Heartbreak Hotel" supposedly was inspired by an unidentified man who committed suicide in Miami, leaving behind only a note with the single line, "I walk these lonely streets." Others, however, insist the song was inspired by the small Heartbreak Hotel that existed in rural Kenansville, Florida. The real inspiration for the song continues to be debated, but the song endures. Axton went on to write over two hundred songs, fourteen of which were hits. She was the mother of Hoyt Axton, a well-known songwriter, country music star and actor in the 1960s. In 1997, she drowned in her hot tub after suffering a heart attack at the age of eighty-two.

April 22, 1880

City of Ormond Beach Incorporated Today: Ormond Beach was incorporated today. With its hard, white sandy beach, Ormond became popular with wealthy Americans seeking relief from northern winters after the Civil War. In 1886, the St. Johns & Halifax Railroad arrived. A few

Before the advent of automobiles and planes, tourists reached their vacation destinations via railroads or by taking riverboats, such as this Ocklawaha River steamer. *The Lewis N. Wynne Private Collection.*

years later, in 1887, the first bridge across the Halifax River was built. The Ormond Hotel opened on January 1, 1888, and was purchased by Henry Flagler in 1890. Flagler expanded it, and it became one in a series of Gilded Age hotels catering to passengers aboard his Florida East Coast Railway. The hotel was the winter home of John D. Rockefeller from 1914 to 1918 but was torn down in 1922. Rockefeller bought a home in Ormond Beach known as the "Casements."

April 23

1911—Speed Record Set at Daytona Beach: Bob Burman set a speed record at Daytona Beach today, covering a mile in 25.4 seconds in his two-hundred-horse-power "Blitzen" Benz. In 1909, he was the winner of the Prest-O-Lite Trophy Race and competed at the inaugural Indianapolis 500 in 1911. Racing for promoter Ernest Moross, Burman also set a world record at the Indianapolis Motor Speedway this same year. He was killed on April 8, 1916, in Corona, California, when he rolled over in his open-cockpit Peugeot car during a race.

1982—Key West Secedes! Conch Republic Proclaimed!: After a frustrating five days of massive traffic jams and the loss of thousands of dollars in cancelled hotel reservations caused by roadblocks set up by federal agencies to search cars for illegal immigrants and drugs, Key West mayor Dennis Wardlow proclaimed the southernmost city in the United States to be the independent "Conch Republic." Complete with a demand for massive federal aid for the new "country," Wardlow threatened to print "Bubba Bucks," a distinctive currency for use in the city. Although the roadblocks were soon removed, the idea of an independent Conch Republic lives on and has become a major marketing tool to attract tourists to the city.

April 24, 1974

Professional Football Comes to Tampa: Owners of teams in the National Football League approved a franchise for the city of Tampa today. Known as the Tampa Bay Buccaneers, the franchise quickly proved to be one of the most inept teams in the league, losing its first twenty-six games. The Buccaneers won their first game in 1977. From 1979 until 1982, the team had winning seasons but then experienced fourteen years of consecutive losing seasons. Following that modest run, however, the team then compiled an unenviable record of fourteen consecutive losing seasons. The dismal record of the Bucs assured them of the right to draft among the first teams each year, but the team's owners refused to pay top salaries; some players refused to play for the team. Others, such as quarterbacks Doug Williams, Trent Dilfer and Steve Young, quickly left for other teams, and each of these quarterbacked winning Super Bowl teams. Defensively, the Bucs managed to draft and retain outstanding players, and several of these—Lee Roy Selmon, Derrick Brooks and Warren Sapp—were elected to the Pro Football Hall of Fame when their careers were over. In 2002, the Buccaneers won the Super Bowl under coach John Gruden.

April 25

1884—Noted African American Baseball Player Born: John Henry "Pop" Lloyd, member of the African-American Baseball Hall of Fame, was born in Palatka today. He played both catcher and shortstop in the Negro Leagues and is generally considered to be one of the two best shortstops to ever play baseball. He was inducted posthumously into the Baseball Hall of Fame in 1977.

1928—Tamiami Trail Opened: The Tamiami Trail, linking Tampa and Miami through the Everglades, officially opened today. When Florida ran out of funds to

As more and more tourists and vacationers began to come to Florida, vast land-clearing operations were undertaken to build subdivisions, hotels, golf courses and, most important, roads to handle the increasing numbers of automobiles. This Burgert Brothers' photograph shows land-clearing operations near present-day Oldsmar. *Burgert Brothers Collection, Tampa Public Library.*

complete the road, Barron Collier stepped forward with the remainder. The Tamiami Trail took thirteen years to complete and cost $8 million.

April 26

1818—Andrew Jackson Executes Two British Subjects: Major General Andrew Jackson convened a court-martial today for two British subjects in West Florida, Alexander Arbuthnot and Robert C. Armbrister. The two were charged with inciting the Creek Indians against the United States, found guilty and put to death. The action was controversial and created a diplomatic rift between the United States and Great Britain.

1962—American Rocket Crashes on the Dark Side of the Moon: The American *Ranger IV* rocket, launched four days earlier from Cape Canaveral, crashed today on the far side of the moon but failed to send back pictures due to a loss of internal power some two hours after launch. It was the first time an American spacecraft had successfully reached the moon.

April 27

1929—WCTU Chartered in Jacksonville: The Woman's Christian Temperance Union of Florida was chartered today in Jacksonville. The organization was first organized in

1883 and became the driving force behind the ratification of the Eighteenth Amendment to outlaw the sale of alcoholic beverages in the United States. The prohibition of liquor led to the "Roaring Twenties," a period of time when bootleggers and other criminals became national heroes.

1929—Famed Female Pilot Visits Hometown: Barbara Bancroft, the first licensed female airplane pilot on the east coast of Florida, visited her hometown of Melbourne. Bancroft, who held license number 6200, was a charter member of the group of female pilots known as the "Ninety-Nines," which was organized on November 2, 1929, at Curtiss Field, Valley Stream, Long Island, New York. All 117 of the female pilots in America were invited to come together to create an organization to support one another and to further the cause of aviation. Amelia Earhart, perhaps the best-known female pilot of the time, was elected president of the group, which took its name from the fact that ninety-nine female pilots attended the inaugural meeting.

April 28

1885—Rollins College Established: Rollins College, Florida's oldest private institution of higher education, was established in Sanford today. The college was created at the urging of Lucy Cross, founder of the Daytona Institute in 1880, when she brought up the need for such a college before

the convention of Congregational Churches in 1884. The school, named for benefactor Alonzo Rollins of Chicago, held its first classes on November 4, 1885, in Winter Park. Since its founding, the college has produced a number of notable graduates and has played a prominent role in post-secondary education in the Sunshine State. Among the graduates of the college, perhaps the best known was the late Fred Rogers, whose children's television program, *Mr. Rogers' Neighborhood*, ran for more than two decades. The college has played host to several United States presidents, including Calvin Coolidge (1930), Franklin Delano Roosevelt (1936), Harry S. Truman (1949) and Barack Obama (2012).

1960—Titan *ICBM Launched Today from Cape Canaveral*: After several technical glitches and delays over a five-week period, the decision was made to launch the rocket. The glitches continued at launch when a hydraulic line carrying oxygen burst on the launching pad. The launch continued, however, and the ICBM sped down the test range. The *Titan* ICBM successfully completed a flight of more than three thousand miles.

April 29, 1925

New Town of Coral Gables Chartered: The charter for the town of Coral Gables was approved today. The city was developed by George Edgar Merrick. Merrick, the son of

a minister, had turned the family's 160-acre farm, Coral Gables Plantation, into a burgeoning city of 1,600 acres by 1919. Along with Carl Fisher, who was developing Miami Beach, he was largely responsible for creating the boom in Florida development in the early 1920s. Unlike Fisher, who hoped to attract the wealthiest Americans, Merrick wanted to create a city of permanent, middle-class homeowners. The hurricane of 1926 ended the land boom, and his declining fortunes forced Merrick to liquidate his holdings, although he remained a civic and social leader in the area.

The rapid development of the Miami area was paralleled by development on the eastern side of the state. D.P. "Doc" Davis copied Carl Fisher's technique of dredging up new land and created Davis Islands in Tampa Bay Harbor. Surveyors and real estate agents, known as binder boys, were kept busy laying out new subdivisions and selling them before any houses were built. The 1920s were truly a "boom" period in Florida history. *Burgert Brothers Collection, Tampa Public Library.*

April 30

1803—Louisiana Purchase Treaty Signed: The treaty ceding the territory of Louisiana to the United States was signed today in Paris. The portion of West Florida, from the Perdido River to the Mississippi River, was not part of the original treaty, but the United States claimed the area as part of the purchase of the Louisiana Territory. In one bold stroke, President Thomas Jefferson doubled the size of the United States through this diplomatic coup.

2014—Florida Panhandle Pelted by Two Feet of Rain: North Florida suffered violent rainstorms overnight, part of a weather system that spawned deadly tornadoes, hail and heavy rains from Oklahoma to Georgia. More than twenty deaths were reported across the southern states. Authorities in Pensacola reported that more than twenty inches of rain had fallen on portions of the city and surrounding areas. Roads were washed away, and Interstate 10, the major highway across the panhandle, was closed because of flooding.

MAY

May 1, 1562

Jean Ribault Leads Group of French Huguenots to Florida: Ribault left France on February 18, 1862, with 150 colonists and arrived on this day at the mouth of the St. Johns River, which he named the River Mai (May). He erected a stone column claiming the land for France and then turned north with his fleet to explore and map the coastline. When he arrived at Port Royal Sound in present-day South Carolina, he built a small fort on Parris Island, which he named Charlesfort in honor of the French king Charles IX. After a short time, he decided to leave a small force of men at the fort and return to France for supplies. Once he arrived in France, he became involved in the country's religious war and had to flee to England for safety. In the meantime, another group of colonists, under the leadership of René Goulaine de Laudonnière, arrived in Florida and established Fort Caroline on the site of Ribault's 1562

landing. By 1565, when Ribault arrived with ships, supplies, and more colonists, the settlement was in desperate straits. Laudonnière returned to France, leaving Ribault to face a previously unknown threat from Spanish colonists led by Pedro Menéndez de Avilés, who eventually massacred Ribault and his colonists.

May 2

1815—Reconstruction Governor of Florida Born: David Shelby Walker, the eighth governor of Florida (1865–1868), was born today in Russellville, Kentucky. A Whig and a Constitutional Unionist, Walker opposed Florida's secession in 1861. However, when the decision passed, he supported his state. Walker won an election for governor on November 29, 1865, unopposed, and was inaugurated on December 20, 1865. His term in office was focused on restoring the state government while Florida was under military occupation during Reconstruction. After leaving the governor's office on July 4, 1868, he returned to practicing law, and in 1878, he was appointed a circuit court judge, a position he held until his death on July 20, 1891.

1965—Early Bird Satellite Begins Broadcasts: The U.S. Early Bird satellite, launched from Cape Canaveral on April 6, started broadcasting transmissions from Europe to North America today. The Early Bird, or Intelsat I, was the first

commercial communications satellite to be placed in a geosynchronous orbit. It was a demonstration platform to show how communications could be improved through the use of satellites. Although the Early Bird satellite was originally scheduled to operate for only eighteen months, it operated for nearly four years. During its operation, the satellite handled television, telephone and FAX transmissions between Europe and North America.

May 3, 1901

Jacksonville Hit by Devastating Fire: Around noon on this day, workers noticed that sparks from the chimney of a nearby house had ignited a fire in a pile of Spanish moss that had been laid out to dry. Although the workers attempted to put out the blaze, strong winds in the area made it impossible, and the fire burned out of control. In eight hours, the fire consumed nearly 150 city blocks and destroyed about 2,400 buildings. Some ten thousand residents of the city were left homeless. The loss was estimated at $15 million in 1901 dollars. The fire was the largest urban fire ever in the southeastern United States, and local newspapers reported that the glow of the flames could be seen as far away as Savannah, Georgia. Residents of Raleigh, North Carolina (415 miles away), could see and smell smoke from the fire. The fire also killed seven persons. Governor William Sherman Jennings imposed martial law and dispatched

units of the state militia to maintain order and to help with the recovery. Reconstruction of the city began immediately, although the destruction of the Duval County courthouse and the loss of real estate records created great difficulties.

May 4, 1973

Donald Segretti Accused of Dirty Tricks in Election: Donald Segretti, the "dirty tricks" man for President Richard M. Nixon, was charged with publishing fraudulent campaign documents in the 1972 Florida primary today. Segretti used a series of forged letters to publicize false accusations against potential Democratic presidential contenders Edmund Muskie, Henry "Scoop" Jackson and Hubert H. Humphrey. A letter, purportedly by Muskie, was circulated that criticized the French Canadians and their culture. Another forged letter on Muskie office letterhead accused Jackson of fathering an illegitimate child with an underage woman. Another forged letter accused Hubert H. Humphrey of sexual misconduct as well. Segretti was eventually charged with breaking federal laws regarding the collection and use of campaign funds. Convicted of misdemeanor charges in Florida, he served four months of a six-month sentence in prison and had his law license suspended for two years. He returned to California, where he remained active in politics as a candidate and consultant. In 2000, he managed John McCain's campaign in Orange County.

May 5

1961—Shepard First American in Space: Alan Shepard became the first American in space today as his *Freedom 7* capsule, atop a Redstone rocket, carried him 115 miles into the atmosphere. Shepard spent fifteen minutes in space and landed 302 miles from Cape Canaveral near the Bahamas. During the journey, he maneuvered his spacecraft by firing small rockets. Both Shepard and the capsule were retrieved by the U.S. Navy. Although a success, Shepard's achievement lost some of its luster because the Soviet Union had beaten the United States in the race to launch a manned space flight by three weeks, when Yuri Gagarin, aboard the *Vostok I*, became the first human to reach space.

1961—Tornado Touches Down in St. Petersburg: On this day, a tornado, rated as an F-2 by the U.S. Meteorological Service, briefly touched down in St. Petersburg. The tornado, accompanied by three-quarter-inch-sized hail, struck the Northeast High School and the nearby Meadowlawn neighborhood. It was on the ground for fifty yards but did minimal damage.

May 6, 1851

Gorrie Granted Patent for Ice Maker: Dr. John Gorrie, a physician in Apalachicola, was granted patent number 8080 today for

his ice-making machine. Gorrie moved to Apalachicola in 1833. A resident physician for two hospitals, he was active in community and business affairs. His medical research interests centered on the study of tropical diseases, in particular malaria and yellow fever, which he attributed to "bad" air, or "miasma." Although he was right for the wrong reasons, his advocacy of draining swamps near residential areas lessened outbreaks in the city. He also advocated cooling the sickrooms of malarial patients by suspending pans filled with ice from ceilings, allowing the cooler air to flow down on the patients. Because ice was expensive to buy and had to be brought by ships from the Great Lakes, he began to experiment with ways to manufacture it. He was successful and received a patent for his prototype. He hoped to recover the money he had spent on developing his machine, but when he died on June 29, 1855, he was impoverished. His invention led the way for commercial ice-making machines and eventually for the development of air conditioning. He is one of two Floridians honored with a statue in the Capitol Rotunda in Washington, D.C.

May 7, 1877

Bank of Jacksonville Founded: Founded by William Barnett, the Bank of Jacksonville ultimately became a statewide operation until it was sold to Nations Bank in 1998. William B. Barnett was born in September 1824 in West Virginia

but moved to Leesburg, Indiana, in the 1840s. After moving farther west to Kansas, he formed the Barnett, Morrill and Jones Bank in Hiawatha in 1877. He sold his interest in that bank in 1877 and moved to Jacksonville. With an initial investment of $43,000, he formed the Bank of Jacksonville. After some lean years, the bank began to prosper after the Great Fire of 1901 when it was the only bank to survive. Barnett died on September 2, 1903, but his son, William Bion Barnett, became president and the family connection continued. In 1926, the bank built a $1.5 million office building in Jacksonville. Surviving the stock market crash of 1929, the bank continued to grow in later years as it instituted major financial innovations such as establishing the state's first credit card franchise in the 1970s.

May 8, 1889

DeLand University Becomes Stetson University: Stetson University was founded in 1883 as DeLand Academy by New York philanthropist Henry Addison DeLand. The name was changed in 1887. The name was changed again in 1889 to honor hat manufacturer John B. Stetson, a major benefactor of the university who served as a founding trustee. Mr. Stetson also provided substantial assistance when financial reverses restricted DeLand's ability to contribute. Stetson University was affiliated with the Florida Baptist Convention from its founding in 1885

until 1907, when the convention was defeated in its effort to force Stetson to amend its charter. From 1907 to 1919, the Florida Baptist Convention operated the competing Columbia College in Lake City, Florida, but that school failed to garner adequate financial support and closed. In 1919, the relationship between Stetson University and the Florida Baptist Convention was reestablished and continued until 1995, when it was terminated. Stetson's campus is just north of the downtown area of DeLand, roughly halfway between Orlando and Daytona Beach, Florida. The 175-acre campus is on the National Register of Historic Places as the Stetson University Campus Historic District and is recognized for its collection of the oldest education-related buildings in the Sunshine State.

May 9, 1980

Sunshine Skyway Bridge Collapses After Being Hit by Freighter: Sunshine Skyway Bridge, which crossed Tampa Bay at St. Petersburg, was struck by a phosphate freighter, the *Summit Venture*, causing a 1,200-foot section of the bridge to collapse. Thirty-five people were killed when a Greyhound bus, several cars and a pickup truck fell into the bay. Only Wesley MacIntire, the driver of the pickup truck, survived. Richard Hornbuckle and his three passengers escaped injury when the automobile he was driving stopped fourteen inches short of the edge of the collapsed portion

of the bridge. In addition to the tragedy on May 9, the bridge had been the scene of another accident on January 28, when the Coast Guard cutter *Blackthorn* was rammed by the freighter *Capricorn*. Twenty-three individuals were killed on the cutter. A new $244 million replacement bridge was opened to traffic on April 20, 1987. The approaches to the old cantilever bridge remain in use as Skyway Fishing Pier State Park.

May 10

1861—Lincoln Suspends Right of Habeas Corpus in Florida: Union president Abraham Lincoln issued a proclamation today suspending the writ of habeas corpus in Florida, citing the existence of an "insurrection" against the United States in the state. This action followed similar actions in Virginia and Maryland. The proclamation had little effect on the legal rights of Floridians since it could only be enforced in areas under Union control. Lincoln, whose suspension of habeas corpus in Maryland had been challenged in the U.S. Supreme Court, ignored the ruling and continued to issue such proclamations. He justified these actions by the rebellion against the federal government.

1865—Tallahassee Surrenders to Union Forces Led by McCook: Major General Samuel Jones, CSA, formally surrendered Tallahassee, the only Confederate state capital east of the

Mississippi that was not captured by military action, and all Confederate troops and property to Federal brigadier general Edward M. McCook. The official transition of power to Union forces would not come until May 20, when a large Union flag was raised over the capitol. As part of the ceremonies, General McCook read the Emancipation Proclamation, formally freeing all slaves in the Sunshine State.

May 11, 1910

Famed Female Aviatrix Born in Pensacola: Jacqueline Cochran was born today in the small town of Muscogee, near Pensacola. Born Bessie Lee Pittman, she changed her name to Jackie Cochran and moved to New York, where she became enamored of flying and became a licensed pilot. She set a new speed record for female pilots in 1937. Before America entered World War II, Cochran volunteered for transport/ferry duty with the British air force. When the United States entered the war, she helped create an organization of female pilots to ferry American planes to war zones. After the war, she continued her involvement with the military and flew jet planes. She became the first woman to break the sound barrier.

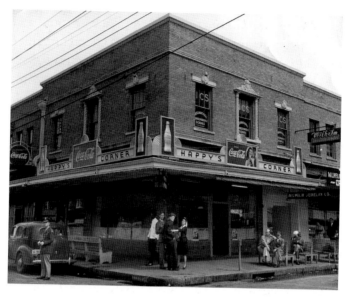

During World War II, Florida was home to almost two million trainees who explored the streets and sights of Florida cities. Merchants did a flourishing business catering to the wishes of trainees, while young girls and boys got a whiff of adventure talking, dating and marrying these trainees. Like towns everywhere, certain locations became "hot spots," where young people could meet and socialize. *Burgert Brothers Collection, Tampa Public Library.*

May 12, 1740

English Troops Move Against Spanish in St. Augustine: General James Edward Oglethorpe, who founded the British colony of Georgia in 1733, undertook an expedition to capture

St. Augustine to oust the Spanish from Florida. Relations between the British in Georgia and Spanish authorities in Florida were unsettled, leading to frequent conflicts along the colonies' borders. Oglethorpe first captured the outlying forts of Fort San Diego, Fort Picolotta and Fort Mose before he proceeded to St. Augustine. Oglethorpe deployed his batteries on the island of Santa Anastasia while a British naval squadron blockaded the port. On June 24, Oglethorpe began a twenty-seven-day bombardment. On June 26, three hundred men—Spanish and free black allies—attacked Fort Mose. The garrison was taken by surprise, and the fort was retaken. The Spanish managed to send supply ships through the blockade, which ended any hope of starving St. Augustine into capitulation. Oglethorpe then planned to storm the fortress by land while the British ships attacked the Spanish in the harbor. The British naval commander, however, decided to forgo the attack during hurricane season, so Oglethorpe gave up the siege and returned to Georgia.

May 13, 1955

Jacksonville Riots Follow Elvis Performance: In what has been called "the first rock and roll riot" in the United States, Jacksonville was shocked this night following Elvis Presley's concert at the newly opened Wolfson Ball Park. Elvis, who had offhandedly told the women in his audience of

fourteen thousand, "Girls, I'll see you backstage," was chased backstage by screaming girls, who ripped parts of his clothing off. Elvis managed to escape to safety, although he was forced to hide when some more determined young ladies managed to make their way into his dressing room through a heating duct. City civic and religious leaders were outraged. When Elvis came back to the city in 1956, he was met by law enforcement authorities with unsigned warrants prepared by Juvenile Court judge Marion Gooding. Elvis was warned that if he engaged in "hip shaking during his performances," the warrants would be executed, and he would be arrested for impairing the morals of minors. Presley's managers secured legal representation, and the shows proceeded, although they were toned down. While the King's performances were moderate in nature, he did poke fun at Judge Gooding. He reputedly closed his sixth and last show by changing his traditional "Thank you very much" to "F——k you very much!"

May 14, 1949

President Truman Establishes Rocket Testing Range: President Truman signed a bill today establishing a rocket test range at Cape Canaveral. The Cape was determined to be a good site for the testing because it was away from heavily populated areas; had a huge overwater flight area; was considered safe from devastating hurricanes; and was

accessible by road, rail, air and ocean shipping. The West Indies and South Atlantic provided island sites for the installation of optical and radar-tracking stations. The Cape was located near the equator, which would prove to be an asset because rockets launched from the Cape could take advantage of the rotational speed of the Earth, which is greatest at the equator, to achieve orbit with less thrust required. At the time, the entire facility was under the joint management of the army, navy and air force. However, soon the air force assumed total control. The former Banana River Naval Air Station was designated the Joint Long Range Testing Facility, which later became Patrick Air Force Base. A separate Cape Canaveral base encompassed more than fifteen thousand acres initially and became home to rocket research and development in early 1950. This facility, with its adjunct bases, has undergone several name changes since 1949.

May 15

1933—Ringling School of Art Becomes Independent Institution: The Ringling School of Art, originally founded as part of Florida Southern College in 1931, was incorporated today as a separate institution. The concept of founding this art school originated with Dr. Ludd M. Spivey, then president of Southern College, now called Florida Southern College in Lakeland. The school is located in Sarasota.

1947—Florida State University Named: Florida State College for Women, which held its first classes in 1857, was reorganized and renamed Florida State University today. It also became a coeducational institution. By 1933, the Florida State College for Women was the third-largest women's college in the United States. Florida State was the larger of the original two universities in Florida until 1919. Returning soldiers using the G.I. Bill after World War II created a demand for more educational opportunities, and a Tallahassee branch of the University of Florida was opened on the campus of the Florida State College for Women. Male students were housed in barracks on nearby Dale Mabry Field. By 1947, the Florida legislature had formally granted FSCW coeducational status and renamed it Florida State University.

May 16, 1824

Famed Confederate General Born: Edmund Kirby Smith, Confederate general and commander of the Confederate Trans-Mississippi West, was born today in St. Augustine. Smith was a graduate of West Point (1845), fought in eight battles of the Mexican-American War, taught mathematics at West Point and was a noted botanist. In 1861, he resigned his position with the U.S. Army to enter Confederate service. Smith organized the Army of the

Shenandoah and was severely wounded at the Battle of First Bull Run. After Tennessee and Kentucky campaigns, he was given command of the Department of the Trans-Mississippi West. When Vicksburg surrendered on July 4, 1863, Smith's command was isolated from the rest of the Confederacy. His control over the Confederacy west of the Mississippi was virtually absolute and was referred to facetiously as "Kirby-Smithdom." After the Civil War, Smith taught mathematics at the University of the South. During the war, Smith signed his orders and reports as "E. Kirby Smith," and thus began the custom of referring to him as "Kirby Smith." Following his death, his family adopted this as their family name and hyphenated it as "Kirby-Smith." He is one of two individuals to represent Florida in the Hall of Statues in the Capitol in Washington, D.C.

May 17, 1913

Aviators Cross the Straits of Florida: Domingo Rosillo and Augustin Parlá flew across the Straits of Florida, from Key West to Havana, to become the first persons to fly between the United States and Cuba. The aerial trip between Key West and Havana was considered to be extremely dangerous. North American aviator J.A.D. McCurdy had tried it without success in 1913, and the two Cubans repeated his attempt with the hope of having better luck. The city council of

Havana offered a reward to aviators who accomplished the feat, promising "ten thousand pesos for whoever arrives first and five thousand for the second." Rosillo, flying a Bleriot plane, departed first. He arrived in Cuba two hours and thirty minutes later. Parlá, flying a plane built by Glenn Curtiss, left later but was forced to return after a flight of only four minutes when he experienced equipment problems. He repaired his machine and departed two days later. While he successfully negotiated the Straits, he crashed in the Bay of Mariel thereafter.

May 18, 1955

Famed Black Educator Dies: Mary McLeod Bethune, founder and first president of Bethune-Cookman College in Daytona Beach, died today. Bethune's career in education began when she received a scholarship to attend Scotia Seminary in North Carolina. A second scholarship provided the means for her to attend the Moody Bible Institute in Chicago. After teaching for eight years at schools in Augusta, Georgia, and Palatka, Florida, she opened her own school. In 1923, Bethune-Cookman College was created. In 1924, Mrs. Bethune was elected president of the National Association of Colored Women's Clubs. In 1935, she founded and became the first president of the National Council of Negro Women. A close friend of Mrs. Eleanor Roosevelt, Mrs. Bethune

was part of the "Black Cabinet," which advised President Franklin Delano Roosevelt on matters regarding African Americans in the United States. She was also a consultant to the founding conference of the United Nations. In 1973, Mary McLeod Bethune was inducted into the National Women's Hall of Fame. On July 10, 1974, a sculpture by artist Robert Berks was erected in her honor in Lincoln Park in Washington. It was the first monument honoring a black woman to be installed in a public park in the District of Columbia.

May 19, 1988

Notorious Drug Smuggler Convicted: In Jacksonville, Carlos Lehder Rivas was convicted of smuggling more than three tons of cocaine into the United States. Carlos Lehder was a co-founder of the Medellín Cartel, one of the most successful of the Columbian drug cartels during the 1970s and 1980s. He, along with Pablo Escobar, developed new ways to import illicit cocaine into the United States, making both men billionaires. Early in his criminal career, Lehder served a sentence in a federal prison in Danbury, Connecticut, for car theft. Once released on parole, he began to import small quantities of cocaine into the United States using carriers and small planes and slowly built a multibillion-dollar empire. When Columbian officials began to cooperate with the United States to eliminate

the Columbian cartels, he fled to Norman's Cay, a private island he had purchased in the Bahamas. He was forced to flee the Bahamas, and his financial assets were frozen by several countries. He was arrested in Columbia and extradited to the United States. In late 1987, he was put on trial in Jacksonville, found guilty and sentenced to life without parole, plus 135 years.

May 20, 1913

Railroad Baron and Hotelier Dies: Henry Morrison Flagler died today. Flagler first visited Florida in 1878. He began his economic ventures in Florida by purchasing several short railroad lines and combining them into a single system, the Florida East Coast Railway. Gradually, Flagler extended his lines southward, eventually reaching Key West. Where the railroad went, he either purchased existing tourist hotels or constructed his own. Flagler is the acknowledged "Father of Florida Tourism" because of his investments in creating travel destinations along east Florida's beaches. He and Henry Plant, the builder of the fabulous Tampa Bay hotel and a railroad magnate, were friends and rivals, but since Plant's railroads and hotels were primarily on Florida's west coast, there was little direct competition between the two early developers.

May 21, 1542

Hernando De Soto Dies: Hernando De Soto died today and was buried by his men on the banks of the Mississippi River. His exact burial spot was kept a secret, for his men didn't want the Native Americans to know of his death. A member of Pizarro's army that conquered Peru in 1533, De Soto had gained great wealth before returning to Spain. In May 1539, he returned to North America with nine ships, six hundred men, supplies of hogs and cattle and two hundred horses in search of gold and an overland route to the Far East. He landed at Tampa Bay, which he named *Bahía del Espíritu Santo*, or Bay of the Holy Spirit. Moving north from Tampa Bay, De Soto and his men spread European diseases, against which the natives had no immunity, and killed thousands with this early form of germ warfare. The Spanish also changed the environment of the southern region of North America when cattle, pigs and horses escaped from their camps. From 1539 until his death in 1542, De Soto led his ever-decreasing force though Florida, Georgia, Alabama, Mississippi, Oklahoma, Arkansas and Texas. With his death, the three hundred survivors of his expedition made their way south and west to Mexico.

May 22, 1865

Jefferson Davis's Luggage Arrives Near Archer: Part of the baggage of Confederate president Jefferson Davis arrived at David Levy Yulee's Cotton Wood plantation near Archer today. Davis was attempting to flee the North American continent after the surrender of Confederate armies in Virginia and North Carolina. Davis left Richmond and made his way south. Separating from his Cabinet members in Washington, Georgia, on May 5, he and his wife, accompanied by a small troop of Confederate soldiers, made their way farther south. He was captured on May 10 in Irwinville, Georgia. On May 19, Davis was imprisoned at Fortress Monroe on the coast of Virginia. Meanwhile, Davis's belongings continued on the train bound for Cedar Key, Florida. They were first hidden at Cotton Wood in Florida and then placed in the care of a railroad agent in Waldo. On June 15, Union soldiers seized Davis's baggage, together with some of the Confederate government's records, from the agent. For years, rumors persisted that a considerable part of the Confederate treasury was buried on Yulee's property. Treasure hunters have followed Davis's escape route for decades looking for buried treasure. None has ever been found.

May 23

1864—Union Gunboat Captured and Destroyed Near Palatka: Commissioned in late 1862 or early 1863, *Columbine* was used in the Atlantic Blockading Squadron off South Carolina. In May 1864, *Columbine* was sent to Jacksonville in support of the Union force operating along the St. John's River. On May 23, while returning from a trip to Palatka, near Horse Landing, *Columbine* was attacked by land-based Confederate forces, under the command of Captain J.J. Dickison and equipped with an artillery piece. The gunboat ran aground and was captured and burned. More than half of its crew were killed or wounded in the fighting, and others drowned while trying to escape the carnage. During the spring of 1864, the Confederates destroyed four other Union ships in the St. John's River with the use of a new weapon, the floating torpedo.

1939—Corse Proposes New Federal Writers' Project: Dr. Carita Doggett Corse, director of the Federal Writers' Project in Florida, wrote to the national director in Washington, enclosing a proposal for a "Recording Expedition Into the Floridas," as drawn up by Zora Neale Hurston, a Florida Federal Writers' Project editor. Hurston's proposal outlined Florida's diverse heritage and concluded with an emotional appeal for the recording project. It was approved.

May 24, 1818

Andrew Jackson Captures Pensacola: In December 1817, President James Monroe directed General Andrew Jackson to stop attacks by Seminole and Creek Indians on American settlers in Georgia, Alabama and South Carolina. In addition, Monroe wanted the Spanish territory of Florida closed as a haven for runaway slaves from these southern states. Known as "Maroons," fugitive slaves allied themselves with Indians in Florida, often acting as interpreters and military advisors. Jackson began to push the Indians southward, farther into the territory, burning villages and destroying crops. He destroyed the villages of Tallahassee and Miccosukee before moving against a Spanish fort at St. Marks. Jackson decided to march on Pensacola and take the Spanish fort there. He did so, arriving on May 24, and quickly taking the fort. Jackson's actions evoked protests from both the British and the Spanish, but the loudest protests came from his political enemies in Congress, who demanded that he be court-martialed and punished for his illegal actions. Secretary of State John Quincy Adams, who was negotiating a treaty for the United States to take control of Florida from Spain, rose to Jackson's defense, and no punishment was meted out. When the United States acquired Florida in 1821, Jackson was appointed the first territorial governor, a post he held for three months before resigning.

May 25, 1979

John Spenkelink Executed as Florida Resumes Death Penalty:
John Spenkelink was put to death today at Starke as
Florida reinstituted the death penalty after its use had
been restricted by the U.S. Supreme Court. Spenkelink
was convicted of the murder of Joseph Szymankiewicz,
a hitchhiker he had picked up. According to Spenkelink,
Szymankiewicz had used a weapon to terrorize and
sodomize him while they traveled. Spenkelink attempted
to flee one night as Szymankiewicz was sleeping, but he
awakened and wrestled with Spenkelink, who pulled
a pistol. As the two men struggled over the weapon,
Szymankiewicz was shot and killed. Although Spenkelink
was offered a deal to reduce the charge to second-degree
murder in exchange for a guilty plea, he refused to accept
it. His two court-appointed lawyers were unsuccessful
in defending him, and he was convicted. Sentenced to
death, Spenkelink was sent to Raiford Prison in Starke
and placed on death row. Few thought he would ever
be executed because the Supreme Court had ruled the
capital punishment laws of most states unconstitutional.
The Florida legislature had rewritten and approved a new
law in 1973. Spenkelink's execution was scheduled for
May 25, 1979. He became the first inmate to be executed
under Florida's revised law.

May 26, 1845

David Levy Yulee Elected to Congress: David Levy Yulee was elected as Florida's first member of the U.S. House of Representatives today. Yulee did not take the seat but was elected to the U.S. Senate later that year, a position he did take. Yulee was the first Jewish member of the Senate. He had previously served as a territorial delegate to Congress. Defeated for reelection in 1850, Yulee concentrated his time on developing his agricultural and railroad interests. He chartered the Florida Railroad in 1853 and, with grants under the Florida Internal Improvements Act, began constructing the road from Fernandina to Cedar Key. He was also financially involved with several other rail projects, earning him the nickname of "Father of Florida Railroads." He won a new term to the Senate and served until January 21, 1861. Originally known as David Levy, he added Yulee to his name, the name of one of his ancestors, soon after his 1846 marriage to the daughter of ex-governor Charles A. Wickliffe. Yulee became a Christian and raised his children as Christians, although he was subjected to anti-Semitism throughout his career. He was imprisoned for nine months after the war at Fort Pulaski before being pardoned. He then returned to railroad building in Florida. He died in 1880.

May 27

1887—Florida's Lake County Created: This was the forty-seventh county created by the Florida legislature. Orange and Sumter Counties gave up parts of their original territory for the creation of Lake County, which is named after the more than one thousand lakes within its borders.

2009—Ship Becomes Artificial Reef: On this day, the former missile-tracking ship *General Hoyt S. Vandenberg* was deliberately sunk off the Florida Keys to create an artificial reef. The ship first saw duty as the *General Harry Taylor* and served as a U.S. Army troop transport. Recommissioned as the *Vandenberg* in 1963, the ship tracked NASA's launches and was also used as a monitor for Russian missile launches. The active career of the *Vandenberg* came to an end in 1983, when it was retired to the James River Naval Reserve Fleet. In 1993, it was struck from the naval register and transferred to the U.S. Maritime Administration.

May 28, 1864

Union Ships Destroy Saltworks: Union soldiers from the Federal schooner *Fox* destroyed saltworks between the Suwannee River and St. Marks. Twenty-five kettles and one hundred bushels of salt were destroyed. The Union navy conducted a vigorous campaign against

saltworks along the coast because salt was essential to food preservation and to the manufacture of gunpowder. Individuals involved in the manufacture of this commodity were exempted from the Confederate draft, paid higher wages and considered as essential for the Confederate cause. With the capture of traditional salt mining territory by the Union army, salt extracted from seawater became the major source for Confederate supplies by 1863. The process for manufacturing salt was simple—use iron kettles to boil seawater until only salt was left or use large vats to hold the water until evaporation was complete. Despite the efforts of the Federal sailors to stop salt production, the simplicity of the process and the construction of small salt-making facilities on isolated stretches of beaches prevented them from doing much more than temporarily disrupting such enterprises. During the Civil War, salt was considered to be as valuable as, if not more valuable than, gold.

May 29, 1586

English Sea Dog Sacks St. Augustine: Sir Francis Drake, the famous English "Sea Dog," burned and sacked the town of St. Augustine today. Drake's attack against this small Spanish outpost in North America was part of ongoing hostilities between the English and Spanish in Europe over Queen Elizabeth I's support for Dutch Protestants who were rebelling against the Spanish who controlled

Holland. The conflict escalated rapidly, culminating in the launching of the large Spanish Armada against England in 1588. Drake, who had made his reputation attacking and capturing Spanish galleons, had previously sacked the city of Santiago in the Cabo Verde Islands and Santo Domingo. From Santo Domingo, Drake sailed to Cartagena, which fell and was occupied until a ransom of 110,000 ducats was paid. St. Augustine was Drake's next target. After encountering Spanish soldiers in small forts outside the town, he moved his men into St. Augustine, which had been abandoned by the Spanish. The English occupied the town overnight before moving out the next day. As they left, they carried off all items of value they could find and torched the town. The Spanish reoccupied the smoldering city after Drake's men left the area.

May 30, 1865

John C. Breckinridge Flees Through Indian River Lagoon: Former U.S. vice president and Confederate general John C. Breckinridge, accompanied by his son and a small group of Kentucky soldiers, arrived at Carlisle's Landing on the Indian River Lagoon today. Breckinridge and his small party were fleeing Union soldiers on their way to Cuba. Breckinridge started his journey when General Robert E. Lee abandoned Richmond. He moved south to Danville, Virginia, where he attempted to persuade Confederate

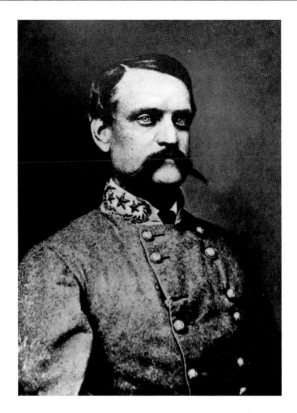

John C. Breckinridge, the last secretary of war for the Confederacy, escaped capture by Union forces when he fled south along Florida's east coast to Cuba. He was afraid that he would be accused of treason and shot or imprisoned because he had been the vice-president of the United States prior to the outbreak of the Civil War. *Lewis N. Wynne Private Collection.*

president Jefferson Davis to surrender all Rebel forces. Unable to convince Davis, he followed him to Washington, Georgia, to attend the final meeting of the Confederate cabinet. He returned to the United States in 1868 when amnesty was granted to former Confederates.

May 31, 1539

Hernando De Soto Lands in Florida: Hernando De Soto, Spanish governor of Cuba, landed at Tampa Bay with a large force of men, animals and equipment as he prepared to scour the southeast in search of gold and valuables. With nine ships and more than 600 men, he planned to spend four years exploring, collecting gold and gathering information about North America that might aid in further Spanish colonization. For three years, De Soto and his men roamed the present-day American South, engaging in numerous conflicts with Native Americans but finding no gold. After many twists and turns, De Soto died in 1542 in present-day Arkansas and was buried on the banks of the Mississippi River. Exhausted, his men eventually made their way down to Texas and then Mexico. Of the 620 men who had landed with him in Florida, only 311 survived.

JUNE

June 1, 1881

Sale of Four Million Acres of State Land Approved: Hamilton Disston, a wealthy manufacturer from Philadelphia, concluded the largest land purchase ever made in the United States when he bought four million acres from the State of Florida today. Disston, who first came to the Sunshine State in 1877, was the head of the Henry Disston & Sons company and was interested in residential real estate development and agricultural land reclamation. He organized the Atlantic and Gulf Coast Canal Company and Okeechobee Land Company to pursue these interests in Florida. In early 1881, he secured a contract to drain much of the state-owned flooded lands, hoping to drain twelve million acres, half of which would pass to his company. In June 1881, he negotiated the outright purchase of an additional four million acres from the state, paying only twenty-five cents an acre. Through this sale, the State of Florida, which

was broke and unable to pay its debts, managed to avoid bankruptcy. The Disston Purchase triggered a land boom in the state, but two devastating freezes in the mid-1890s ended it. Disston died on April 30, 1896, surrounded by controversy. One Philadelphia newspaper and a distant nephew of Disston reported his death was a suicide while other newspapers across the country reported that he died at home of a heart attack.

June 2, 1937

Miami Abuzz with Speculation about Flight of Amelia Earhart: Miamians were still talking about the June 1 departure of aviator Amelia Earhart and navigator Fred Noonan from Miami International Airport on their "'round-the-world" flight. Earhart had captured the imagination of the American public with a series of well-publicized flights in the 1920s and 1930s. In 1928, she was the first female passenger on a transatlantic flight when, with pilot Wilmer Stultz and mechanic Lou Gordon, Amelia flew from Newfoundland to Wales aboard the trimotor plane *Friendship*. She wrote about her experience in the bestselling book *20 Hours, 40 minutes*, which was published by George Putnam, whose company had sponsored the flight. She married Putnam in 1931, and he became the biggest promoter of her career. In 1932, she became the first woman to solo across the Atlantic

Ocean, and in 1935, she became the first person to fly from Hawaii to the mainland of the United States. In 1935, she purchased a Lockheed *Electra* airplane and began planning a flight around the world. Departing from Miami International Airport, she and Noonan expected the flight to take about eight weeks. Earhart and Noonan reached Lae, New Guinea, and after refueling and resting, they left on the next leg of their journey. On July 2, all contact with Earhart's plane was lost, and no trace of it has ever been found.

June 3, 1965

International Audience Watches Manned Space Flight: Gemini *4*, the second manned space flight in NASA's Project Gemini, was launched from Cape Kennedy Air Force Station today with astronauts James McDivitt and Edward H. White II aboard. It was the tenth manned American spaceflight and the longest manned mission to date. The two astronauts circled the Earth sixty-six times in four days. The highlight of the mission was the first space walk by an American astronaut. Ed White floated free outside the spacecraft, although tethered to it, for about twenty minutes. The *Gemini 4* was the first American space flight in which control of the mission was shifted to the Manned Spacecraft Center in Houston immediately after takeoff. An international audience from twelve

European nations received live television broadcasts of the liftoff via the Early Bird communications satellite that had been placed into orbit earlier in the year.

June 4, 1828

Plantation Purchased by Wealthy Nuttall Family: The El Destino plantation, near Tallahassee, was purchased today by the Nuttall family for $2,350. The original plantation, which contained some 480 acres, grew to 7,638 acres by the end of 1828. It was located in western Jefferson and eastern Leon Counties and was primarily a cotton-growing operation. In 1832, William B. Nuttall bought El Destino from his father's estate for $17,000. Nuttall died, leaving the property to his widow, Mary Savage Nuttall. Mary Nuttall inherited a large number of slaves from her uncle, William Savage. To employ these slaves, Hector Braden sold her Chemonie Plantation six miles north of El Destino. She thus became the owner of two of the largest plantations in the state. On May 18, 1840, George Noble Jones married Mary Savage Nuttall and purchased El Destino and Chemonie plantations, adding them to his vast holdings in Georgia. The acquisition of Florida by the United States had opened the territory to plantation agriculture and slave labor. By 1860, Florida, now a state, had a population of 144,000 persons, of whom 70,000–75,000 were African slaves.

June 5, 1995

Early Hurricane Hits the Sunshine State: Hurricane Allison was the first named storm and the first hurricane of the 1995 Atlantic hurricane season. It delivered heavy rains and caused minor damage, primarily across Florida and Georgia. The storm developed on June 2, less than forty-eight hours after the official start of the hurricane season, and made landfall in the Big Bend area of Florida on June 5. Allison's winds knocked down power lines, utility poles and trees, leaving residents without power or telephone services. The highest storm surge in Florida was about six to eight feet in Wakulla and Dixie Counties. There were no deaths reported as a result of Allison. Damage was estimated at $860,000, primarily from the storm surge.

June 6, 1944

Allies Invade Normandy Beaches: Thousands of Floridians and soldiers/sailors trained in Florida participated in the Normandy invasion today. Florida, with its clear skies and sunshine, rapidly became a preferred training location for more that 1.5 million military recruits after Pearl Harbor. More than ninety bases for all branches of service were built in Florida within a few short months, and no area of the state was exempt from use by the services. Along Florida's coasts watchtowers were erected as German

U-boats conducted an extensive submarine campaign against Allied ships in 1942 and 1943. The Normandy invasion marked the beginning of the end for Nazi Germany and followed Allied victories in North Africa, Sicily and the Italian peninsula.

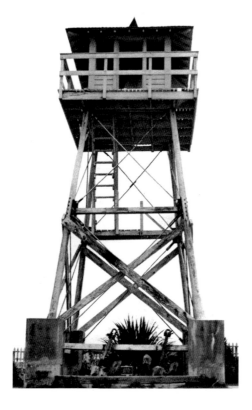

Hastily constructed roads and bridges were built all over Florida during 1942. Many of them led directly to isolated beaches where civilian volunteers manned observation towers watching for enemy submarines and airplanes. *Florida Historical Society.*

June 7, 1873

Labor Unrest Hits North Florida: Workers in Jacksonville sawmills went on strike today. African American sawmill workers idled mills as they sought to bring owners to the bargaining table. The workers, members of the Jacksonville Labor League, which was composed of mostly African American members, walked away from their jobs in protest of long working hours and low pay. Jacksonville was a center of lumbering in Florida. Supported by the Jacksonville

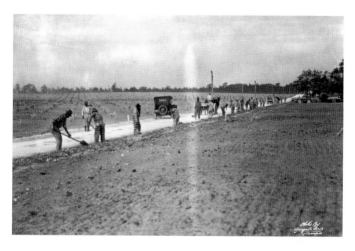

Labor was always in demand in Florida, particularly after the end of World War I when thousands of African Americans deserted the Sunshine State and headed for cities like Detroit and Chicago in the industrialized northern states. In order to maintain the growing infrastructure—roads, sewers, bridges—Florida turned to prisoners incarcerated in its jails. *Burgert Brothers Collection, Tampa Public Library.*

Labor League, the strikers demanded a ten-hour workday and a daily wage of fifty cents. Mill owners quickly filled vacant positions with white scab laborers, and the strike collapsed after a month.

June 8, 1845

Old Hickory Dies in Nashville: Andrew Jackson, general and former president of the United States, died today at the Hermitage, his plantation in Nashville, Tennessee. Jackson was especially important in the modern history of Florida, since he was largely responsible for its acquisition by the United States following his invasion of the then Spanish province. His invasion of Florida in pursuit of runaway slaves and Native Americans who were raiding plantations in Georgia and Alabama brought his soldiers into conflict with Spanish authorities. Unable to suppress the activities of Seminole and Creek Indians within the borders of its Florida territory, Spain surrendered its claim to the area in the Adams-Onís Treaty, which was negotiated in 1819 and ratified by the American Congress in 1821. Jackson served as the governor of the new American territory for about three months before resigning and returning to Tennessee. The city of Jacksonville, located at the mouth of the St. Johns River, is named in his honor.

June 9, 1865

Missionary Arrives to Start Churches: The first African American missionary in Jacksonville, Reverend William G. Steward, arrived today from Charleston to begin organizing churches and establishing schools for the newly liberated freedmen in the state. He was the first pastor from the African Methodist Episcopal denomination to arrive in Florida after the Confederate surrender. Steward, along with Charles H. Pearce, another AME clergyman, was instrumental in the founding of a school, Brown Theological Institute, in Jacksonville. The school experienced financial difficulties soon after its founding and remained closed for much of the 1870s. It reopened in 1883 with a new name, East Florida Conference High School. It was soon renamed the East Florida Scientific and Divinity High School. During the next decade, the curriculum was expanded and the name changed once again. It became Edward Waters College, in honor of the third bishop of the AME Church. Although the original college was destroyed in the Great Fire of 1901 that destroyed about 80 percent of Jacksonville, it was rebuilt in 1904 and continues operations today.

June 10, 1990

Rap Group Arrested for Obscenity: Miami-based rap group 2 Live Crew was arrested today in Hollywood, Florida, for

performing songs from its album, *As Nasty as They Wanna Be*, which had already been ruled obscene by a federal judge, Jose Gonzalez, and therefore was illegal to sell. One cut on the album, *Me So Horny*, was deemed especially obscene. When record retailers continued to sell the album in defiance of the court's ruling, several were arrested, including Charles Freeman. Broward County sheriff Nick Navarro arrested three members of 2 Live Crew after they performed their *As Nasty as They Wanna Be* album at a nightclub in Hollywood. The event was hosted by radio personality Ira Wolf. Freedom of speech advocates from around the world supported the rap group, and at the trial of the three men, several prominent academics, including Henry Louis Gates Jr., testified in their defense. They were acquitted. Freeman, who had been convicted of obscenity charges in a Broward County court, had his conviction overturned on appeal. The Supreme Court refused to hear Broward County's appeal.

June 11, 1964

Martin Luther King and Seventeen Others Arrested in St. Augustine: St. Augustine, the nation's oldest city, was the center of opposition to integration in the Sunshine State. Local segregationists, such as the Ku Klux Klan, responded to demands for equality by engaging in violent confrontations and intimidating activities. Dr. Martin Luther King came

to St. Augustine at the invitation of Dr. Robert B. Hayling, a local dentist and a leader in the civil rights movement in the city. Hayling also issued a call for northern students to come to St. Augustine on spring break to protest segregation. Four prominent Boston women came as well. One of them, Mary Parkman Peabody, the mother of the governor of Massachusetts, was arrested at a sit-in. Today, King and seventeen other protestors were arrested during a sit-in at the Monson Motor Hotel. It was the only time he was arrested in Florida. In jail, King continued to urge Americans to come to St. Augustine to support the demonstrators. His famous "Letter from the St. Augustine Jail" to his old friend Rabbi Israel Dresner got immediate results, and on June 18, Dresner and other rabbis were arrested for jumping into the pool at the same Monson Motor Hotel.

June 12, 1913

Collins Bridge to Miami Beach Opened: John S. Collins, who owned much property on the beach, started construction of the bridge but ran out of money. Millionaire Carl G. Fisher, who was visiting Miami, offered to lend Collins the money to complete it. In exchange for two hundred acres of beachfront property, Fisher made good on his offer. In 1913, the beach was still primarily used for agricultural purposes, but Fisher began to increase his holdings by using

dredges to pump millions of tons of sand from the ocean. He quickly began to develop Miami Beach, triggering the phenomenal 1920s boom. The original bridge was replaced in 1925 and renamed the Venetian Causeway.

Carl Fisher, an Indiana automobile manufacturer and entrepreneur, became enchanted with Miami during a visit there. He was able to secure land on the isolated Miami Beach through trades, loans and outright purchases. He set out to make Miami Beach the playground of America's rich, and he succeeded. He used dredges to expand his land holdings and erected palatial hotels to cater to the wealthy. By 1925, Miami Beach was known worldwide and became the destination of choice for those "who wanted to be seen." *Richard Moorhead Private Collection.*

June 13, 1974

Florida's First Female Cabinet Officer Appointed: Dorothy Glisson, the head of Florida's elections office, was appointed to the position of secretary of state today by Governor Reubin Askew. Her appointment became effective on July 9. She filled the vacancy left by Richard Stone's resignation. Stone resigned in order to run for the Democratic nomination for U.S. Senate. Glisson was the first woman to sit as a member of Florida's cabinet. Glisson stated she had no plans to run for election to the position in the November elections and would return to her job as elections supervisor in January 1975. The main job of cabinet members was to set policies concerning public education, the management of public lands and environmental regulations. Governor Askew announced his appointment of Glisson at a luncheon of county supervisors meeting in Fort Myers. "She's the only one for the job," he said.

June 14, 1826

Noted Supporter of Cuban Independence Born: Joseph Fry, who gained notoriety as an American supporter of the Cuban insurrection of the 1870s, was born today in Tampa. Fry graduated from the U.S. Naval Academy and served with the navy for fifteen years before resigning and joining the fledgling Confederate navy in 1861. Rising to the rank of

commodore, he was left unemployed when the Confederacy surrendered in 1865. A supporter of Cubans fighting against Spanish control of Cuba in the 1870s, he became captain of the *Virginius*, a former Confederate ship. He recruited a crew and sailed for Cuba with a full cargo of munitions and a contingent of Cuban rebels. After a short chase, the *Virginius* was captured by the Spanish ship *Tornado*, and Fry, his crew and the Cuban rebels were taken prisoner. The Spanish put the captured men on trial and sentenced them to death. Fifty-three men, including Captain Fry, were executed before a British frigate arrived in Cuba to stop the executions. Relations between the United States and Spain continued to deteriorate over the issue of Cuban independence. The Spanish-American War ultimately resolved the dispute when Spain was defeated and Cuba was granted its independence.

June 15, 1978

Former Supreme Court Justice Disbarred: Today former Florida Supreme Court justice David L. McCain was disbarred by the Florida Supreme Court for using his influence on lower court justices on behalf of his friends. Once regarded as the best attorney in Fort Pierce, McCain was considered overly ambitious. In 1966, he worked tirelessly for the election of Claude Kirk as governor. As a reward, Kirk later appointed him as a judge on the Fourth Court of Appeals.

Four years later, Kirk appointed McCain to a vacant seat on the Florida Supreme Court after refusing to accept a report by the Florida Bar that found McCain unqualified for the appointment based on "legal improprieties" and "suspected criminal activities." Elected to a full term on the court in 1973, he became the focus of newspaper reports alleging he had received a $10,000 bribe to reverse the conviction of Richard Nell, a labor union official convicted of bribery. *St. Petersburg Times* and *Tampa Tribune* articles persuaded the newly created Judicial Qualifications Committee to investigate McCain, and it recommended that he be impeached. McCain resigned before he could be impeached. In 1982, he was arrested for smuggling ten thousand pounds of marijuana. He fled the state and died of cancer before he could be tried.

June 16, 1955

Judge and Wife Go Missing: Judge Curtis Eugene Chillingworth and his wife of West Palm Beach mysteriously disappeared today. Chillingworth was elected as a circuit judge in 1924. As a judge, he gained a reputation for enforcing strict judicial ethics among jurists in Palm Beach County. Chillingworth and his wife were last seen at a dinner in West Palm Beach, Florida, on the evening of June 14. They left the dinner early, telling friends that they were expecting a carpenter to arrive early the next morning to build a playground for

their grandchildren. When the carpenter arrived, he got no response after he knocked on the door of the home. When Judge Chillingworth failed to keep an appointment later that day, the police were called to investigate. Officers found bloodstains on the walkway to the beach, but no other indications of foul play. No evidence of where the couple had gone was found, and they were declared legally dead two years later. A local criminal, "Lucky" Holzapfel, told a friend that he had been hired to kill Chillingworth by municipal court judge, Joseph Peel. Peel was involved with local criminals and was afraid Chillingworth would expose his activities. In September 1960, Holzapfel confessed to murdering the judge and his wife. He named Bobby Lincoln, another small-time criminal, as his accomplice. Both men were convicted. Based on their testimony, Joseph Peel was also convicted in 1961.

June 17, 1942

Germans Invade Florida: Four German saboteurs landed today on Ponte Vedra Beach near Jacksonville as part of Operation Pastorious, a plan to create confusion through sabotage. They were to link up with a second team of four agents who had landed on Long Island, New York. Not very skilled, they failed in their mission. One man, Walter Dasch, decided to expose the operation to the FBI. The saboteurs were arrested and tried by a military tribunal. Six

were convicted and sentenced to death. They were executed within hours of their conviction. Dasch and Ernst Burger, who was an American citizen, were spared and returned to Germany after the war.

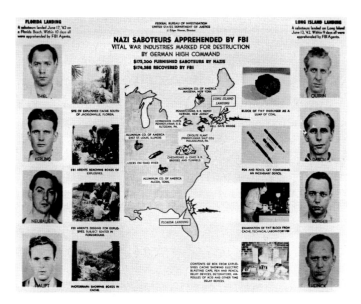

In early 1942, four German saboteurs came ashore near Ponte Vedra on a mission to sabotage the American war effort. Four more Germans landed on Long Island. When one of the men defected, the entire operation was stopped by the FBI. *Beaches Area Historical Society, Ponte Vedra.*

June 18, 1983

Sally Ride Becomes First American Woman in Space: Sally Ride flew into orbit aboard the shuttle *Challenger* in 1983 to become America's first woman in space. She took a second trip aboard the same shuttle one year later. Born on May 26, 1951, Ride grew up in Los Angeles and went to Stanford University. Ride beat out one thousand other applicants for a spot in the astronaut program. She went through a rigorous training program and got her chance to go into space and the record books in 1983. As a mission specialist, she helped deploy satellites and worked other projects. The next year, Ride again served as a mission specialist on a space shuttle flight in October. She was scheduled to take a third trip, but it was cancelled after the tragic *Challenger* accident on January 28, 1986. Ride served on the presidential commission that investigated the space shuttle explosion. She became the director of the California Space Institute at the University of California–San Diego in 1989. In 2001, she started her own company, Sally Ride Science, to help young women pursue careers in science and math. On July 23, 2012, Sally Ride died following a seventeen-month-long battle with pancreatic cancer.

June 19, 1947

Banana River Naval Air Station Dedicated: In a strange set of events, the Banana River Naval Air Station, which opened in 1939, was formally dedicated as a defense installation today, just weeks before it was decommissioned. NAS Banana River was a major training base for pilots, radiomen, gunners and bombardiers. In 1948, NAS Banana River was selected as the site of the Long Range Proving Grounds and became operational in 1949. American missiles were launched from the base. Control of the facility was transferred to the air force on June 22, 1948. Now known as Patrick Air Force Base, it serves as the headquarters of the Air Force Space Command.

June 20, 1918

Cocoa Man Catches German Spy on Train: Ralph Rubin, a Cocoa man who joined the army in 1918, was credited with discovering a German spy on his leave from his base in South Carolina. On the train he was taking home, he was approached by an inquisitive stranger, who aroused his suspicions. He told a conductor who arranged for the train to be met by several men, including a uniformed policeman. The suspected spy tried to flee. After running through several cars, he was caught when he exited the train. The man admitted that he was a German spy and

German saboteurs brought large quantities of explosives and money ashore in April 1942, including this cleverly disguised bomb, which appears to be a simple piece of coal. German spies and saboteurs had also invaded the United States during World War I. *Beaches Area Historical Society, Ponte Vedra.*

that he was trying to find out information about military training camps.

June 21, 1982

Florida Senate Refuses to Ratify Equal Rights Amendment: In special session, the Florida Senate declined to ratify the Equal Rights Amendment. The amendment, which needed three more states to ratify it before the June 30 deadline for adoption, was hotly debated. The Florida House of Representatives approved the measure by a narrow 60–58 vote, the fourth time the lower house had done so. The Florida Senate, on the other hand, had consistently refused to approve the amendment. After a mere two hours of debate, the senate voted against ratification by a vote of 22–16. Five thousand persons were in the chambers and the capitol rotunda when the final vote was taken, and law

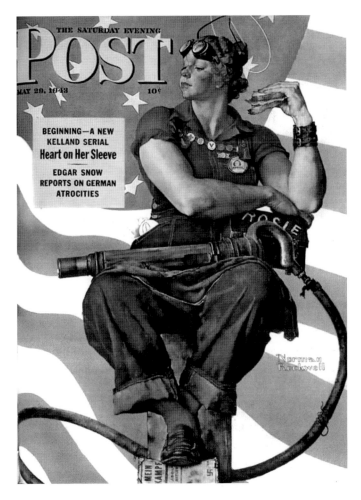

Rosie the Riveter was an iconic painting done by Norman Rockwell to pay homage to the accomplishments of American women in making the war effort on the homefront a success. *Camp Blanding Infantry Museum.*

enforcement officials feared that violence would break out. Florida voters had rejected the amendment in an earlier referendum. Each year, a version of the ERA is introduced in Congress but has yet to pass.

June 22, 1564

French Establish Fort Caroline: Fort Caroline was the first French colony in the present-day United States. It was located on the banks of the St. Johns River in what is now Jacksonville. It was established under the leadership of René Goulaine de Laudonnière on June 22, 1564, as a safe haven for Huguenots. Laudonnière turned over command of the fort and its inhabitants to Jean Ribault in 1565. The French settlement was immediately attacked by the Spanish ships of Pedro Menéndez de Avilés, which were rebuffed. Menéndez retreated south and established St. Augustine in September 1565. Ribault decided to pursue the Spanish with several of his ships but encountered a hurricane. In the meantime, Menéndez returned and sacked the fort on September 20. At this time, the garrison contained 200 to 250 people. The only survivors were about 50 women and children who were taken prisoner. A few defenders, including Laudonnière, managed to escape and made their way to France. Ribault's fleet was destroyed in the hurricane. Ribault and several hundred men made their

way to shore, where they were located by Menéndez. When a surrender was demanded by Menéndez, Ribault, believing his men would be well treated, capitulated. Menéndez then executed Ribault and his men as heretics.

June 23, 1938

Marineland Opened Today: Marineland, then called Marine Studios, opened today near St. Augustine. More than 30,000 tourists, scientists and photographers attended the opening. Marineland was first conceived as an oceanarium that could be used to film marine life. A site was selected on the Atlantic Ocean, which eventually became the town of Marineland and included a motel, restaurants and a marina. The facility began operations with a bottlenose dolphin as its main attraction. The park was very popular with tourists and also used for numerous movies, including *Creature from the Black Lagoon*. Marineland attracted over 900,000 visitors per year in the mid-1970s, but attendance

Following page: Florida's economy has always depended on tourism. From the early 1800s until the present, tourist dollars have contributed greatly to the state's coffers. In order to promote tourism, Floridians have worked to create an atmosphere of endless fun on its beaches, in its hotels and with amusements like horse racing and jai alai. *Lewis N. Wynne Private Collection.*

declined when SeaWorld opened in Orlando. Marineland was purchased by Georgia Aquarium on January 1, 2011.

June 24, 1952

Captured V-2 Launched from Cape Canaveral: The first German V-2 rocket was launched today from Cape Canaveral. Captured German rockets became the basis of the U.S. early missile program, and German rocket scientists, brought to the United States at the end of World War II, provided the initial expertise needed to get the American rocket program going. Operation Paperclip was a secret program that actively sought out such individuals, many of whom were individuals who had participated

in war crimes, including the design and construction of crematoriums for extermination camps, the development of the gases used for exterminating the inmates of concentration camps, experiments on live inmates of these camps that often resulted in horrific deaths and the use of slave labor—which resulted in thousands of deaths—to produce German rockets. Most were members of the notorious SS, including Werner Von Braun, or had participated in war crimes in Poland, Russia and other areas of Europe. In addition to scientists and engineers, the American military collected complete V-2 rockets, spare parts, engineering documents and other materials for use in developing a rocket program. These materials were turned over to contractors for further development.

June 25, 1868

Florida Readmitted to the Union: Florida was conditionally readmitted to the United States today, but federal occupation of the state would not end until 1877. Though Lincoln's readmission plan was lenient, his tragic death in April 1865 ended its implementation, and Radicals in Congress demanded more stringent conditions. When Congress was in adjournment, Andrew Johnson, Lincoln's successor, readmitted the former Confederate states under a plan aimed at destroying the power of the prewar planter aristocracy. He appointed provisional governors for the

defeated states and instructed them to repeal the ordinances of secession, repudiate Confederate war debts and ratify the Thirteenth Amendment. Newly elected state legislatures immediately enacted laws, known as the Black Codes, which severely limited the rights of emancipated blacks. When Congress came back into session, angry Radicals took control of Reconstruction and imposed harsher terms. Reconstruction came to an end in 1877 when the southern states and the supporters of Rutherford B. Hayes, who was the Republican candidate for president, reached a political bargain: Florida gave Hayes the electoral votes he needed to become president, and Hayes removed federal troops.

June 26, 1549

Spanish Priest Killed by Native Americans: Luis Cancer de Barbastro, a Spanish missionary, was clubbed to death by Indians today. Cancer, who had previously worked in Guatemala, wanted to establish missions in west Florida, an area that had seen much conflict between the Native Americans and the expeditions of Pánfilo Narváez and Hernando De Soto. With a small group of fellow priests and an interpreter, he left Havana in early 1549. The priests' ship landed south of Tampa Bay, where they encountered a group of peaceful Indians. Cancer then sent the interpreter and two priests overland to contact what they thought would be a large and receptive group of Indians

at Tampa Bay. Cancer returned to his ship and proceeded up the coast to rejoin his group. When the ship arrived, it was greeted by the interpreter and a group of Indians. Cancer was informed that the Indians were peaceful and were entertaining the other priests as guests. Cancer was warned by an escaped Indian slave that the Indians had killed the two priests. Although his fellow priests wanted to flee immediately, Cancer refused to leave. The next day, he and his companions rowed to shore, where they saw a group of Indians. Cancer waded to shore and knelt to pray. He was attacked and beaten to death. The other men in his party managed to escape.

June 27, 1911

First African American Legislator of the Twentieth Century Born: Joe Lang Kershaw, the first African American man to be elected to the Florida House of Representatives in the twentieth century, was born today in Live Oak. Kershaw was elected to the house in 1968 and represented Dade County. Kershaw served fourteen years in the house of representatives and introduced the legislation that produced the Florida Human Rights Commission. He also won passage of the Cane Pole Law, which allowed Floridians—mostly poor blacks, according to Kershaw—to fish with cane poles without having to obtain a state fishing license. A graduate of Florida A&M University, he was

a high school civics teacher at several black schools in Miami. He was also a football coach. Larry Little, a former professional player for the Miami Dolphins and a member of the National Football League Hall of Fame, was among the many players Kershaw coached. Kershaw died on November 7, 1999, from congestive heart failure. His son, Joe Lang Kershaw Jr., also served in the Florida House of Representatives.

June 28, 1566

Jesuit Priests Join Spanish in Florida: Three Spanish Jesuit monks left Spain today to join Pedro Menéndez de Avilés in Florida. Their mission was to Christianize the Native Americans in the peninsula and bring them under Spanish control. The missionaries were unsuccessful in their initial attempts. When one of them was killed by Indians, the other two withdrew temporarily to the West Indies. On their return, Menéndez established a garrison of fifty soldiers at San Antonio, on Charlotte Bay, in the territory of Cacique Carlos, to protect one of the priests. The second missionary was sent, along with a garrison of soldiers, to Tegesta on the Miami River. Florida Indians did not take kindly to the missionary efforts of the priests, and both were forced to abandon their efforts. In 1568, fourteen additional Jesuits, under Father Juan Bautista de Segura, journeyed to Florida to resume missionary work, but poor treatment

caused Native Americans to rise in rebellion and force the missionaries to again abandon their efforts. When Segura and six other priests attempted to establish a mission on Chesapeake Bay in Virginia, the Native Americans killed them. In 1573, Franciscan monks took up the challenge and eventually established a system of twenty missions in Spanish territory.

June 29, 1817

Amelia Island Captured: Today, General Gregor MacGregor, a military adventurer, captured Amelia Island from the Spanish. MacGregor, a former officer of the British army who had bought his way out of service, was involved in liberation efforts in Venezuela, Mexico and New Granada (present-day Colombia) as a general in the army of Simón Bolívar. In 1817, MacGregor claimed to be ordered to liberate Florida from Spanish rule. Financed by American backers, he led an army of only 150 men—including recruits from Charleston and Savannah, some War of 1812 veterans and 55 musketeers—in an assault on Fort San Carlos at Fernandina on Amelia Island. Through spies within the Spanish garrison, MacGregor learned that the force there consisted of only 55 regulars and 50 militiamen. He spread rumors in the town, which soon reached the garrison commander, that an army of more than 1,000 men was about to attack. On June 29, he advanced on the

fort and, by deploying his men in small groups coming from various directions, gave the impression of having a much larger force. The Spanish fled. MacGregor then raised his flag over the fort and proclaimed the "Republic of the Floridas." MacGregor abandoned the island on September 4, when faced with the possibility of Spanish reprisals.

June 30, 1965

NBA Star Mitch Redmond Born: Mitchell James "Mitch" Redmond, a professional basketball player and member of the Naismith Basketball Hall of Fame, was born today in Fort Lauderdale. He played his college ball at Moberly Area Community College and Kansas State University before being drafted by the Golden State Warriors in 1988. He won the Rookie of the Year Award for the 1988–89 season. In 1991, he was traded to the Sacramento Kings and played for that team until 1998, when he was traded to the Washington Wizards. He signed with the Los Angeles Lakers as a free agent in 2001 and ended his career as a Laker in 2002. Before joining the NBA, he played for the U.S. men's national basketball team that won a bronze medal in the 1988 Summer Olympics in Seoul, South Korea. He was also a member of the national team again in the 1996 Summer Olympics in Atlanta. The team won the gold medal and included eleven other NBA players.

JULY

July 1, 1898

American Army Battles Spanish Soldiers in Cuba: Floridians eagerly read the newspaper accounts of the fighting at San Juan and Kettle Hills in Cuba on this date. Most of the American troops had trained in camps in the state. Although General William Shafter, the commander of the American force, had his prewar headquarters in Tampa, large camps were established in Fernandina, Miami and Lakeland. Lieutenant Colonel Theodore Roosevelt received most of the press notices and became an instant

Following page: General William Shafter, who weighed in excess of 350 pounds, was in overall command of the American military during the Spanish-American War. Derisively referred to as *El Gordo*, the "Fat One," he used a horse and buggy to get around the battlefields in Cuba because no horse could carry his weight for any significant period of time. *The Lewis N. Wynne Private Collection.*

military hero. Based on his military exploits and the publicity surrounding them, Roosevelt was elected vice president in 1900 and assumed the presidency when McKinley was assassinated.

July 2, 1693

Spanish Explorer Reaches Pensacola Bay: A Spanish expedition led by Laureano del Torres y Ayala arrived at Pensacola Bay today. In 1689, Conde de Gálvez, the viceroy of Mexico, decided that Pensacola was a much better port than St. Augustine and was better located to protect Spanish interests in Florida. He recommended that St. Augustine be abandoned and the garrison in that city be transferred to Pensacola. When he sent an officer to secure permission to colonize Pensacola Bay, the king of Spain Charles II was in favor of his proposal, but the royal council was not. The council rejected the idea unless a scientific survey could justify the move or unless the French made moves toward the area. The conde sent Admiral Andrés de Pez, accompanied by Dr. Carlos de Sigüenza y Góngora, to Pensacola to conduct the survey. Laureano del Torres y Ayala, the governor-elect of St. Augustine, led a land expedition to the Pez group. Although both Pez and Torres reported favorable impressions of the Pensacola region, they noted that it did not have a supply of suitable building stone or a significant population of

Native Americans. Based on their reports, the king issued an order to occupy Pensacola on June 13, 1694, but no immediate action was taken.

July 3, 1971

Rocker Jim Morrison Drowns in Paris: James Douglas Morrison of the rock group the Doors was born in Melbourne, Florida, on December 8, 1943. His father was a career naval officer, who was stationed at many different bases, and he attended schools in different states. After high school, he went to live with his paternal grandparents in Clearwater, Florida, and attended classes at St. Petersburg Junior College. In 1962, he transferred to Florida State University. In January 1964, Morrison moved to Los Angeles to attend the University of California–Los Angeles. After graduating with a degree from the UCLA film school, Morrison led a bohemian lifestyle in Venice Beach. He formed the band the Doors, and in June 1966, Morrison and the Doors were the opening act at the Whisky a Go Go. The Doors achieved national recognition after signing with Elektra Records in 1967. Their single "Light My Fire" spent three weeks in the number one position on the Billboard Hot 100 chart in July/August 1967. After several run-ins with law enforcement over his onstage antics, Morrison moved to Paris in 1971 with longtime companion, Pamela Courson. He is buried in Père Lachaise Cemetery in Paris, one of the city's most visited tourist attractions.

July 4, 1924

Conners Highway Opens: Developer William J. "Fingey" Conners built the first road across Florida, which is now known as Route 80 and U.S. 98/441. Conners, who visited the Everglades in 1917, bought four thousand acres east of Canal Point, near Lake Okeechobee. The lake was only accessible by boat, but an automobile could reach Twenty Mile Bend, about halfway to the lake. Conners requested permission from the state to build a toll road to the lake, and the legislature granted his request. Construction began immediately. The toll road ran from West Palm Beach to Okeechobee, but a free section continued on to Tampa. The Conners Toll Highway was dedicated in 1924. The toll was $1.50 per car and driver and $0.50 cents extra per passenger and was charged at each tollbooth. Although the toll amounted to only $0.01½ per mile, the average daily toll income was estimated at $1,000.00 to $2,000.00, which quickly recouped the $1.8 million it cost to build. The highway was advertised as part of the Dixie Highway and as a cross-state alternative to the unpaved Tamiami Trail. After Conners's death in 1929, the state bought the road and abolished the tolls.

July 5, 1812

American Soldiers in St. Augustine: Letter from the correspondence of Lieutenant Colonel Thomas Adam Smith, U.S. Army commander in Florida (1812–13), to the adjutant and inspector general on the matter of the republic of east Florida:

> *Camp Before St. Augustine*
> *5th July, 1812*
> *Sir:*
> *I have the honor to acknowledge the receipt of your favors of the 26th and 27th of May, 1st, 2nd, and 13th of June. I transmit herewith a return of the Detachment under my command for June.*
>
> *I have been informed by his Excellency Governor Mitchell that at least one hundred and fifty more Volunteers are on their way to join me. This force with the Marines on Amelia Island aided by six or eight gunboats will be sufficient to reduce the town if authority is received to take active measures in a short time.*
>
> *The Volunteers at present with me* [are] *only engaged to serve twenty days after their arrival, but I expect to be able to prevail on them to remain longer, particularly if I am authorized to reduce the town and the citadel* [Castillo de San Marcos]. *The* [Spanish] *garrison has been reinforced with one hundred blacks from Havana.*

I send herewith the copy of a contract made with Maj[or] Long for the supply of rations in this Province during the pleasure of the Secretary of War.

July 6, 1812

American Soldiers Besiege St. Augustine: In 1812, a group of Americans who called themselves the Patriots invaded Florida and seized the town of Fernandina. The Patriots were sure the inhabitants of the province would join their cause and proclaim their independence from Spain. Once independence was achieved, the Patriots planned to transfer control of the territory to the United States. Although the United States officially denied it was behind the invasion, soldiers of the United States supported the Patriots in their conquest, eventually confronting the Spanish at St. Augustine. Lieutenant Colonel Thomas Adam Smith, who commanded the American soldiers, reported:

> *The Spaniards have not altered their conduct since the arrival of the one hundred black troops and it is difficult to determine whether they or the Patriots are the most inactive. It is unfortunate that the [U.S.] Government did not authorize the taking of the town immediately on my arrival before its walls. The Spaniards were then so panic struck and badly defended that it would have fallen an easy prey. If well defended now, the lives*

of many brave men will make its possession a dear attainment. However, if prompt measures are even now taken, I conceive the Garrison will not hold out long.

July 7, 1835

President Jackson Seeks to Prevent New War With Indians: President Andrew Jackson approved a measure today to prevent traders and runaway slave hunters from entering Seminole territory in an attempt to quickly end the ongoing skirmishes between white Floridians and Seminoles. The measure was not successful, and the continued conflicts resulted in a demand by whites that the Indians be forced to leave Florida and be relocated in territory in the western part of the United States. While some Seminoles did agree to give up their Florida homes, others did not, and the U.S. Army was dragged into the Second Seminole War. The war, which lasted from 1835 until 1842, did not resolve the problem of removal, and the question would again surface in the 1850s. At that time, Secretary of War Jefferson Davis initiated a program to force the Seminoles into a final conflict. The plan called for the survey and sale of land in southern Florida to European American settlers and for a larger number of soldiers to protect the new settlers. Open warfare erupted in 1855, and the war dragged on until 1859, when all but a few hundred Native Americans had left Florida.

July 8, 1951

State Librarian and Historian Dies: Noted historian William Thomas Cash, the first state librarian, died today. A former teacher and school superintendent in Taylor County, Cash was a member of the Florida House of Representatives for several terms and a member of the state senate. From 1925 until 1928, he was the editor of the *Perry Herald*, but in April 1927, he was appointed state librarian, a post he held until his death. Cash expanded the state library from a small collection of 1,500 uncatalogued volumes to over 50,000 volumes. He took advantage of federal make-work programs during the Depression to increase the number of employees in the library and to expand its holdings. He also used the Works Progress Administration's Rare Books Project to employ the more educated unemployed people in the state to locate, transcribe and catalogue rare books in private collections. He wrote two books, *The History of the Democratic Party in Florida* and the four-volume set *The Story of Florida*. He was a leading member of the Florida Historical Society until his death.

July 9, 1835

Two-Time Florida Governor Born: William Dunnington Bloxham, who was the thirteenth and seventeenth governor of Florida, was born today in Leon County. As governor, Bloxham

inherited a state that was teetering on the brink of bankruptcy in 1881. Florida was so broke, in fact, that the state could not pay its employees or meet its bonded obligations. When the state's indebtedness threatened to derail contracts to drain the Everglades that had been negotiated by Philadelphia industrialist Hamilton Disston, Governor Bloxham was able to convince him to relieve the state's financial distress through the purchase of four million acres of public land for twenty-five cents an acre. Disston did so, and Florida was saved from bankruptcy. During his second term as governor in the 1890s, Bloxham again faced severe economic problems in the state because two consecutive years of hard freezes had devastated the citrus industry. The state's economy was revived somewhat when the American military selected Florida as its primary location for the training of troops during the Spanish-American War of 1898.

July 10, 1875

Famed Educator Mary McLeod Bethune Born: Mary McLeod Bethune was born today in Mayesville, South Carolina. After two decades as a teacher, she opened the Daytona Educational and Training School for Negro Girls in Daytona on October 3, 1904. Since she had only $1.50 in cash, it was necessary for her to scrounge to keep the school open. Describing the early days of the school's operation, Mrs. Bethune wrote, "We burned logs and used the charred

splinters as pencils, and mashed elderberries for ink...I haunted the city dump and the trash piles behind the hotels, retrieving discarded linen and kitchenware, cracked dishes, broken chairs, pieces of old lumber. Everything was scoured and mended." In 1923, the school became coeducational when it merged the Cookman Institute of Jacksonville. In 1931, it was granted junior college status, and ten years later, the Florida Department of Education approved it as a four-year college. Bethune achieved national prominence as an advisor to Franklin and Eleanor Roosevelt during the New Deal. The school is now Bethune-Cookman University.

July 11, 1969

Carpenter Appointed First President of UNF: Dr. Thomas G. Carpenter became the first president of the University of North Florida–Jacksonville today. The university was founded in 1969 when one thousand acres between downtown Jacksonville and the Jacksonville Beaches were set aside for the campus. Until this time, the only publicly funded institution of higher learning in Jacksonville was Florida Community College. Construction began in 1971, and the school opened in the fall of 1972 with an initial enrollment of 2,027 juniors. Originally, UNF was designated as a "senior" college, meaning that it could enroll only upperclassmen and graduate students. The first graduating class numbered only 35 students in 1973, but

the university quickly expanded. In 1974, it was accredited by the Southern Association of Colleges and Schools. Although there was a legislative effort to merge UNF with the University of Florida, in 1980, the bill proposing the merger was vetoed by Governor Bob Graham. Freshmen and sophomores were admitted for the first time in 1984, and by 1995, enrollment exceeded 10,000 students. The University of North Florida fields seventeen intercollegiate teams that compete at the NCAA Division I level.

July 12, 1958

Jacksonville Resident Wins Major Golf Title: Daniel David Sikes Jr., a resident of Jacksonville, won the National Public Links championship today in Chicago. He was born in Wildwood but raised in Jacksonville, and he attended Andrew Jackson High School. He attended the University of Florida and play on the school's golf team from 1951 until 1953. He was selected as an All-American in 1952—the University of Florida's first All-American golfer. Sikes graduated from Florida in 1953 and was inducted into the University of Florida Athletic Hall of Fame as a "Gator Great." He returned to school later and earned his degree from the university's College of Law. Sikes won the U.S. Amateur Public Links championship in 1958 while in law school. He turned professional in 1960 and won six tournaments on the PGA Tour, half in his home state of Florida. Sikes also

played on the Ryder Cup team in 1969 at Royal Birkdale. He was instrumental in helping organize the Senior PGA Tour, later renamed the Champions Tour, and he won three senior tour events. Sikes died in Jacksonville at age fifty-eight in 1987. He was posthumously inducted into the Jacksonville Sports Hall of Fame in 1988.

July 13, 1865

William Marvin Named Provisional Governor: William Marvin was appointed provisional governor of Florida today by President Andrew Johnson, who directed him to call a constitutional convention to write a new constitution for the state. Although the convention met in Tallahassee on October 28 and wrote a constitution, which would have become effective on November 7, it never became law since Radical Republicans in Congress assumed responsibility for Reconstruction and Johnson's program was rejected. Marvin, a native of New York, came to Florida in 1835 when Andrew Jackson had appointed him as the federal attorney for the Southern District of Florida. In 1847, James K. Polk appointed him as the federal judge for that district, a position he filled until 1863 when he resigned and moved back to New York. Although Marvin was elected to the U.S. Senate by the Florida legislature, Republicans in the Senate refused to recognize his election. He then moved back to New York permanently and died there in 1902.

July 14, 1832

Congress Appoints Committee to Find Land for Native Americans:
Today Congress appointed a three-man committee to
find a suitable area for relocating Indians from Georgia,
Alabama and Florida. The congressional action followed
the passage of the Indian Removal Act in 1830, which
mandated that Indian tribes be moved west of the
Mississippi. States had already started the process of
removal by first denying that Indians possessed the legal
rights to own land. Although the state actions were
challenged in court, federal officials refused to enforce the
court rulings, and the challenges moved to the Supreme
Court. In *Worcester v. Georgia*, Chief Justice John Marshall
ruled that the Cherokee tribe in Georgia was "an
independent nation" that deserved protection; Jackson
ignored his ruling. Indian removal was the key controversy
in the 1832 presidential election between Jackson and
Henry Clay, and Jackson's overwhelming defeat of Clay
demonstrated that more Americans supported the idea
of removal than opposed it. By 1836, the Cherokees
of Georgia and the Creeks of Alabama were forcibly
removed along the infamous Trail of Tears. Between
1835 and 1840, the federal government spent almost $500
million in an effort to remove the Seminoles from Florida.

July 15, 1902

Democratic Party Adopts Primary System: Democrats in Florida held the first ever primary election today to select candidates for state offices. The party adopted a "closed" primary system, which allowed only registered members of the Democratic Party to vote in the primary. Party leaders approved the primary system, which replaced the nominating convention system, as a way for citizens to have a voice in the political process. Although there was a Republican Party in Florida, it had few supporters and little power. Essentially, Florida was a "closed" state, and all important city, county, federal and state offices were held by Democrats. By creating a primary system that allowed only members of the Democrat Party to vote, the weak influence of Republicans was further reduced. Florida was not the only state to adopt the system of primary elections. It is still in force, and both the Democrats and Republicans utilize primaries.

July 16, 1969

Astronauts Bound for the Moon: Astronauts Neil Armstrong, Ed Aldrin and Michael Collins were launched from the John F. Kennedy Space Center today aboard Apollo 11 on a mission to land a man on the moon. Apollo 11 was the fifth manned mission of NASA's Apollo program and

fulfilled a national goal proposed in 1961 by the late John F. Kennedy in a speech urging Americans to adopt the goal "before this decade is out, of landing a man on the Moon and returning him safely to the Earth." Armstrong became the first man to step onto the lunar surface on July 21. He informed the world watching on television that it was "one small step for [a] man, one giant leap for mankind." Aldrin soon joined him on the surface. The men spent about two and a half hours outside the spacecraft, collecting almost forty-eight pounds of lunar material for return to Earth. A third member of the mission, Michael Collins, piloted the command spacecraft alone in lunar orbit. The men stayed a total of about twenty-one and a half hours on the lunar surface before returning to the command spacecraft for the trip back to Earth. They returned to Earth and landed in the Pacific Ocean on July 24.

July 17, 1821

Jackson Formally Takes Possession of Florida: General Andrew Jackson formally accepted sovereignty of Florida on behalf of the United States in Pensacola at Government House, the center of Spanish authority. American troops, led by Colonel George Brooke, for whom Fort Brooke—later Tampa—was named, exchanged courtesies with Governor Don José Cavalla to start the ceremony, and a formal exchange of ownership documents followed. According to

the document signed by Jackson and Cavalla, the United States received all

territories and dependencies of West Florida, including the fortress of St. Marks, with the adjacent islands dependent upon said province, all public lots and squares, vacant lands, public edifices, fortifications, barracks, and other buildings which are not private property, according to, and in the manner set forth by, the inventories and schedules which he has signed and delivered with the archives and documents directly relating to the property and sovereignty of the said territory of West Florida, including the fortress of St. Marks.

July 18, 2013

Florida Businessman and Corporation Found Guilty: The federal Environmental Protection Agency announced today that a Florida man and his corporation had been found guilty of deliberately destroying protected wetlands in the Sunshine State. According to the EPA news release, Brian Raphael D'Isernia of Panama City Beach and Lagoon Landing, LLC, were sentenced today in a federal court in Panama City for illegal dredging and destroying wetlands. The two defendants were ordered to pay $2.25 million, the largest criminal fine assessed for wetlands-related violations in Florida history. D'Isernia was sentenced to pay $100,000

while Lagoon Landing, LLC was sentenced to pay $2.15 million and to a term of three years' probation. D'Isernia pleaded guilty to knowingly violating the Rivers and Harbors Act by dredging an upland ship-launching basin in Allanton without obtaining a permit. Lagoon Landing, LLC, pleaded guilty to a felony violation of the Clean Water Act for knowingly discharging a pollutant into waters of the United States without a permit. Lagoon Landing was also found guilty of altering and filling wetland areas of its property without obtaining a permit and was ordered to pay $1 million to the National Fish and Wildlife Foundation, a charitable nonprofit organization created by Congress.

July 19, 1901

First School for African Americans Rebuilt: Shortly after Emancipation, a group of African Americans in Jacksonville organized the Education Society and, in 1868, purchased property to build a school to educate the children of former slaves. Financial problems delayed progress on the building, known as the Florida Institute, until December of that year, when the first school opened. The school was a wooden structure and was named in honor of Edwin McMasters Stanton, Lincoln's secretary of war who was an advocate of free schools for former slaves. Stanton School was the first school for African American children in Florida. For a number of years, the Freedman's Bureau operated the

school, and white teachers were employed by the bureau. The first building was destroyed by fire in 1882, and a replacement building was also destroyed by fire in the May 3, 1901 fire that destroyed much of Jacksonville. A new school was constructed in 1901 and remained in use until 1917, when it was replaced by a new "fireproof" building.

July 20, 1985

Mel Fisher Finds Spanish Galleon: On this day, treasure hunter Mel Fisher discovered the wreck of the *Nuestra Señora de Atocha*, the most famous ship in a fleet of Spanish ships that sank in 1622 off the Florida Keys. On September 6, a severe storm drove the *Atocha* onto coral reefs near the Dry Tortugas, about thirty-five miles west of Key West. The vessel quickly sank; only three sailors and two slaves survived. After the surviving ships brought the news of the disaster back to Havana, Spanish authorities dispatched five ships to salvage the *Atocha* and its sister ship the *Santa Margarita*, which had run aground nearby. The *Atocha* went to the bottom in about fifty-five feet of water, making it difficult for divers to retrieve any of the cargo or guns from the ship. A second hurricane in October of that year made salvage attempts even more difficult by scattering the wreckage. The wreck's location was lost for centuries, but with the aid of research by historian Eugene Lyon, Mel Fisher thought he could find it. Funded by investors who

believed his efforts would be successful and return them healthy profits, he searched for sixteen years before he found the wreck. Fisher had earlier recovered portions of the wrecked cargo of the sister ship *Santa Margarita* in 1980.

July 21, 1899

Ernest Hemingway Born in Illinois: Ernest Hemingway, noted American author and one-time resident of Key West, was born on this date. From 1931 until 1939, Key West was home to Hemingway, who had first visited the city on a visit home from Paris. He moved to Key West in 1931 and settled there with his second wife, Pauline, to write; sail his boat, *Pilar*; and fish. His home is now operated as a museum and a tourist attraction, and descendants of his six-toed cats still roam the premises. Visitors can also visit Hemingway's writing studio. After a museum visitor expressed concern about the cats' welfare, the U.S. Department of Agriculture sent investigators to the museum and subsequently ordered the operators to tag the cats for identification and provide them shelter. The museum fought the order in court but lost its case when an appeals court ruled that the cats "substantially affect" interstate commerce and thus were protected by federal laws. The cats are considered to be among Key West's most important tourist attractions.

July 22, 1839

American Soldiers Killed in a Surprise Attack: Twenty-three U.S. soldiers were killed in a surprise dawn raid by Indians on the Caloosahatchee River near present-day Fort Myers. The detachment, under the command of Lieutenant Colonel William S. Harney, was assigned to Charlotte Harbor to guard a trading post. A force of two hundred Seminoles was led by Holata Micco (Billy Bowlegs), and Chakaika, the last of the Caloosa chiefs, launched the attack, which resulted in the deaths of the soldiers. Although the Americans did not know which band of Indians had attacked the trading post, most suspected Sam Jones, whose band of Mikasuki Indians had come to a peaceful agreement with General Alexander Macomb. In order to maintain his good relations with the American soldiers, Jones promised to turn over the men responsible for the attack in thirty days. On July 27, Jones invited the officers at the fort to a dance at the Mikasuki camp. The officers declined but sent two soldiers and a black Seminole interpreter in their place. The Mikasuki killed the soldiers, but the interpreter escaped and reported that Sam Jones and another chief, Chitto Tustenuggee, were involved in the attack. By August 1839, Seminole raiding parties operated as far north as Fort White in Columbia County as the Second Seminole War continued.

July 23, 1836

Indians Attack Cape Florida Lighthouse: Seminole Indians attacked the Cape Florida lighthouse on Key Biscayne today. Assistant lighthouse keeper John W. Thompson, aided by a slave, managed to barricade the lighthouse and return fire on the attackers. During the fight, the slave was killed and Thompson badly wounded. During the attack, the Seminoles set the lighthouse afire, and Thompson retreated to the top of the structure to save himself from the flames. He found a keg of gunpowder and threw it down to the first floor, where it exploded. The Indians were certain that the men inside were dead and abandoned their attack. While grievously wounded, Thompson was still alive. He was rescued a few days later when men from the USS *Motto*, which was cruising off the coast, responded to the loud explosion and made their way to the lighthouse. Surprised to find a survivor, they went back to their ship to get equipment to scale the walls to reach Thompson. He was lowered to the bottom of the lighthouse, ferried to the waiting ship and taken to Key West to have his wounds treated. The lighthouse was repaired and put back into operation.

July 24, 1950

Army Launches Bumper 8 Rocket: Bumper 8, a captured German V-2 rocket mated with a U.S. Army WAC Corporal rocket, was launched from Cape Canaveral, thus inaugurating the American space program on Florida's east coast. The vast expanse of the Atlantic Ocean provided the distances needed for testing long-range missiles. Although another rocket combination, known as Bumper 7, was scheduled for launch first, saltwater corrosion in vital parts delayed the launch, and Bumper 8 was launched first. The test firing also marked the move of the test program from White Sands Proving Grounds to Cape Canaveral. On July 29, Bumper 7 was launched. Rocket development moved forward swiftly as a result of the test data gathered during the Bumper flights, and soon newer rockets replaced them. The V-2, which was forty-five feet long and could produce fifty-five thousand pounds of thrust at liftoff, was part of the massive lode of German technology that the United States confiscated at the end of World War II.

July 25, 1917

Themes of White Slavery Dominate American Movies: The *Jacksonville Times-Union* reported today that for only fifteen cents, readers could see Norma Talmadge starring in *Poppy* at the Imperial Theater while for the same price,

they could see *Is Any Girl Safe?* at the Rialto. The latter film was described as a "must see" because it revealed the "white slave secrets" that placed women in America at risk of being forced to become prostitutes. Norma Talmadge repeatedly played "modern" women who moved upward in socio-economic status from humble beginnings, enacting a feminine version of the American fantasy of being able to transcend one's own class origins, while *Is Any Girl Safe?* was typical of the white slavery genre that was popular in the 1910s. The popularity of the slavery movies came as a result of the publication of *McClure's Magazine*'s 1909 exposé of police corruption, slave trafficking and the demoralizing impact of urbanization. John D. Rockefeller Jr. chaired an investigation of the magazine's article and reported that there was some truth to the story. From 1913 until 1916, white slave trade pictures dominated the motion picture industry's production of films before being replaced by war movies and action films.

July 26, 1916

Popular Governor Farris Bryant Born: Cecil Farris Bryant, the thirty-fourth governor of Florida was born today in Marion County. A popular and successful politician, he was elected to the first of five consecutive terms in the state house of representatives in 1946. In 1953, he was elected as Speaker of the house. He was elected governor in 1961 and

promoted a program on improving education, particularly higher education, in the state. He pushed for the approval of a constitutional amendment that authorized the state to sell bonds for the construction of colleges. He also championed the construction of a network of modern highways throughout Florida, such as the Florida Turnpike from Fort Pierce to Wildwood, as the best way to accelerate economic and population growth in the Sunshine State. Immediately following the end of his gubernatorial term, President Lyndon Johnson appointed him to head the Office of Emergency Planning and to serve as a member of the National Security Council.

July 27, 1954

Noted Florida Female Politician Dies: Ruth Bryan Owen, the first Florida woman to serve in Congress, died today in Copenhagen, Denmark. The daughter of William Jennings Bryan, she was a vigorous campaigner who fervently embraced the cause of Prohibition. The liquor lobby used her opposition to the repeal of Prohibition to defeat her in the election of 1932. Owen was thrice married and the mother of four children. She married William H. Leavitt in 1903 but divorced him in 1909. In 1910, she married Reginald Owen, a British army officer, and followed him to several foreign posts. He was wounded during World War I, and the family moved to Florida, where he died

in 1928. Owen first ran for the Democratic nomination for Congress in Florida's Fourth Congressional District in 1926, but she lost. Two years later, she ran again and was elected. Her opponent contested the election on the grounds that she lost her citizenship when she married Owen, an alien. She argued her case before the Committee on Elections and won. Owen was appointed the American minister to Denmark in 1933 and served until 1936, when she married a Dane, Borge Rohde. In 1949, she served as an alternate representative to the Fourth General Assembly of the United Nations.

July 28, 1864

Confederate Attempt to Break Sherman's Siege of Atlanta: Confederate Floridians participated in the Battle of Ezra Church today as Major General John Bell Hood attempted to break Union general William Tecumseh Sherman's siege of Atlanta. Hiram Smith Williams, a member of the Fortieth Alabama Regiment during the war and a postwar resident of Rockledge, Florida, noted in his diary:

> *Up and off early this morning to the Arsenal in the North West part of the city. Here were rested until about 11:00 o'clock when the whole army was moved rapidly to the left…the first thing we knew, the cavalry fell back past us, and the balls falling around us showed*

that the enemy was near. Such confusion I never saw, the troops hurrying past us and forming in line of battle, while the continuous roar of musketry showed that they were hotly engaged. Falling back half-a-mile we stopped to await orders near the road, and I can truthfully say that I never saw so many wounded men in the same length of time before…A few more such affairs as this and that of the 22nd [the Battle of Atlanta] *and we will have no army left.*

July 29, 1898

Soldiers Suffer Typhoid in Miami Camp: In the U.S. Army camp at Miami, soldiers fell victim to typhoid and intestinal disorders brought about by unsanitary conditions and rations of beef packed in formaldehyde. Only 332 American soldiers were killed in combat during the war, but diseases such as typhoid and malaria killed 2,957. In 1898, thousands of U.S. volunteers were trained in the

Following page: When the Spanish-American War started, the American Army numbered fewer than fifteen thousand soldiers, but within a few weeks, more volunteers than could be handled were available. Camps were hastily constructed, frequently in scrublands or marshes, and training got underway. Many soldiers were issued woolen uniforms left over from the Civil War, which were not well suited from the semitropical climate of Florida or Cuba's tropical climate. *Tampa Bay History Center.*

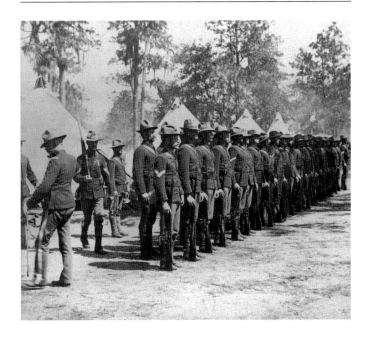

southeastern United States in camps located in scrubland or swampy areas that were unhealthy. Although army medical personnel stressed the need to maintain sanitary conditions, commanders paid little attention to sanitation. As a result of the Spanish-American War experience, the American military devised new standards for camp cleanliness.

July 30, 1956

Delta Burke Born: Hollywood actress Delta Burke was born today in Orlando. She was Miss Flame of Orlando in 1972, and in 1974, she became Miss Florida, the youngest woman to do so. She appeared on local television for several years, including a stint in the locally produced *Bozo the Clown* show. In 1980, she won the role of Bonny Sue Chisholm in the miniseries *The Chisholms*. She had recurring roles on several other televisions shows. Her role as Suzanne Sugarbaker on *Designing Women*, which won her two Emmy nominations, made her a major television star. During her tenure on the show, she feuded with producer Linda Bloodworth-Thompson and co-star Dixie Carter, which led to her being fired. Burke has continued acting in various TV guest roles and has performed in live theater. She also created a line of clothing called Delta Burke Designs. She is married to actor Gerald McRaney, and together, they operate an antique store in Collins, Mississippi.

July 31, 1863

Sidney J. Catts Born: Florida's twenty-second governor, Sidney Johnston Catts, was born near Pleasant Hill, Alabama, on this date. An ordained Baptist minister, Catts was a candidate for Congress from the Fifth District of Alabama in 1904 but failed to get elected. Catts moved to DeFuniak

Springs, Florida. In 1916, he campaigned to become the Democrat nominee for governor but lost. He then became the nominee of the Prohibition Party and triumphed in the general election. Catts's administration was turbulent and marred by several allegations of fraud and nepotism. A virulent racist, he feuded with the NAACP and refused to condemn two 1919 lynchings. Catts was defeated in his bid for the Democratic nomination for U.S. senator in 1920 and was twice defeated in efforts to regain the governorship. Allegations of criminal activities continued to dog Catts after he left public office, and near the end of his life, he was accused of being a member of a counterfeiting ring. Catts had an undeniable appeal for many Floridians and his unsuccessful races to regain political office were closely contested. Catts was credited with authoring the statement, "People in Florida have only three friends—Jesus Christ, J.C. Penney and Sidney J. Catts!"

AUGUST

August 1, 2008

Wife of Murdered Dentist Resentenced: Virginia Larzelere, the defendant in one of the most sensational murder cases in Volusia County, was resentenced by a Florida court today. She was found guilty of orchestrating the murder of her husband, dentist Norman Larzelere. Norman was shot in his office by a masked gunman, who turned out to be Virginia's son and his adopted son. Police suspected that she promised to pay her son $200,000 to carry out the killing. Jason Larzelere was charged with first-degree murder but was acquitted by a jury. The motive for the killing was thought to be a $2 million insurance policy on her husband. Although Virginia Larzelere maintained her innocence, a jury voted 7–5 for conviction and imposed the death sentence. Her death sentence was vacated in 2008, but the Appeals Court imposed the new sentence of life with the possibility of parole. She will be eligible for parole in 2033.

August 2, 1991

Space Shuttle Atlantis *Blasts Off*: STS-43, the shuttle *Atlantis*, was launched today on a nine-day mission from Cape Canaveral to launch a tracking and data relay satellite that would provide communications between Earth and low-orbiting spacecraft. The new satellite was the last of four satellites in a network that was designed to establish a system of continuous communications with American spacecraft and to eliminate electronic blind spots. Originally scheduled for July 23, the launch of *Atlantis* was rescheduled for July 24, because of minor mechanical problems on the shuttle. The new date was scrubbed because additional mechanical problems were found, and the launch was pushed to August 2. *Atlantis* carried a crew of five and was commanded by John E. Blaha. Although the crew continued to experience additional mechanical problems during the mission, they were minor and did not impact the safety of the shuttle. *Atlantis* returned to Earth on August 11.

August 3, 1763

Spain Trades Florida for Havana: In 1763, Spain transferred title to the province of Florida to Britain in exchange for the return of Havana, Cuba, which had been captured by British troops during the Seven Years' War. Almost all of the Spanish inhabitants and most of the remaining indigenous

population followed the Spanish to Cuba, leaving Florida almost completely void of people. The British divided their new possession into East Florida and West Florida and began an aggressive campaign to recruit colonists to settle the peninsula. Land grants and government subsidies were awarded to British subjects, and East Florida prospered under British rule. West Florida remained largely unsettled. During the American Revolution, most British settlers in Florida remained loyal to the Crown, and many Loyalist from the thirteen colonies in rebellion fled south to Florida. Spain, an American ally, received the province back when the British signed the Treaty of Paris in 1783, which ended the American Revolution.

August 4, 1842

Congress Approves the Armed Occupation Act: The Armed Occupation Act allowed that each settler who would agree to cultivate five acres or more of land in eastern and southern Florida for a period of five years would receive 160 acres of land and one year's rations from the federal government. Settlers were expected to provide militia service, if needed, against the warring Seminole Indians. The federal government set aside 200,000 acres for settlement and specified that all lands granted should be located more than two miles from the nearest military installation. In all, 1,184 permits were issued for some

189,440 acres. Designed to attract settlers to American Florida and to reduce military expenditures in the fight against the Seminoles, the Armed Occupation Act was a success. Historians Paul George and Joe Knetsch estimated that each permit accounted for an average of five new settlers, which meant an estimated six thousand new residents were drawn to Florida.

August 5, 1898

Yellow Fever Strikes American Army in Cuba: The War Department today ordered all non-infected American soldiers in Cuba to prepare to evacuate as soon as possible. Lieutenant Colonel Theodore Roosevelt, in a letter to the secretary of war, predicted, "If we are kept here it will in all human possibility

Opposite: African American troops, the famous "Buffalo Scouts," were trained in southern areas during the Spanish-American War, and they played an important role in the fighting in Cuba. Southerners had difficulty dealing with armed and organized black troops in their midst since the presence of such troops offered a direct challenge to the Jim Crow system of segregation. *Tampa Bay History Center.*

Page 234: Within a few weeks after the Japanese sneak attack on Pearl Harbor and the outbreak of World War II, Colonel James "Jimmy" Doolittle assembled a group of pilots to train to fly B-25 bombers off a carrier deck at Eglin Army Air Force Base in the Florida Panhandle. The group's mission was to bomb Tokyo. On April 18, 1942, the mission was carried out. *Richard Moorhead Private Collection.*

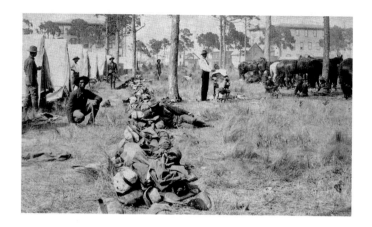

mean an appalling disaster, for the surgeons here estimate that over half the army...will die." Yellow fever struck the Americans in July and infected nearly 2,000 soldiers. An African American regiment supposedly immune to tropical diseases was sent to care for the sick. In forty days, more than one-third of the regiment's 460 men died.

August 6, 1945

Americans Use New Bomb Against Japanese: Floridians, like other Americans, were shocked by the news that the United States had obliterated the Japanese city of Hiroshima with an atomic bomb on August 5. Nevertheless, they expressed approval of President Harry Truman's decision to drop the bomb. Truman, announcing the news from aboard the

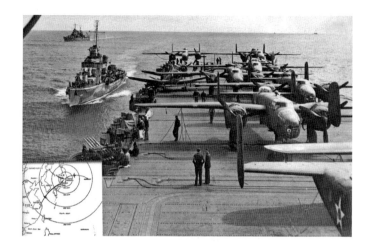

cruiser USS *Augusta* in the mid-Atlantic, said the device was more than two thousand times more powerful than the largest bomb used to date and warned the Japanese the Allies could completely destroy their capacity to make war. Unconditional surrender was a last chance for the country to avoid complete destruction, he said.

August 7, 1836

Army Abandons Fort Drane: Captain Charles S. Merchant and his men evacuated Fort Drane today because of sickness. The fort, located on the plantation of General Duncan L. Clinch, had been constructed to provide protection for

settlers in Marion County and surrounding areas. It became overcrowded following the defeat of American troops at the first Battle of the Withlacoochee and the massacre of Major Francis L. Dade's command. In April, Fort Drane had been attacked by a large force of Indians under Osceola, but it had not fallen. As civilians flocked to the fort for protection, living conditions deteriorated and dysentery and typhoid became prevalent. Fort Drane was evacuated in July and completely abandoned in August. In 1838, American troops returned, but the fort was occupied and abandoned several more times during the Second Seminole War. Despite the unhealthy conditions that persisted during the different occupations, the army considered it to be valuable for use as a supply depot.

August 8, 1896

Famous Author Born: Marjorie Kinnan Rawlings, Florida's Pulitzer Prize–winning author, was born on this date in Washington, D.C. She graduated from the University of Wisconsin–Madison with a degree in English in 1918. The next year, she married journalist Charles Rawlings and moved to Louisville, Kentucky, to write for the *Courier-Journal*. With a small inheritance, she purchased an orange grove in Cross Creek, Florida, and moved in 1928. Charles Rawlings did not enjoy living in rural Florida, and the couple divorced the same year. Rawlings saw much to write

about in the lives of the people in the area, and in 1933, she published *South Moon Under*, her first novel and a contender for the Pulitzer. In 1938, she wrote *The Yearling*, which won the 1939 prize. She married Norton Baskin, a hotel operator in Ocala, in 1941, and the couple established a residence in St. Augustine, although she continued to spend time in Cross Creek. In 1942, she published *Cross Creek*, an autobiographical account of her relationships with her neighbors that led to her being sued for slander by one of them. The court found Rawlings guilty and awarded damages of one cent to the woman who had sued her. Rawlings's final novel, *The Sojourner*, was published in 1953, just months before her death on December 14.

August 9, 1565

Menéndez Sails from Spain: The first parish priest of St. Augustine, Martin Francisco López de Mendoza Grajales, was a member of Menéndez's expedition to Florida and recorded his experiences:

> *On Thursday, August 9, about noon, we came in sight of Porto [sic] Rico, but at nightfall, the pilot being fearful lest we should run aground on the sand-banks which surround the island and its harbor, ordered all the sails to be brailed up. Next morning, however, the breeze having stiffened a little, we again set sail, and*

entered the port on Friday, St. Lawrence's Day, at about three in the afternoon. On entering the harbor, we discovered our first galley anchored there, with the San Pelago, which had become separated from us in a storm. Loud cries of joy resounded on all sides, and we thanked the Lord that He had permitted us to find each other again, but it would be impossible for me to tell how it all happened. The captains and ensigns came immediately to see us, and I regaled them with some confectionery and other things which I had brought with me.

August 10, 1956

Elvis Returns to Jacksonville: In August 1956, Elvis Presley and his band rolled into Jacksonville, Florida, to play six shows on Friday, August 10, and Saturday, August 11, 1956. Elvis had performed in Jacksonville in May of the previous year, and a mini-riot had broken out as love-struck girls clamored to touch him. On his return to the city, local law enforcement officials were instructed to stop the show and arrest Elvis if he performed any "gyrations" during his act. Police, some armed with movie cameras, attended all the performances, and some filled seats in the orchestra pit in front of the stage to prevent female fans from storming the stage. Local judge Marion Gooding, who had signed arrest warrants for Elvis if he included his famous "hip

waggling" in his act, was on hand to determine if any of the performances were indecent. Although the singer mocked the judge by wiggling his little finger at him, he refrained from shaking his hips. Elvis's subdued performances met the judge's approval, and the performances went off without any police interference.

August 11, 1953

Hulk Hogan Born: Terry Bollea, better known as Hulk Hogan, was born in Augusta, Georgia, today. As a youngster, he moved to Tampa, Florida, and then to Venice Beach, California. A massive 295 pounds, he became a professional wrestler at age twenty-three. He was a favorite when he appeared regularly on television's World Championship Wrestling programs and had thousands of young fans, known as "Hulksters," who bought merchandise that bore his image. One of the most popular toys of the 1980s and early 1990s was a "Hulk" action figure doll. When his popularity began to wane in the mid-1990s, he changed his wrestling persona from a good guy to a villain and reclaimed his fan base. From 2005 to 2009, he no longer wrestled, but he remained in the public eye with movie appearances and a reality television show, *Hogan Knows Best*, based on his family life. In 2010, Hogan was involved in a scandal when a video was released showing him having sex with the wife of his friend, shock jock Bubba the Love Sponge.

August 12, 1898

Peace Treaty Ends Spanish-American War: Floridians celebrated today when President William B. McKinley signed the Paris Peace Protocol that officially ended the war between Spain and the United States. The war had lasted 110 days. The Spanish-American War came about because of a series of escalating disputes between the two nations, most of which centered on the question of Cuban independence. Floridians were heavily involved in raising money, smuggling arms and ammunition and providing safe haven for Cuban dissidents. Cuban cigar workers in Jacksonville, Tampa, Ocala and Key West actively supported the cause of Cuban independence.

August 13, 2004

Hurricane Charley Devastates the Sunshine State: Hurricane Charley was the second hurricane of the 2004 Atlantic hurricane season and battered Florida with winds of 150 miles per hour. The storm made landfall in southwestern Florida at maximum strength, making it the strongest hurricane to hit the United States since Hurricane Andrew struck Florida in 1992. On Friday, August 13, the storm hit the Dry Tortugas, just hours after Tropical Storm Bonnie struck northwestern Florida. This was the first time in history that two tropical cyclones struck the same state in a twenty-

four-hour period. Hurricane Charley produced severe damage as it made landfall on the peninsula near Port Charlotte and continued north by northeast through the central and eastern parts of the Orlando metropolitan area with winds gusting up to 106 miles per hour. The storm exited the state over New Smyrna Beach and Ponce Inlet, just south of Daytona Beach.

August 14, 1888

Jacksonville Hit by Yellow Fever Epidemic: In late July, Jacksonville residents were informed that a visiting businessman had died from yellow fever while in the city. Over the next few weeks, the number of reported cases continued to grow, and by August 14, the entire city was panic stricken over the growing epidemic. Jacksonville's population in early July was reported at 130,000 persons, but by early September, the number of persons in the city had dropped to 14,000 as the population fled, hastily boarding ships, railroads and carriages. Although civil authorities erected barricades on roads leading out of Jacksonville, these were easily avoided and could not halt the rush of people fleeing the city. As Jacksonville's population left, cities and towns along the routes used by fleeing refugees set up quarantine stations and blockades and established patrols to keep them moving on. A few towns offered rewards to citizens who detained refugees

from Jacksonville while others proposed shooting them or tearing up railroad tracks that connected to Jacksonville. Within Jacksonville, detention camps were established to house individuals diagnosed with the disease. The outbreak lasted until November, and 5,000 individuals were reported to have contracted the disease. Of these, some 400 died.

August 15, 1934

First Emergency Relief Camp for Women Established: The first Federal Emergency Relief Administration (FERA) camp for unemployed women in Florida opened on Anastasia Island today. This camp was the first New Deal program in the South. Women experienced difficulties in finding employment during the Depression since most had never held paying jobs. The FERA established sewing rooms, canning factories and secretarial positions to provide employment. Nearly 15 percent of all FERA/WPA workers in Florida were women, and 90 percent of these were single,

Following page: Although the Florida legislature was slow to recognize the equality of women in the workforce or at the polls, it was hard to logically deny the reality that women had proven their worth during World War II by performing virtually every job in defense industries and many in the military services. *Lewis N. Wynne Private Collection.*

"I've found the job where I fit best!"

**FIND YOUR WAR JOB
In Industry – Agriculture – Business**

widowed, divorced or had been deserted by their spouses. Inadequate as the federal effort to find employment for women was, it did help.

August 16, 1898

Military Personnel Ordered Out of Key West: All military personnel were ordered out of the city of Key West today because of a possible outbreak of yellow fever. Military doctors, having no understanding of the origins of yellow fever, malaria or typhoid—the major diseases that killed soldiers—sought to avoid them by evacuating affected areas. Key West, which lacked abundant sources of fresh water for the sailors and

soldiers stationed there, was particularly susceptible to outbreaks of diseases. The naval hospital there also served as a major collection point for servicemen suffering from such illnesses, which in turn made epidemics more likely. The evacuation in 1898 was short-lived, and the military soon returned to this important port supply center.

Tampa, with its deep port and railroad connections, became the major military base for the U.S. Army in 1898. Supplies, such as these field artillery pieces, could be brought to Port Tampa and easily loaded onto ships bound for Cuba. *Tampa Bay History Center.*

August 17, 1864

Union Forces Defeated at Gainesville: The so-called Battle of Gainesville was fought today when a Confederate force defeated a larger Union detachment from the Federal garrison in Jacksonville. Gainesville, a railroad junction and depot in north-central Florida, was occupied by Union troops under the command of Colonel Andrew L. Harris. The attack was led by soldiers of the Second Florida Cavalry under the command of Captain John Jackson Dickinson. Although supported by the local militia and elements of Fifth Florida Cavalry Battalion, the Confederate force was outnumbered by the Federal troops, who were taken by surprise. After about two hours of fighting, Colonel Harris gave the order to retreat. Dickinson chose to pursue the disorganized retreating Union columns and gained a major victory. Of the 342 men in the Union force, 28 were killed, 5 were wounded and 188 were captured. Some 86 went missing or were unaccounted for. The Confederates captured 260 horses and a twelve-pound howitzer. Confederates losses were reported as 3 soldiers killed and 5 wounded, of whom 2 died the next day. Colonel Harris and 40 Union troops escaped. After hearing the account of his defeat, all the remaining Union forces in the north-central Florida area withdrew to the garrisons at Jacksonville and St. Augustine.

August 18

1871—Hurricane Strikes Near Cape Canaveral: A small hurricane with sustained winds of around one hundred miles per hour struck the Florida coast today near Cape Canaveral. A second hurricane struck south of the Cape a week later, on August 25. It was considered unusual for hurricanes to occur near the Cape—so unusual, in fact, that the absence of major storms in the area was a primary consideration when the decision was made to locate the Space Center there in the 1950s. Hurricane Charley, which hit Florida on August 13, 2004, was the most recent hurricane to pass over the Cape.

1887—Eatonville Founded: Today, only ten years removed from Reconstruction, a group of twenty-seven men, led by Joe Clark, came together for the purpose of founding what would turn out to be the first African American community incorporated in the United States. Eatonville was named for a white man, Josiah Eaton, who served as mayor of the neighboring town of Maitland. The town of Eatonville, tucked away just north of the city of Orlando, is rich in black history and home to a little more than two thousand people. Its most famous resident was the late Zora Neale Hurston.

August 19, 1977

Florida's New Capitol Finished: Construction of Florida's present capitol was declared completed on this day, and the building would be opened officially on March 31, 1978. The building has twenty-two stories above ground and three below, and the twenty-second floor contains a public viewing platform. Construction of the capitol cost $43,070,741 and required 3,700 tons of structural steel, 2,800 tons of reinforcing steel, twenty-five thousand cubic yards of concrete, twelve thousand square feet of walnut paneling, sixty-two thousand square feet of marble, sixty thousand square feet of carpet, ninety-two thousand square feet of terrazzo, fourteen elevators, 30 miles of telephone wire and 250 miles of electrical wire. In 1972, the legislature authorized money for a new capitol complex to include house and senate chambers and offices, along with the twenty-two-story executive office building. Restoration of the old capitol became an issue in 1978 when Governor Reubin Askew and house Speaker Donald Tucker urged that the building be demolished. Luckily, the old capitol building was saved and refurbished. It reopened to the public in 1982.

August 20, 1943

Historic Breakers Hotel Becomes a Military Hospital: Henry Flagler's Breakers Hotel in Palm Beach today opened as

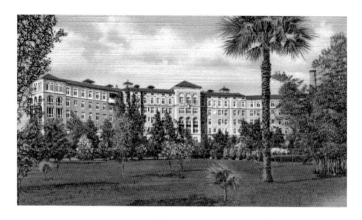

Large luxury hotels were also utilized as hospitals for servicemen wounded overseas. Some large hospitals, like this one on Davis Islands in Tampa, contained wards that were operated by military doctors and nurses. Every available space was used to accommodate the wounded. Camp Blanding, which had opened in 1939, had the largest hospital in the southern states by 1943. *Lewis N. Wynne Private Collection.*

a plastic/neurosurgery facility for G.I.s who had been wounded in action. First known as the Palm Beach Inn, it was later called the Breakers. From 1942 to 1944, the army operated the hotel as the Ream General Hospital, established to treat the expected high numbers of wounded from the Allied invasion of North Africa. Many of the other large hotels in the Sunshine State were appropriated for military use during the war years, including the many hotels in Miami Beach, the Don Cesar in St. Petersburg and the Belleview Hotel in Belleair.

August 21, 1992

Floridians in Way of Atlantic Storm: Floridians kept a wary eye open as a tropical wave over the Atlantic showed signs of developing into a major hurricane, and weather forecasters advised them to make hurricane preparations and evacuate low-lying areas. As the storm, now named Andrew, strengthened, it continued its westward movement toward the Sunshine State. On August 23, Andrew struck the Bahamas as a Category 5 hurricane. Although it weakened to a Category 4 storm briefly, it had regained its Category 5 strength by August 24 as it crossed over the warm waters of the Gulf Stream and continued toward Florida. The National Hurricane Center predicted that Hurricane Andrew would come ashore somewhere around Jupiter Inlet. High winds and heavy rains pelted Florida well in advance of the eye of the storm. Floridians braced for what was coming.

August 22, 1992

Tropical Storm Andrew Now Hurricane Andrew; Warnings Issued: This morning, Floridians were greeted by the news that Hurricane Andrew, with 110 mile-per-hour winds, was located about 500 miles east of the Sunshine State and that a hurricane watch was in force from Titusville in Brevard County to Key West. The approach of the hurricane

dominated the news, and military authorities began to evacuate vulnerable aircraft. An estimated twenty to thirty thousand tourists were vacationing in the Florida Keys and were urged to flee the low-lying islands. As thousands tried to leave the Keys, they were forced to drive the single highway connecting the Keys to the mainland, which produced a massive traffic jam. As the hurricane came closer to the Sunshine State and forecasters predicted storms surges as high as fourteen feet above normal, residents of south Florida joined the rush north to safety. Since most evacuees chose to flee by way of Interstate 95, traffic ground to a halt. Heavy rains further slowed evacuations.

August 23, 1992

Evacuations Create Chaos as Andrew Nears: Hurricane Andrew reached a Category 4 classification today; Floridians wondered where the hurricane would come ashore. The National Hurricane Center in Miami issued continuous updates that gradually narrowed the storm's expected landfall between Jupiter Inlet and Miami. Located about 300 miles east of Miami in the early morning hours, the hurricane continued to build in intensity, and winds soon reached 150 miles per hour. The size and ferocity of the storm placed most of south Florida in danger, and experts predicted the entire eastern coast would suffer high winds, high tides and heavy rains; however, by midday they had

narrowed their predictions of Andrew's landfall to the Miami area in the early morning hours. Civil officials ordered mandatory evacuations in nine counties: Broward, Charlotte, Collier, Lee, Martin, Miami-Dade, Monroe, Palm Beach and Sarasota. Despite clogged roads and gas shortages, almost 1.2 million people were evacuated inland. Though chaotic, the evacuations reduced the number of fatalities from the storm.

August 24, 1992

Hurricane Andrew Strikes as a Category 5 Storm: Hurricane Andrew hit the Florida mainland at Homestead, south of Miami. The Miami-Dade County cities of Florida City, Homestead and Kendall received the brunt of the storm, which had winds in excess of 150 miles per hour. Some 63,000 homes were destroyed, and more than 100,000 more were damaged. About 175,000 people were left homeless. As many as 1.4 million people lost their electrical service at the height of the storm. In the open Everglades, an estimated seventy thousand acres of trees were knocked down as the storm crossed the peninsula on its way to the Gulf of Mexico. Rainfall amounts in the Sunshine State were reported as high as 13.98 inches. About $25 billion in damage and forty-four fatalities were reported in Florida as the storm moved rapidly across the state. It exited the state after only four hours, and

after regaining some strength in the Gulf, Andrew struck Morgan City, Louisiana, on August 26. Overall, Andrew caused sixty-five fatalities and $26 billion in damage, which made it the fifth-costliest hurricane in history. Only Hurricanes Katrina and Wilma in 2005, Ike in 2008 and Sandy in 2012 caused more damage.

August 25, 1983

Melbourne Hit by Tropical Storm Barry: The 1983 Atlantic hurricane season was the least active season in fifty-three years. Only four of the tropical depressions formed during the June–December 1 season reached tropical storm or hurricane status. Barry formed on August 25 and crossed Florida as a tropical storm before strengthening into a hurricane and making landfall near Brownsville, Texas. The tropical storm made landfall near Melbourne on the morning of August 25, about forty miles south of Cape Canaveral, where the space shuttle *Challenger* sat on its launch pad. The storm had formed so quickly and so close to the Florida peninsula that NASA did not have time to move the shuttle to the safety of the Vehicle Assembly Building. Barry's failure to strengthen into a hurricane over Florida and its rapid exit from the state allowed NASA to proceed with the *Challenger* launch on August 30. Tropical Storm Barry in 1983 was the first of six storms and hurricanes to bear that name.

August 26, 1920

Nineteenth Amendment Added to the Constitution: The Nineteenth Amendment granting women the right to vote was formally ratified by a sufficient number of states to add it to the Constitution today. Florida did not ratify this amendment until May 13, 1969. Despite the refusal of the legislature to ratify the amendment, women had been granted the right to vote in city elections as early as 1917, when Flovilla, Moore Haven, Palm Beach and Pass-a-Grille allowed them to cast their ballots. Though the legislature would pass a law in 1921 that provided the vote to all residents in the state, it was not until 1969 that it symbolically ratified the Nineteenth Amendment—the last state to do so.

Although the Florida legislature did not ratify the amendment to the U.S. Constitution that granted women voting rights, it did not need to since enough other states ratified it and made it law. In the fifty years that passed before the legislature finally ratified the amendment, women, like this ship worker in Tampa, had empowered themselves through hard work and ingenuity. *Lewis N. Wynne Private Collection.*

August 27, 1923

Legislator Gwen Cherry Born: Gwen Sawyer Cherry, the first African American female legislator in Florida, was born today in Miami in 1923. She graduated from FAMU and taught in Miami schools for more than two decades. She returned to FAMU to get her law degree and was admitted to the Florida Bar in 1965. In 1970, Cherry was elected to the Florida House of Representatives and was reelected for three more terms. She was instrumental in creating the legislature's Black Caucus and sponsored legislation to create a state holiday in honor of Martin Luther King Jr. Cherry was active in national politics as well. During her terms in the legislature, she also taught law courses at FAMU. Cherry died in a Tallahassee car accident in February 1979. In 1986, she was inducted into the Florida Women's Hall of Fame. FAMU's College of Law dedicated a lecture hall in her honor. Gwen S. Cherry was a popular lecturer, lawyer and legislator and is recognized as a major contributor to the advances made by African Americans in twentieth-century Florida.

August 28, 1565

Menéndez Lands at St. Augustine: Pedro Menéndez de Avilés landed in north Florida today and celebrated the Feast of San Augustín. As was the custom, Menéndez gave the

location the name of the saint. Not until September 8, however, would Menéndez and his party return to found the first permanent settlement by Europeans in Florida. Father Francisco López de Mendoza Grajales recorded the event:

> *Later Tuesday, the 28th, it dawned with a calm greater than any since the beginning of the voyage. We were a league and a half from the* Captiana *and the rest* [of the ships]...*about two in the afternoon, my God provided from His mercy and sent us a good wind. Immediately with full sails we joined the* Captiana...*and God and the prayers of His Blessed Mother permitted that this same afternoon we recognized land. We drew near to discover what land it was and anchored a league off shore, and this all the rest did also. We found ourselves in Florida not far from our enemies, which was a great consolation and joy to all of us.*

August 29, 1764

James Grant, British Governor, Arrives in East Florida: Under the terms of the 1763 Treaty of Paris, Great Britain gained control of Florida in exchange for the return of the city of Havana, which it had captured from the Spanish during the Seven Years' War. Florida was divided by the British into two provinces, East Florida and West Florida. In 1763,

James Grant, a military officer who had served in South Carolina, was appointed governor of East Florida and arrived in St. Augustine to assume his duties on this date. Grant worked diligently to promote the colonization of East Florida and granted large tracts of land to colonists. Several large plantations, including the ill-fated Turnbull plantation in New Smyrna, were established during his tenure as governor. He also provided assistance to noted botanist William Bartram and his son during their explorations of Florida. When Grant became ill in 1771, he left Florida to return to Britain for medical care. He resigned his position and never returned to Florida. Lieutenant Governor John Moultrie served as governor until Patrick Tonyn was appointed to fill the vacancy created by Grant's resignation.

August 30, 1983

First Night Launch of Shuttle: STS-8 was the eighth shuttle mission and the third flight of the *Challenger* spacecraft and was the first shuttle to be launched at night. The launch also marked the first time an African American astronaut, Guion Bluford, went into space. Although originally scheduled for an earlier August 4 launch, technical problems pushed the scheduled launch to August 20. The launch was postponed once again when Barry, a quick-moving tropical storm, struck the Florida coastline just south of the Space Center. The

Challenger remained on its launch pad during the storm but suffered no damage. The shuttle returned to Earth on September 5 and landed at Edwards Air Force Base in California at night. Thus, the *Challenger* became the first shuttle to be launched and to land at night. The mission was commanded by astronaut Richard B. Truly and successfully achieved its primary mission of placing an Indian communications satellite into orbit.

August 31, 1864

Confederates Defend Atlanta Against Sherman's Army: Floridians watched anxiously as Confederate forces battled to save Atlanta from the Union army led by William T. Sherman. If Atlanta fell, Floridians felt sure an invasion of the Sunshine State would quickly follow. Hiram Smith Williams, who settled in Rockledge in 1872 and served two terms as a state senator in the 1880s, was a Confederate enlisted man during the battle and recorded his impression of the fight in his diary:

> *The ordeal is past and J*[ohn] *B*[ell] *Hood is gone under. Went to East P*[oin]*t yesterday morning, remained there all day, and this morning early came down to Jonesboro. Our infantry reached here, and charged the enemy in their works as usual, only to be repulsed with heavy loss. This horrid useless waste*

of human life, this wholesale butchery is terrible and should damn the authors through all time...Our boys have been repulsed all along the line, and I see it requires no military man to tell that Atlanta is gone.

SEPTEMBER

September 1, 1864

Atlanta Falls: Floridians watched the destruction of Atlanta by Union forces today with a great deal of dread, certain that Sherman would continue southward to Florida. This possibility continued to dominate the thoughts of Florida leaders for several weeks until it became apparent that Sherman was headed for coastal Georgia. Once again, Hiram Smith Williams commented on the outcome of the battle for the city:

> *The great struggle is over. Atlanta is being incinerated. Our* [General Stephen D. Lee's] *Corps was put in motion early this morning to march towards the city and cover the retreat of Stewart's Corps while* [General William J.] *Hardee was left at Jonesboro to hold the forces there in check. The troops are already demoralized and such straggling I never saw before.*

Proceeded to within five miles of Atlanta where we camped. Stewart's Corps is busy destroying stores in the city and report says will leave to-night. Well I am heartily glad of it and if it had been evacuated six weeks ago it would have been better.

September 2, 1935

Hundreds Dead as Storm Destroys Overseas Highway: The 1935 Labor Day hurricane was the most powerful hurricane to make landfall in the United States and the Atlantic Basin in recorded history. When the hurricane formed on September 1, federal officials worried about the safety of WPA workers building the Overseas Highway to Key West and dispatched a train to the Keys to evacuate them and their families. The train was almost swept away by strong winds before reaching the camps late on September 2, just as the storm hit the islands. Water swept over the low-lying islands as the storm surge reached twenty feet, killing an estimated 477 men, women and children. The exact number of deaths caused by the storm is unknown, and many of the dead were swept out to sea. For several weeks after the passage of the hurricane, bodies washed ashore as far away as Cape Sable. Authorities, facing a health hazard created by decaying bodies, ordered the immediate cremation of more than three hundred bodies. Many of the dead were never identified, and in 1937, a memorial was built in Islamorada to house their ashes. The

storm continued northwest and made its second landfall at Cedar Key on September 4.

September 3, 2013

Key Westers Celebrate New Swim Record: On this day, Key West residents celebrated the success of sixty-four-year-old Diana Nyad, who became the first person to swim from Cuba to Florida without the protection of a shark cage. On August 31, she jumped into the water in Havana, Cuba, and fifty-three hours later swam ashore at Key West. It was her fifth attempt at achieving this feat. Born in New York on August 22, 1949, but raised in Fort Lauderdale, she was a high school swimming champion. As an adult, she made headlines in 1975 when she swam around the island of Manhattan in less than eight hours. Three years later, she made her first attempt to swim from Cuba to Florida but was forced to give up after forty-two hours in the water. The next year, she set a record when she swam from the Bahamas to Juno Beach, Florida, a distance of 102 miles, in only twenty-seven and a half hours. Although she retired from marathon swimming after this event, she decided to make another effort to swim the Florida Straits in 2011. An asthma attack left her unable to complete the swim, and another attempt a month later also ended in failure. A fourth attempt in August 2012 had to be aborted because of stinging jellyfish and debilitating cramps.

September 4, 1935

Famous Writer Weighs In on Hurricane Deaths: Today Ernest Hemingway completed a scathing article that blamed government officials for the deaths of the World War I veterans and their families who perished in the powerful hurricane that struck the middle Florida Keys on September 2. The men had been building a highway to open a better and faster way to reach the isolated city of Key West from Miami. Until the road was completed in 1938, the only ways to get to Key West were by boat or by railroad. Most of the men died at Islamorada station when a rescue train from Miami was swept off the tracks by a tidal wave, drowning the people who were boarding boxcars. After the hurricane passed, rescuers were shocked to find bodies everywhere— floating in the water, in the debris of buildings and even in the trees. Hemingway, who lived in Key West at the time and was part of the rescue efforts, was so shocked he wrote the article condemning the federal government for negligence and the Flagler railroad for moving too slowly in attempting rescue efforts. Published in *Life* magazine, the article generated a great deal of public outrage.

September 5, 1565

Spanish and French Forces Exchange Gunfire: Pedro Menéndez de Avilés, the newly appointed Spanish *adelantado* of

Florida, encountered French Huguenot soldiers under the command of Jean Ribault at Fort Caroline at the mouth of the St. Johns River today. After a brief confrontation and an exchange of gunfire, the Spanish withdrew from the area and sailed south to a small inlet they had visited days earlier. Three days later, he formally proclaimed the founding of the Spanish city of St. Augustine. Ribault decided to pursue the retreating Spaniards with six ships and most of his soldiers. He soon arrived at St. Augustine and demanded the surrender of Spanish forces but decided to keep his ships near the coast since he was unfamiliar with the channels in the inlet. As he waited for a response to his demands, Ribault's fleet was struck by a hurricane and blown out to sea. Menéndez took advantage of the bad weather and marched against Fort Caroline, which fell four days later to the Spanish, who promptly executed more than one hundred French soldiers. Two French ships managed to escape the harbor, return to pick up survivors and sail to France.

September 6, 1930

First Publix Grocery Store Opens: On this date, George Jenkins opened the first Publix Food in Winter Haven. Five years later, he opened a second store in the same town. On November 8, 1940, he closed these stores and replaced them with the first Publix Super Market, a modern air-

conditioned store with terrazzo floors and fluorescent lighting. Among the innovations he introduced were doors controlled by an "electric eye" that opened and closed automatically. In 1945, he bought the Lakeland Grocery Company and its nineteen stores, which became Publix stores. Basing his store operations on the concept of stocking all stores from a single large warehouse, he began to expand the Publix chain throughout Florida. Today, the chain includes 1,077 stores in several southern states, which not only sell groceries but offer additional services like pharmacies, delis and bakeries. Jenkins also introduced the concept of employee ownership to the grocery business, and today, the largest block of shares in the company is owned by thousands of participating employees. The Publix Company has consistently been ranked as one of *Fortune* magazine's "100 Best Companies to Work For." Annual sales now exceed $28 billion.

September 7, 1990

Fort Pierce Girl Contracts HIV from Dentist: Today, Kimberly Bergalis of Fort Pierce identified herself as the young woman who had been infected with HIV-AIDS as a result of dental procedures performed by Dr. David J. Acer. This incident was the first known case of the clinical transmission of the deadly virus. A Fort Pierce resident, Bergalis moved to Florida from Pennsylvania with her family in 1978. Following graduation

from high school, she enrolled at the University of Florida in 1985 to pursue a degree in business administration. In December 1987, Acer, who had been diagnosed earlier as being HIV-positive, removed two of Bergalis's molars. Two years later, Bergalis began to exhibit symptoms of AIDS and was diagnosed with the disease in January 1990. When the Centers for Disease Control and Prevention investigated, it determined that the most likely source of her infection was Acer, who immediately wrote letters to all his patients asking them to be tested for HIV infection. The Florida Department of Health tested more than one thousand of his patients and discovered two others who were HIV-positive. Before her death at age twenty-three, Bergalis and her family crusaded for laws that would require medical workers to get tested for AIDS and to mandate the use of more stringent techniques of sterilization of equipment. Today, a county park in Saint Lucie County is dedicated to the memory of Kimberly Bergalis.

September 8, 1565

St. Augustine Is Founded: Francisco López de Mendoza Grajales, chaplain to the Pedro Menéndez's expedition to Florida, recorded the event:

> *Saturday, the eighth of September…the General disembarked with many banners displayed and many*

trumpets and other instruments of war, discharging much artillery. As I was on the Land since the day before, I took a cross and went out to receive them with the Psalm Te Deum Laudamus, *and the General came directly to the cross with all the rest that came with him, and kneeling on the knees on the earth they kissed the cross. There were a great number of Indians looking at these ceremonies and thus they did all they saw done. On this same day the General took possession of this land for His Majesty and all Captains swore him to be General of all this land.*

September 9, 1918

Labor Shortages Close St. Augustine Hotels: The *Jacksonville Times-Union* announced today that the season bookings had been cancelled for the Alcazar Hotel in St. Augustine and the Breakers in Palm Beach. The Ponce de Leon in St. Augustine hoped to open its season early to accommodate visitors, but a severe labor shortage was cited as the cause for the cancellations. The military draft and a mass migration of more than 500,000 African Americans to northern cities caused this significant shortage of available labor. Black men were leaving the southern states to work for the railroads and in fast-growing industrial plants in the northern states. Besides the hotels in St. Augustine, many other southern industries, including agriculture, lumber and turpentine, were hard hit. Jacksonville alone

lost 6,000 black workers during the migrations of 1916–19. In addition, the imposition of the draft, which required all men twenty-one years old or older to register for military service, further aggravated the shortage as young men of all races entered military service. Those who failed to register faced up to a year in prison, so many men did not wait to be drafted but voluntarily joined.

September 10, 1964

First Hurricane Since 1880 Hits North Florida: Hurricane Dora, the first hurricane to strike the northern part of the Sunshine State since 1880, swept across north Florida today after coming ashore near St. Augustine. With winds of around 125 miles per hour, the hurricane brought a storm surge of twelve to fifteen feet. Heavy rains, falling trees and downed power lines combined with the strong winds to wreak more than $250 million in damages. The storm came on shore about six miles north of St. Augustine in the early morning hours. Once it made landfall, it gradually weakened to tropical storm status before turning to the northeast. After lingering over the border between Georgia and Florida for more than a day, it began to rapidly accelerate over South Carolina and North Carolina before exiting the continental United States near the Outer Banks on September 14. In addition to the monetary damage it inflicted, the storm was responsible for five deaths.

September 11, 2001

President Bush in Sarasota on September 11: On this morning, President George W. Bush paid a visit to the Emma E. Booker Elementary School in Sarasota where he listened to children demonstrate their reading skills. During the presentation, Andrew Card, Bush's chief of staff, whispered the news of the first of what would be four terrorist attacks with hijacked planes. The two World Trade Centers and the Pentagon were struck by the first three planes while a fourth plane, which was suspected of targeting the White House, crashed in Pennsylvania when passengers fought the hijackers in an effort to regain control. American reaction was immediate, and all air traffic in the United States was halted to prevent other attacks. The attacks killed at least three thousand people and caused $10 billion in physical damages. Investigations by federal agencies conducted over the next few weeks identified the hijackers as members of Al Qaeda cells who had received advanced pilot training at schools in Florida. Despite multiple intelligence warnings about the possibility of such attacks, federal agencies failed to take action to prevent them. Florida would become a primary investigation site in the aftermath of the 9/11 tragedy.

September 12, 2001

Confusion Reigns After Terrorist Attacks: Floridians, like other Americans and much of the world, reacted in shock to the magnitude of the terrorist attacks on the World Trade Centers and the Pentagon the previous day. Because all aircraft were grounded as a precaution against more attacks, thousands of tourists visiting Florida attractions were unable to leave the state, and thousands more who had reservations for Florida hotels and attractions were unable—and unwilling—to attempt to reach their destinations. Overall, the loss to the Florida economy was placed at about $1 billion during the first few days after the attacks. In the United States, stock markets were closed until September 17, and investors lost an estimated $1.4 trillion. In New York City, more than eighteen thousand small businesses were closed as a result of the attacks, resulting in a net loss of wages estimated at $2.8 billion. Within hours of the attack, more than half of the nation's FBI agents were actively involved in investigating the events. They identified Mohamed Atta, whose luggage was discovered at Logan Airport in Boston, as the leader of the nineteen terrorists involved in the hijackings. They also uncovered definitive links to Al Qaeda, the international terrorist organization led by Osama Bin Laden.

September 13, 1948

Pensacola Junior College Opens Doors: Pensacola Junior College was the first public junior college created by the Florida legislature under the Minimum Foundation Program Act of 1947, signed into law by Governor Millard F. Caldwell. Jesse Barfield and Margaret Andrus helped James L. McCord, principal of Pensacola High School, prepare the initial proposal, and the Escambia County School Board received authority to establish the college. McCord became the first director of PJC, and Barfield and Andrus took positions on the faculty. The first classrooms were located in the Aiken Boarding House, and 136 students were enrolled. The president of Florida Pulp and Paper Company, James H. Allen, contributed the first two years' rent for the facility. In June 1953, the college, which was growing rapidly, moved into the old Pensacola High School. In May 1955, Governor LeRoy Collins signed a bill appropriating $1,243,000 to the college, which allowed the school to purchase a permanent campus in 1956. A college for Pensacola's African American population, Booker T. Washington Junior College, was established in 1949. In 1965, the two institutions merged.

September 14, 1898

Julia Tuttle Dies in Miami: Julia DeForest Tuttle came to the Miami area in 1875 from Cleveland with her husband, Frederick, to visit a forty-acre orange grove her father had purchased. She loved the experience but returned to Ohio with her family. In 1890, when her father died and left her his land in Florida, she sold her home in Ohio and relocated to Biscayne Bay. With money she had inherited from her father, she soon acquired more land, including the property that was once Fort Dallas. She also purchased another property and converted it into her home. In 1891, Tuttle brought her family to live there. Tuttle was active in the Miami community, acquiring more land and promoting the small town. She is known as the "Mother of Miami" for her efforts to bring more people to the area. One popular and persistent, though discredited, myth about her is that she was responsible for luring Henry Flagler and his railroad to Miami when, during a rare winter freeze, she sent him a bouquet of citrus blossoms and a promise to share her land holdings with him.

September 15, 1978

Circuit Judge Samuel Smith Impeached: Today, the Florida Senate impeached Samuel S. Smith of Lake City, a circuit court judge who had been twice convicted of engaging in

a criminal conspiracy to sell 1,500 pounds of marijuana that had been seized by the Suwannee County sheriff and his deputies. Smith was the first official in Florida to be removed from office through impeachment, although not the first to face the process. Several individuals have resigned from office rather than go through the ordeal of a public trial. Some of the officials who faced impeachment ranged from two justices of the state Supreme Court to the state's education and an insurance commissioners, but all of the accused resigned before the process could be completed. In 1973, Tom Adams, the lieutenant governor, was charged by the Florida House of Representatives with using state employees for personal gain, but the house failed to approve impeachment by the necessary two-thirds vote. It did, however, censure him for the same charge. Smith remains the only state official removed from office through the impeachment process.

September 16, 1928

Floridians Brace for Strong Hurricane: Floridians, who had experienced a devastating hurricane in September 1926, braced for another round of high winds, torrential rain, and high tides on this afternoon just two years later. The expected hurricane struck the Florida coast near West Palm Beach with a large tidal surge, winds estimated at over 150 miles per hour and ten inches of rain. Thousands

D. Collins Gillette was one of the developers of Temple Terrace, a 1920s community near Tampa. Despite the minor inconvenience of a hurricane in 1921, he believed that the Tampa would continue to prosper for decades. In 1925, he was the king of the Gasparilla Festival, a highly sought-after position by the city's wealthiest men; by the end of 1926, he was virtually penniless. He was wrong in his belief. *Burgert Brothers Collection, Tampa Public Library.*

of residents of the city were left homeless, but the disaster at West Palm Beach could not compare to the thousands of farm workers who died when the dikes around Lake Okeechobee broke after the storm moved inland.

September 17, 1928

Hurricane Kills Thousands in Florida: The hurricane that struck Palm Beach the day before continued its destructive journey across the Florida peninsula today. Farm workers living around Lake Okeechobee were unaware of the approaching hurricane that was headed their way. The storm struck the area in late afternoon, drenching the region with heavy rains and causing the lake, which had been filled to almost overflowing by heavy rains during the week before the storm, to rise by four to six feet. The dikes surrounding the lake were breached, and walls of water six to eight feet high rushed through the nearby small towns and villages. Estimates of the number of people killed ranged from three thousand to as high as ten thousand. In the heat and dampness left in the wake of the hurricane, bodies decomposed fast, and officials burned them in pyres or buried them in mass graves. Because most of the dead were African American farm workers or Bahamian immigrants, little effort was made to establish their identities. At first,

some officials downplayed the scale of the disaster because of the bad publicity Florida had received after the 1926 storm, but newspapers were soon featuring headlines that declared "Florida Destroyed!"

September 18, 1926

Hurricane Devastates Miami and South Florida: The Category 4 hurricane that devastated Miami today brought a sudden halt to the Florida land boom. The hurricane struck with winds in excess of 145 miles per hour, and heavy rains destroyed homes, public buildings and construction sites. Miami and Coral Gables, which had been promoted as America's paradise, lay in ruins, and thousands of investors who had purchased homes and tracts of land abandoned the state, leaving their monetary commitments behind. Although promoters attempted to revive the boom, an even more destructive hurricane hit the state two years later, ending any chances for a revival.

Following page: Tourists headed for the resorts in south Florida during the 1920s frequently traveled by rail. The Florida East Coast Railway provided comfortable berths for overnight journeys, first-class dining cars and even club cars where travelers could relax and enjoy smoking or having a drink. *Lewis N. Wynne Private Collection.*

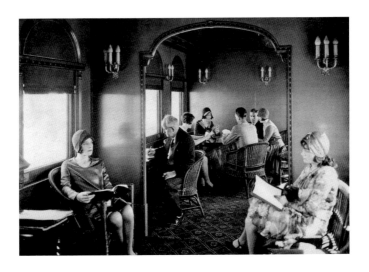

September 19, 1863

Florida Troops in Battle of Chickamauga: Confederate general Braxton E. Bragg made the opening move in the Battle of Chickamauga campaign when he moved most of his army out of Ringgold, Georgia, and into Tennessee. Florida units that participated in what would become an epic battle were the Marion Artillery, the First Cavalry Regiment, the First (Reorganized) Infantry regiment, the Third Infantry Regiment, the Fourth Infantry Regiment, the Sixth Infantry Regiment and the Seventh Infantry Regiment. The Battle of Chickamauga officially began with skirmishes between the Union troops of General

George H. Thomas and those of Confederate cavalry leader General Nathan Bedford Forrest. Confederate military leaders ordered General James Longstreet and his troops from Virginia to reinforce Bragg's army, and his arrival on the second day of the battle ensured a southern victory, although the Confederate casualties were greater. The Union army retreated to defensive positions around Chattanooga. Union casualties for the two-day battle were 1,657 killed, and the Confederate army lost 2,312.

September 20, 1565

Menéndez Describes His Victory to Spanish King:

> *His Divine Majesty had mercy upon us and guided us in such a way that without losing one man and with only one injured (who is now well), we took the Fort with all it contained, killing about two hundred and thirty men; the other ten we took as prisoners to the forest. Among them were many noble men, one who was Governor and Judge, Called Monsieur Laudonnier, a relative of the French Admiral, and who had been his steward. This Laudonnier escaped to the woods and was pursued by one of the soldiers who wounded him, and we know not what has become of him, as he and others escaped by swimming out to two small boats of the three vessels that were opposite the Fort, with about fifty or sixty persons. I sent them a*

cannonade and call of the trumpet to surrender themselves, vessels, and arms. They refused, so with the artillery we found in the Fort we sank one vessel; the others taking up the men went down the river where they had two other vessels anchored laden with provisions, being of the seven sent from France, and which had not yet been unloaded. It did not seem to me right to leave the Fort and pursue them until I had repaired three boats we found in the Fort.

September 21, 1823

Seminoles Depart Moultrie Creek After Treaty Signed: Seventeen days after their first arrival at Moultrie Creek and following the signing of a peace treaty on September 18, Seminoles departed the area bearing gifts from the American negotiators. The Treaty of Moultrie Creek established a reservation system for Florida Seminoles in the center of the peninsula. The approximately 425 Seminoles who attended the meeting chose Neamathla, a prominent Mikasuki chief, to be their chief representative and speak for them. Under the terms of the treaty, the Seminoles were to place themselves under the protection of the United States and give up all claims to lands in Florida in exchange for a reservation of about four million acres. The reservation would run down the middle of the peninsula from Ocala to around present-day Lakeland, away from the coasts and outside the reach of traders from the Bahamas and Cuba.

Six of the chiefs were allowed to keep possession of tribal lands and villages in areas along the Apalachicola River. Under the Treaty of Moultrie Creek, the U.S. government was obligated to protect the Seminoles as long as they remained peaceful and law abiding, but the terms of the treaty were quickly broken as white settlers moved south and encroached on reservation lands.

September 22, 1958

New Engineering College Opens in Brevard County: The Florida Institute of Technology held its first classes on this day with 154 "missile men" enrolled. The Florida Institute of Technology is a private research university located on a 130-acre campus in Melbourne. Founded as the Brevard Engineering College, the university adopted its present name in 1966. FIT, as it is popularly referred to, has an on-campus student body of about 5,000 and currently boasts more than 60,000 alumni worldwide. With its emphasis on science and technology, FIT is consistently ranked among the top colleges in the United States. The college has five academic divisions and offers a number of graduate and undergraduate programs. Among its graduates are a National Teacher of the Year recipient, five astronauts who have flown in space shuttles, the first female four-star general, two other four-star generals, a 1992 Olympic medalist and a major-league pitcher.

September 23, 1930

Ray Charles Born: Although singer Ray Charles Robinson was born in Albany, Georgia, his family moved to Florida when he was about six months old. His father abandoned the family, leaving them to struggle financially. Beginning at age five, Ray began to lose his eyesight to glaucoma, and when his mother died when he was fifteen, he was sent to the State School for the Deaf and Blind in St. Augustine. At the school, he began to develop his musical talents, eventually mastering the piano and organ. After graduation, he began to play in nightclubs in Florida but soon moved to Seattle. He continued to work as a musician, and his career direction was firmly established. To avoid any confusion with boxer Sugar Ray Robinson, he dropped his last name and became just Ray Charles. He played club dates and cut records, but it was not until the 1960s that he gained an international audience with songs like "What'd I Say," "I've Got a Woman" and "Georgia." The latter song was adopted as the official song of that state. Ray Charles died in 2004.

September 24, 1565

Spanish Return to St. Augustine: Francisco López de Mendoza Grajales, chaplain to Pedro Menéndez's expedition to Florida, recounts the return of Menéndez to St. Augustine following his victory at Fort Caroline:

So today, Monday the 24th, at the hour of vespers, our good General [Menéndez] entered, accompanied by 50 foot soldiers, and they stumbled and were very tired…The news made known, I quickly went to my house and took out a new cassock, the best I had, and a surplice and I took a crucifix in my hands and went out to receive him at a distance before he arrived at this port. He, like a good Christian gentleman, before I reached him, threw himself on his knees with all the rest that came with him, giving thanks to Our Lord for the great mercies received…So great is his zeal and Christianity that all these works are rest for his spirit. Certainly it appears to me that there could not be human strength to endure so much…The fire and desire he has to serve Our Lord in throwing down and destroying this Lutheran sect, enemy of our Holy Catholic Faith, does not allow him to feel weary in the work.

September 25, 2004

Sunshine State Pummeled by Successive Hurricanes: For Floridians, 2004 was the hurricane season to end all hurricane seasons. Hurricane Jeanne struck the peninsula today, just two miles from where Hurricane Frances had struck weeks earlier. The Sunshine State had been hit by three previous storms that had wreaked millions of dollars in damage and had

accounted for more than forty deaths. Jeanne was originally not expected to come ashore in Florida, but forecasters changed their minds when the hurricane took a westward turn. Jeanne hit near Stuart with maximum sustained winds of 120 miles per hour. Rain from previous Hurricanes Frances, Ivan (a Category 5 storm) and Charley, plus two tropical storms, had saturated the ground, and Jeanne brought near-record-level floods. Floridians, seeking to evacuate to safe venues prior to the storm coming on shore, headed to Key West in a strange reversal of normal patterns. Jeanne produced billions of dollars in damages to property in Florida, accounted for extended outages of electricity in central Florida and resulted in four deaths in the Sunshine State.

September 26, 1960

University of South Florida Opens: The University of South Florida opened to a charter class of 1,997 freshmen today on a campus that was part of Henderson Air Field, a World War II base. John Allen was the first president and served until 1970. The university was founded in 1956 but was not opened until four years later after suitable buildings were constructed and faculty and staff members hired. The university expanded rapidly, adding a full array of undergraduate programs, some advanced degree programs, a medical school and several regional campuses. USF now

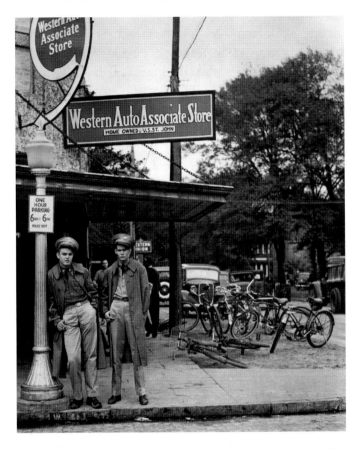

Two million trainees flooded the cities, towns and village of Florida during World War II, creating problems for local law enforcement officials. This iconic picture shows two trainees on the street in Starke, which was adjacent to Camp Blanding. Camp Blanding became the fifth-largest city in Florida because of the huge number of trainees who came and went. *Florida Memory Project, Florida State Photographic Archives.*

has a student body in excess of 48,000 and fields a variety of athletic teams.

September 27, 1864

Confederates Defeated at Marianna: After ignoring much of north Florida for most of the Civil War, Union forces operating out of Pensacola with the support of naval ships along the coast became more aggressive in 1864. General Alexander Asboth moved east with a force of Union soldiers and attacked the hastily prepared Confederate defenses at Marianna today. The following description of the action was offered by William Watson Davis in *Civil War and Reconstruction in Florida*:

> *The raiders come up rapidly. They sweep aside the barricade with artillery and follow this with a determined charge by the 2nd Maine Cavalry. The Confederate force breaks up. Some flee through the town for the Chipola river beyond. Some take refuge in the Episcopal church near the barricade and continue the fight from its windows. A torch is thrown against the church. It took fire. As its occupants rush from the burning building they are shot down and fall amid the gravestones of the churchyard. Some of the boys are burned to death in the church. At the bridge across the Chipola a*

desperate resistance beats back the Federal advance. Marianna is plundered.

September 28, 1953

Governor McCarty Dies in Office: Governor Daniel Thomas McCarty died today from complications from a heart attack suffered in February. A native of St. Lucie County, McCarty was born in Fort Pierce on January 18, 1912, and attended public schools in St. Lucie County. He graduated from the University of Florida in 1934 and was active in the citrus and cattle industries. Entering politics, he represented St. Lucie County in the Florida House of Representatives for several terms. In 1941, he became the Speaker. McCarty sought and lost the Democratic gubernatorial nomination in 1948 but came back to win the Democratic primary in 1952 and the general election that followed. He took office on January 6 but suffered a disabling heart attack on February 25. He died in Tallahassee. Charley Eugene Johns, president of the senate, became the acting governor of Florida following McCarty's death but later returned to the senate. Johns earned notoriety in the early 1960s when the "Johns Committee" conducted a McCarthy-like investigation of the influence of Communists and homosexuals in Florida's educational system. The notorious "Purple Book," which detailed the alleged practices of homosexuals, became the

handbook of Johns's supporters and a widely circulated pamphlet in Florida's gay community.

September 29, 1565

Menéndez Describes Execution of French at Fort Caroline:

> *We had taken their Fort and hanged all those we found in it, because they had built it without Your Majesty's permission and because they were scattering the odious Lutheran doctrine in these Provinces…[t]hat I would not give them passage; rather would I follow them by sea and land until I had taken their lives…[T]here came a gentleman, a lieutenant of Monsieur Laudonnier, a man well versed and cunning to tempt me. After much talk he offered to give up their arms if I would grant their lives. I told him he could surrender the arms and give themselves up to my mercy, that I might do with them that which our Lord ordered. More than this he could not get from me… Thus he returned and they came to deliver up their arms. I had their hands tied behind them and had them stabbed to death, leaving only sixteen, twelve being great big men, mariners whom they had stolen, the other four master carpenters and caulkers—people for whom we have much need, and it seemed to me to punish them in this manner would [be] serving God, our Lord, and Your Majesty.*

September 30, 1967

Sixteen-Year-Old Sets Swim Records: Catie Ball, a sixteen-year-old swimmer from Jacksonville, today set two world swimming records at the U.S.–Great Britain International Swim Meet in London. Ball's 1:17:0 for the 110-yard breast stroke and 2:46:9 for the 220-yard breast stroke were the fastest times recorded to that point for these two events. She won a gold medal in the 1968 Summer Olympics in Mexico while suffering from a severe case of influenza. Ball, who was the dominant female breast stroke swimmer of her generation, attended Lee High School and participated in competitive swimming. In December 1966, she tied the world record of 1:15.7 in the 100-meter breast stroke at the international swim meet at the Hall of Fame pool in Fort Lauderdale, Florida. After the 1968 Olympics, she attended the University of Florida and, while she was a senior, was hired as the head coach of the women's swim team. Her Lady Gators were undefeated in dual meets and placed second at the AIAW national championship during her single-season tenure as coach. She was inducted into the International Swimming Hall of Fame in 1976 and into the Florida Sports Hall of Fame in 2010.

OCTOBER

October 1, 1971

Walt Disney World Opens: Although the Florida Highway Patrol had estimated the opening-day crowds at Orlando's Walt Disney World would exceed 300,000 people, the reality was that a small crowd of only 10,000 persons was on hand when the gates opened. Within a month, more than 400,000 people had paid their entrance fees and visited the Magic Kingdom. Disney executives stated they were pleased with the small crowd because it allowed them to fix any problems that surfaced with a minimal

Following page: Businesses of all kinds supported the war effort. The Walt Disney Corporation, for example, made many friends who would patronize its theme parks later by allowing its artists to develop patches and insignias of various kinds, such as this logo for the Mayport Naval Air Station near Jacksonville. *Lewis N. Wynne Private Collection.*

inconvenience to guests. The opening was the culmination of seven years of planning, construction and training of some 5,500 employees. The official dedication was not held until October 25.

October 2, 1916

Fellsmere Public School Opens: Fellsmere is the oldest school building in Indian River County and cost a grand total of $40,000 to build. It was constructed of masonry, contained 22,680 square feet of floor space, and was designed by architect Frederick Homer Trimble. A short railroad was built for the transportation of building supplies from the main line of the Fellsmere Farms Railroad to the construction site. The school welcomed 136 students on opening day with a staff of seven teachers, including Principal Anderson A. Price. The facility was used as a school until 1964. It later became the Fellsmere City Hall and police station. Fellsmere was a booming agricultural community at one time but has fallen on hard times. It is the home of the annual Fellsmere Frog Festival, an event that draws nearly 50,000 visitors each year.

October 3, 1905

Florida's Thirtieth Governor Born in Blountstown, Florida: A graduate of the university of Florida, Fuller Warren was a political prodigy and was elected at age twenty-one to Florida's House of Representatives while still a student at the university. Trained as a lawyer, he opened his practice in Jacksonville and served on the city council from 1931 until 1937. In 1939, he was again elected to the state house

of representatives. A member of the KKK before World War II, he won the nomination and election for governor in 1948 by campaigning against racism and segregation. During his tenure as governor, he established the state turnpike system and signed the fencing law, which required livestock owners to prevent their animals from wandering freely. He also started the state's reforestation program. Faced with impeachment in 1951 for his involvement with criminal elements, he managed to escape when the house of representatives failed to approve the articles of impeachment. After his term was over, Warren moved to Miami and resumed the practice of law. In 1956, he ran for governor again on a platform of preserving segregation. He was defeated by LeRoy Collins. He died in 1973.

October 4, 1817

Freebooter Aury Takes Control of Amelia Island: Louis-Michel Aury was a Parisian who served in the French navy until he deserted. He became a mercenary working with the revolutionaries in the Spanish colonies in South America and aided their efforts by attacking Spanish ships. He was employed by Simón Bolívar, the leader of the revolutionaries, but left over a disagreement about pay. Aury moved north and accepted a position as resident commissioner of Galveston Island from the fledgling Republic of Mexico. He later declared Galveston to be an

independent republic in 1816. Aury lost the island when another French privateer, Jean Lafitte, took control of it while Aury was away on business. He attempted to establish another base at Matagorda Bay, but when that failed, he left to join the Scottish adventurer Gregor MacGregor in attacking Spanish Florida from Amelia Island. MacGregor left the island in late 1817, but Aury remained and proclaimed the island an independent republic. A month later, however, the arrival of the U.S. Army forced Aury to leave as well.

October 5, 1916

Florida Folklorist Stetson Kennedy Born: Controversial journalist and folklorist Stetson Kennedy was born today in Jacksonville. He died on August 27, 2011. Stetson was an award-winning author and human rights activist whose friendships extended worldwide and included individuals such as Erskine Caldwell, Woody Guthrie and Zora Neale Hurston. As an author, he published several books, including *After Appomattox*, *Palmetto Country*, *Southern Exposure*, *The Jim Crow Guide* and *The Klan Unmasked*. He was also the coauthor, with Peggy A. Bulger and Tina Bucuvalas, of *South Florida Folklife*. After leaving the University of Florida in 1937, he joined the staff of the WPA Florida Writers' Project and, at the age of twenty-one, was put in charge of folklore, oral history and ethnic studies. In the late 1940s and early 1950s, Kennedy infiltrated the

Ku Klux Klan and other white supremacist groups and exposed their inner workings in his writings. Although he was accused of appropriating materials from other activists and embellishing his role against the Klan in later years, he remained a revered figure among social activists and civil libertarians. He was a founding member and president of the Florida Folklore Society and was inducted into the Florida Artists Hall of Fame.

October 6, 1891

Florida's New Deal Governor Born: The twenty-sixth governor of Florida, David Scholtz, who presided over Florida's government in the early years of the New Deal, was born today in Brooklyn, New York. He was educated at Yale and Stetson Universities. After service in the navy during World War I, Scholtz was elected to the Florida House of Representatives. Elected as governor in 1933, Scholtz was a strong supporter of Roosevelt's New Deal, which earned him powerful enemies in the state and effectively ended his political career. In 1938, he lost a bid for a U.S. Senate seat. Scholtz died on March 21, 1953, while visiting the Florida Keys.

Opposite: Workmen employed by the Works Progress Administration did all kinds of jobs. Here two men "rive" shingles for use on public buildings constructed by the WPA and the Civilian Conservation Corps at the Withlacoochee Land Reclamation Project. *Lewis N. Wynne Private Collection.*

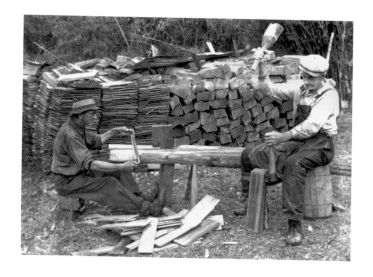

October 7, 1763

Florida Divided by British: On this date, British Florida was divided into East and West Florida along the Chattahoochee-Apalachicola River. Great Britain, which had acquired Florida from Spain this year, viewed the territory differently than the Spanish and the Americans did. Florida was, in the British mind, two states—West Florida included most of the Florida panhandle, as well as British territory in present-day Alabama, Mississippi and Louisiana, while East Florida comprised most of modern-day Florida. Since the newly acquired territory was too large to govern from one administrative center on the east

coast of the peninsula, the British divided it into two new colonies. Both colonies remained loyal to the British during the American Revolution, and when Great Britain signed a treaty with the newly formed United States in 1783, Spain again gained control of Florida. This was Spain's reward for having supported the Americans in their fight against the British Crown.

October 8, 1885

Land Cleared for Ybor City Streets: Today the first trees were cleared for streets in Ybor City, the Tampa suburb that would become the center of cigar production in the United States for more than seventy-five years. Cigar maker Vicente Martínez Ybor purchased land on the outskirts of Tampa. Other cigar manufacturers joined Ybor, and soon, the new town, now called Ybor City, had a booming population of sixteen thousand Spanish, Cuban, Italian, German and Afro-Cuban workers. An estimated 500 million hand-

Opposite: Cigar workers sort tobacco leaves in an Ybor City factory. Beginning in the 1880s, cigar production fueled the economy of Tampa and filled Ybor City with Italian, German, Spanish and African Cubans who worked rolling the cigars. A separate cigar city, West Tampa, was almost as large, and it, too, added to the bustling economy of Tampa. *Burgert Brothers Collection, Tampa Public Library.*

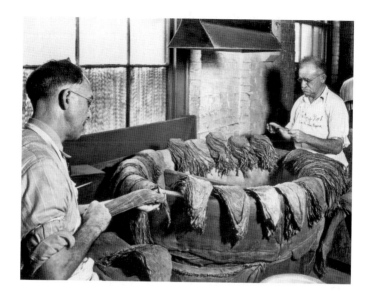

rolled cigars were produced each year. Mechanization ended the growth of Ybor City, and today, this suburb of an expanding Tampa is an entertainment district.

October 9, 1913

Navy Selects Pensacola for Aviation Training: Secretary of the Navy Josephus Daniels appointed a board to recommend a site for naval aviation training. Pensacola was eventually chosen as the best location, and thus began that city's long association with naval fliers. By

1917, Pensacola was operational, and by the end of World War I, the base had almost five hundred officers permanently assigned and had trained more than one thousand pilots in aircraft of all kinds. Although training slowed after the war, the base continued to expand as the navy experimented with aircraft carriers in the 1920s and 1930s. As nations moved more and more to include naval aviation as part of their armed forces, the United States expanded its training programs for naval fliers, and additional bases were created at Jacksonville, Florida, and Corpus Christi, Texas. With the entry of the United States into World War II, other temporary sites were built for pilot training. By the end of the war, the United States had more pilots and more aircraft carriers than any other nation. Pensacola remained the principal training base, however, during the postwar years and was known as the "Annapolis of the Air."

October 10, 1963

Causeway Named for Korean War Medal of Honor Winner: The Emory Bennett Causeway, State Road 528 across the Indian River, was opened today and formally dedicated by Governor Farris Bryant on October 17. Bennett's mother cut the ribbon at the dedication ceremonies. Bennett's Medal of Honor citation reads:

At approximately 0200 hours, 2 enemy battalions swarmed up the ridge line in a ferocious banzai charge in an attempt to dislodge Pfc. Bennett's company from its defensive positions. Meeting the challenge, the gallant defenders delivered destructive retaliation, but the enemy pressed the assault with fanatical determination and the integrity of the perimeter was imperiled. Fully aware of the odds against him, Pfc. Bennett unhesitatingly left his foxhole, moved through withering fire, stood within full view of the enemy, and, employing his automatic rifle, poured crippling fire into the ranks of the onrushing assailants, inflicting numerous casualties. Although wounded, Pfc. Bennett gallantly maintained his one-man defense and the attack was momentarily halted. During this lull in battle, the company regrouped for counterattack, but the numerically superior foe soon infiltrated into the position. Upon orders to move back, Pfc. Bennett voluntarily remained to provide covering fire for the withdrawing elements, and, defying the enemy, continued to sweep the charging foe with devastating fire until mortally wounded.

October 11, 1887

"Barefoot Mailman" Drowns on Duty: James E. "Ed" Hamilton, one of the famed "barefoot mailmen" who delivered mail between Lake Worth/Palm Beach and Miami, disappeared

while on his route today and was thought to have drowned. Hamilton was one of several mailmen who delivered mail along the route and who made their rounds on foot and by boat because no road connected the sixty-eight-mile route from Palm Beach to Miami. Hamilton was the third carrier on the route, which had been established in 1885 when Edwin Ruthven Bradley, a Lake Worth resident, won the postal contract with a bid of $600 per year. Bradley and his son, Louie, took turns carrying the mail once a week for about two years but surrendered the contract to Hamilton two years later. After Hamilton's disappearance, Andrew Garnett, who had previously been the postmaster at Hypoluxo, successfully bid for the barefoot route contract. Charles W. Pierce substituted for Garnett when he could not travel the route. Henry John Burkhardt was the last barefoot mailman. The original postmen were called "beach walkists" or "beach walkers," and the term "barefoot mailman" did not become popular until the publication of Theodore Pratt's book by that name. The book was later made into a movie.

October 12, 1565

French Admiral Jean Ribault Executed: French admiral Jean Ribault, along with about two hundred of his men, was put to death by Pedro Menéndez de Avilés and Spanish soldiers on the banks of the Matanzas River near St. Augustine.

Menéndez, who had been charged by the Spanish king with the task of eliminating the French Huguenots who had established Fort Caroline in Florida, took his charge seriously and followed through with his orders. Of Ribault, who had just returned from France to resume leadership of the French colony, Menéndez reported to King Philip II of Spain:

> *I had Jean Ribault with all the rest put to the knife, understanding this to be expedient for the service of God our Lord and of Your Majesty; and I hold it very great good fortune that he should be dead; for the King of France could do more with him with fifty thousand ducats than with others with five hundred thousand; and he could do more in one year than another in ten, for he was the most experienced seaman and corsair known, and very skillful in this navigation of the Indies and the coast of Florida.*

October 13, 1947

Weeki Wachee Attraction Opens: Weeki Wachee Springs, located in Hernando County, Florida, opened today as a tourist attraction featuring young women dressed as mermaids and breathing from air hoses in performances. The brainchild of professional stunt swimmer Newt Perry, the attraction made use of a natural spring and offered boat rides,

swimming and other activities. During the 1950s, Weeki Wachee was one of the most popular tourist attractions in the Sunshine State, but it gradually lost most of its patrons to the theme parks in the Orlando area. The water park was a prime location for shooting films and television programs. When the park began to lose its visitors, it was purchased by ABC Television, which attempted to revive interest in the venue by featuring it in some of the network's series. The state acquired the attraction in November 2008 and now operates it as a park. Featuring a Class 1 natural spring with a depth of 407 feet, Weeki Wachee Springs is the deepest freshwater cave system in the continental United States. Guests to the park have included Elvis Presley, Ester Williams, Arthur Godfrey and Don Knotts.

October 14, 1964

Hurricane Isbell Comes Ashore as Category 2 Storm: Hurricane Isbell made landfall in Florida today as a Category 2 hurricane with winds of 125 miles per hour. After coming ashore near Everglades City, the storm swept across south Florida before exiting on the Atlantic coast. Once the hurricane reached the ocean, it turned north and gradually weakened. It became a tropical storm with 45-mile-per-hour winds on October 16 before moving inland again at Morehead City, North Carolina. Although the damage from Isbell was generally regarded as light, it did generate

a number of tornadoes. Twelve house trailers, a house and the roof of the local Catholic church were destroyed as a result of one of the tornadoes striking the small town of Eau Gallie on the Indian River Lagoon. Human casualties were also minimal. One person reportedly suffered a heart attack and died while working to board up his home in preparation for the hurricane, and thirty-seven persons were injured because of the storm.

October 15, 1964

Jacksonville Native Bob Hayes Wins Olympic Gold: Robert Lee "Bullet Bob" Hayes, a native of Jacksonville, became the "Fastest Man in the World" today as he raced to a gold medal in the Tokyo Olympic Games. Hayes, who attended Matthew Gilbert High School in Jacksonville, was a standout as a football player for Florida A&M University, but he excelled in track events. As a track star, he was the first person to run the 60-yard dash in under 6.0 seconds, setting a record of 5.9 seconds. He established a new record for the 100-yard dash in 1962 when he completed the distance in 9.2 seconds. He broke his own record the next year with a time of 9.1 seconds. In the Tokyo Olympics, he competed in the 100-yard dash and as a member of the 4 x 100 relay team, winning gold medals in each event. After the Olympics, he concentrated on becoming a receiver for the Dallas Cowboys. He was so fast as a player that

opposing teams were compelled to develop special defenses to stop him. He died in 2002 and was inducted in the Pro Football Hall of Fame posthumously in 2009.

October 16, 1963

NASA Investigates Scandal: Today was a busy day at the Space Center at Cape Canaveral. Twin *Vela Hotel* satellites, designed to detect nuclear explosions in space at a maximum range of 100 million miles, were successfully launched by the Department of Defense. Major Donald K. "Deke" Slayton, one of the original seven Mercury astronauts, resigned his commission in the U.S. Air Force to become a civilian pilot for NASA, which would allow him to be eligible for further space flights. On another front, NASA announced an investigation of "possible improprieties" by a contractor, Management Services, Incorporated, which leased automobiles to the agency. The company was accused of selling automobiles that had been used for only two to three years to NASA employees for as little as $50.00, and some of the automobiles sold were reported to have been driven as few as 50 miles. Local General Motors dealer, Jim Rathman, had raised eyebrows when he offered astronauts the opportunity to drive Corvette sport cars through a "special" lease program in 1962.

October 17, 1943

First Producing Oil Well in Florida in Collier County: Humble Oil Company today announced that it had brought in the first producing oil well in Florida at the Sunniland Field in Collier County. Oil exploration in the state had been ongoing since 1901, when the first "dry holes" were recorded. In 1941, the Florida legislature offered a bonus/reward of

Small and large factories flourished in Florida during World War II, and the state became industrialized. Many small businesses, like this foundry, received government contracts that allowed them to grow and buy new equipment. Labor was scarce during the war, but new efficiencies were found, and needed goods rolled off the assembly lines. *Richard Moorhead Private Collection.*

$50,000 for the first oil well in the state that produced oil in commercial quantities. Since 1943, the Sunniland Field has produced more than 120 million barrels. Florida now has 162 producing wells in six counties. During the gas crisis of the mid-1970s, Florida oil production peaked at 45 million barrels a year but has since declined to less than 2 million barrels annually.

October 18, 1906

Hurricane Strikes Keys and Miami: A major hurricane hit the Florida Keys this evening after having crossed Cuba. It then swept northward to strike Miami, moved out into the Atlantic Ocean, made a looping move off the coast of South Carolina, strengthened and struck the Florida coast again near St. Augustine. It diminished to a tropical depression as it passed over the Sunshine State before exiting into the Gulf of Mexico near Fort Myers. The hurricane was responsible for 240 deaths, of which 135 were workers building the Florida East Coast Railway's over-water extension to Key West. In the Keys, several supply ships and other boats were destroyed, including a dormitory boat in which 104 workers drowned when it capsized. The FEC reported damages in excess of $200,000, and work was disrupted for almost a year while equipment was repaired and new equipment brought in. The overseas extension was not

completed and rail service to Key West established until 1912. Pineapple plantations in the Keys were devastated, and that industry simply ceased to exist. More than one hundred homes were destroyed in Miami, and Jupiter and Fort Pierce, north of that city, also reported heavy damage. As the storm made a second pass over the state, flooding and wind damage was reported in St. Augustine and other inland towns.

October 19, 1910

Original "Bull 'Gator" Born: The original "Bull 'Gator," Ben Hill Griffin Jr., was born today in Tiger Bay near Fort Meade as a hurricane raged. He attended Frostproof High School and then the University of Florida but left before graduating. He returned to Frostproof and entered the citrus business with a ten-acre grove. At the time of his death in 1990, he was listed as one of *Forbes* magazine's four

Following page: When the real estate boom collapsed in 1926–28, another key component of Florida's economy, the citrus industry, collapsed as well. Developers had the hurricanes to blame; citrus farmers could blame an infestation of the Mediterranean fruit fly, and even spraying did not help the citrus groves. Cattle ranchers did not fare much better: ticks and screwworms made the bottom drop out of cattle production. Yet some citrus farmers survived and prospered. *Burgert Brothers Collection, Tampa Public Library.*

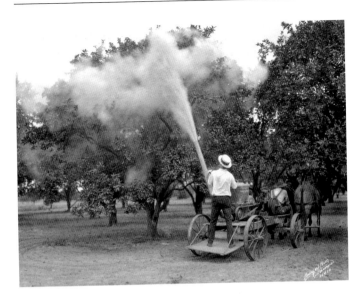

hundred richest Americans, with estimated assets of $390 million. Over the years, he donated more than $20 million to the University of Florida. In 1989, Florida Field, the university's football stadium, was officially renamed Ben Hill Griffin Stadium.

October 20, 1950

Tom Petty Born in Gainesville: Thomas Earl "Tom" Petty is an American musician, singer, songwriter, multi-instrumentalist and record producer. He is best known as the lead vocalist of the group Tom Petty and the Heartbreakers.

In the late 1980s, he was a co-founder of the Traveling Wilburys, a group composed of rock megastars. Petty has also performed solo acts using the pseudonyms Charlie T. Wilbury Jr. and Muddy Wilbury. He has recorded a number of hit singles with various groups and as a solo artist, and his music continues to attract younger fans. Performing in several different music genres, he has sold more than eighty million records, and his live shows continue to sell out. Considered one of the best rock musicians in America, he was inducted into the Rock and Roll Hall of Fame in 2002. Today, Tom Petty lives in California and is still active in the music business.

October 21, 1912

Cohen Brothers Opens Gigantic New Store: Cohen Brothers Dry Goods House, which was established in 1867 by brothers Samuel and Morris Cohen, today opened its new store in Jacksonville. The store, located in the St. James Building designed by noted architect Henry John Klutho, encompassed an entire city block and featured 300,000 square feet of retail space, electric lights and a huge octagonal glass dome for additional natural light. The new building replaced an earlier, smaller store that was destroyed in the Great Fire of 1901. The store was surrounded by large streetlights, the first to be located south of Baltimore. After Jacob Cohen died in 1927, the

glass dome was removed to add more floor space. The St. James Building and the Cohen Brothers store remained landmarks in Jacksonville for years. In 1958, the May Department Stores chain from St. Louis purchased Cohen Brothers and renamed the store May-Cohens.

October 22, 1992

Gene Roddenberry Ashes Hurled into Space: The ashes of *Star Trek* creator Gene Roddenberry were among the items in the cargo carried by the space shuttle *Columbia* as it left the launching pad at Cape Canaveral today. The *Columbia*, commanded by James D. Wetherbee, was on a nine-day mission to launch the Laser Geodynamic Satellite II and to conduct scientific experiments. The dispersal of Roddenberry's ashes into space was also a priority. Roddenberry, who died on October 24, 1991, created and produced *Star Trek*, a television series that featured the adventures of the crew of the starship *Enterprise* as it ventured "where no man has gone before." *Star Trek* began in 1966 and ran for three seasons before it was cancelled. It became a cult favorite after its demise as younger viewers were exposed to reruns. It was revived as an animated series in 1973 and lasted a year. In 1987, a new series, *The Next Generation*, enjoyed success for seven years. In addition, three other copycat series found airtime. There have been at least twelve full-length *Star Trek* movies and more are

scheduled to be made. So great was the show's popularity that America's first space shuttle was named *Enterprise* in honor of the fictional starship in the original *Star Trek*.

October 23, 1926

University of Miami Starts Football Program: The University of Miami freshman football team, in its first year, played its first game today, a 7–0 win over Rollins College before 304 fans. Under head coach Howard Buck, the team went on to post a perfect 8-0 record in its inaugural season. The team adopted the official nickname "Hurricanes," and though the origin of the name is somewhat unclear, some UM alumni insist it was inspired by the powerful hurricane that devastated Miami in 1926 and caused that year's season to be postponed by a month. The university's varsity football program got underway the next year, and Miami won its first game, again beating Rollins College. The Hurricanes compiled a 3-6-1 record for the 1927 season. Two years later, the university joined the Southern Intercollegiate Athletic Association. Miami played the University of Florida for the first time in 1938 and won 19–7. Florida State endured the same fate in 1951 when the Hurricanes defeated the Seminoles by a score of 35–13. Over the years, the University of Miami's football team has won five national championships and has had more players drafted by professional football teams than any other university.

October 24, 1820

Adams-Onís Treaty Signed by Spanish King: The king of Spain Ferdinand VII, signed the Adams-Onís Treaty that officially transferred ownership of Florida to the United States today. Confronted with increasingly restive subjects in his colonial empire and political unrest at home, Ferdinand hoped to conserve his financial resources to strengthen the Spanish monarchy and had no desire to get involved in a military dispute with the United States. The Adams-Onís Treaty was the official recognition of Spain's loss of Florida to the invading U.S. Army led by Andrew Jackson and its terms, which alluded to an exchange of the peninsula for the payment of claims against Spain, allowed the Spanish to avoid a formal surrender and exit the peninsula with dignity. It also resolved some of the long-standing disputes between the two countries formally establishing borders between Spanish possession and territory claimed by the United States. The United States would not take possession of Florida until the treaty was formally ratified by the Senate on February 22, 1821.

October 25, 1921

Hurricane Threatens Tampa Development: Just as Tampa's real estate development was beginning to take off in 1921, the area was hit by a devastating hurricane—the first since 1848.

Florida hurricanes preceded the boom of the 1920s and ended it as well. Two devastating hurricanes in 1926 and 1927 brought on the collapse of the land boom. Zora Neale Hurston, the noted African American author, chronicled the impact of the 1927 hurricane in her book *Their Eyes Were Watching God*. *Lewis N. Wynne Private Collection.*

The storm, which was the last of the 1921 season, caused about $10 million in damages and three deaths. The storm brushed the Florida Keys first without doing any major damage and entered the Gulf of Mexico. Decreasing in intensity slightly, it struck Tampa as a Category 3 hurricane. Rebuilding and cleanup started immediately after the storm passed as Tampa authorities, fearful of a negative impact on the emerging boom in real estate, downplayed the event as an unusual occurrence.

October 26, 1999

Golfer Payne Stewart Killed: Payne Stewart and four other passengers were killed today when the Learjet they were on experienced a loss of cabin pressure and crashed. Stewart was forty-two when he died. The plane left Orlando International Airport and last made contact with air controllers near Gainesville. It crashed near Mina, South Dakota, four hours later when the aircraft's fuel was exhausted. There were no survivors. Investigators postulated that the aircraft's sudden loss of pressure incapacitated all aboard due to hypoxia. Stewart had won the U.S. Open a few months before his death. In 2001, he was inducted posthumously into the World Golf Hall of Fame.

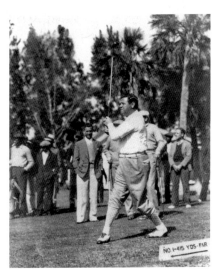

Sports figures were treated like royalty at the hotels of Miami and other cities. Often stars like Babe Ruth supplemented their annual incomes by appearing at special events for fees, or they stayed free with board, meals and drinks "comped" by owners who wanted the privilege of bragging about having famous people as guests. Ruth is playing at the Bobby Jones Golf Complex in Sarasota in the mid-1920s. *Richard Moorhead Private Collection.*

October 27, 1819

Railroad Baron Born: Henry Bradley Plant, developer of railroads on Florida's west coast and founder of the Plant System of railroads and steamships, was born in Branford, Connecticut, today. During the Civil War, Plant was the

General William Shafter (center) and his staff enjoyed the amenities of the Tampa Bay Hotel while planning their invasion of Cuba. Some officers who could afford to rent a luxury suite, such as Lieutenant Colonel Theodore Roosevelt, took rooms while the men they were leading had to make do with rough camps in the scrubs and marshes of the surrounding area. *Henry Plant Museum, Tampa.*

southern manager for Adams Express Company, which he renamed the Southern Express Company. After the war, Plant began to assemble the Plant System. In Florida, the Plant System initially ran from Jacksonville to Palatka and Sanford but soon stretched to Tampa and points south. By 1895, Plant had more than 1,400 miles of railroads under his control. Known as the "Father of Tampa," Plant erected the Tampa Bay Hotel and developed Port Tampa as a deep-water port.

October 28, 1865

Constitution Convention Meets in Tallahassee: A convention, called at the direction of President Andrew Johnson and provisional governor William Marvin, met today in Tallahassee to write a new state constitution as a condition for readmission into the Union. The constitution, which was to become law on November 7 without a vote of the citizens, never became effective because Johnson lost control of Reconstruction to congressional Republicans. Andrew Johnson was a southerner who supported slavery but became Lincoln's vice president. He was a racist, who believed that governments should be made up of only white men, and he opposed Radical efforts to impose the nation's first civil rights laws. Unwilling to join the Democratic party, which was tainted by secession, he attempted to create his own party but failed. There was an attempt to

impeach Johnson, but it failed in Congress by one vote. He lost the 1868 presidential election to U.S. Grant. He eventually was elected to the Tennessee Senate. He died from a stroke in 1875. Johnson followed one of the greatest presidents in office, yet his presidency is often considered one of the worst in U.S. history, even worse than the two terms of Ulysses S. Grant, the man who followed him.

October 29, 1998

Glenn Becomes the Oldest Man in Space: Senator John Glenn took his second trip into outer space today aboard the space shuttle *Discovery*. Glenn, who became the first American to orbit the Earth in *Friendship 7* on February 20, 1962, also became the oldest American in space at age seventy-seven. He was aboard the shuttle *Discovery*, which was making its twenty-fifth flight into space. The launch of the *Discovery* vehicle became the first shuttle launch to be witnessed in person by a sitting American president as President Bill Clinton and First Lady Hillary Clinton watched the takeoff from the roof of the Vehicle Assembly Building. Glenn said he was a "living" experiment on the *Discovery* flight and would serve as a human guinea pig for geriatric studies. Glenn also became the third politician to fly in space, preceded by Senator Jake Garn and then representative Bill Nelson, who is now the senior senator from Florida.

October 30, 1926

Mastodon Bones Found Near Venice Beach: Today workers digging drainage canals near Venice Beach uncovered some large and unusual bones that they suspected were ancient fossils of long-extinct animals. Experts from the Smithsonian Institution and the National Geographic Society were called to the scene to give their scientific appraisals of the bones. J.W. Gidley, a paleontologist from the Smithsonian, immediately identified one of the bones as belonging to a wooly mammoth. He estimated that the prehistoric creature was about fourteen feet high and about twenty-nine feet long. He estimated the age of the bones at 500,000 years old and as being from the Pleistocene era. Florida was home to a wide variety of animals, including small horses, bison, mastodons, sloths and camels. What made this discovery so unusual was the fact that the fossils were found buried in the soil, not encased in rock. Prehistoric bones have been found in other places, some as far inland as Gainesville.

October 31, 1900

Earthquake Rocks Jacksonville: Citizens of Jacksonville and North Florida experienced eight distinctive earthquake shocks this morning. The shocks, rated as 5.0 on the Mercalli Scale, produced broken windows, cracked plaster and ruined dishes in area homes. Although Florida is not

usually considered an area prone to earthquakes, the state has experienced several in modern times. In January 1879, several cities in the Sunshine State felt the aftershocks of an earthquake, and in Jacksonville and St. Augustine, the heavy shaking rocked houses, causing plaster to be knocked from walls and objects to fall from shelves. Daytona and Tampa also experienced severe shaking. In September 1886, Floridians felt the aftershocks of the famous Charleston earthquake. Aftershocks were felt again in October and November of that year. On June 20, 1893, Jacksonville experienced another slight tremor, apparently generated locally, that lasted about ten seconds. On November 18, 1952, slight tremors were felt by many people in Quincy, a small town about twenty miles northwest of Tallahassee. Although windows and doors rattled in most houses, no serious damage was noted by residents.

NOVEMBER

November 1, 1939

Key West Naval Base Reactivated: The American naval base at Key West was originally established in 1823 but closed following the great hurricane of 1935 that destroyed the railroad from the Florida mainland to the island. In the Spanish-American War, Key West had provided anchorage for the entire U.S. Atlantic Fleet and had played an important role in World War I against German ships carrying Mexican oil. The base served as a training

Following page: The draft, which had been created by Congress in 1940, and volunteerism brought so many men into military service by early 1942 that the federal government had to appropriate civilian hotels as barracks and use the hotel grounds as training courses. Many men found themselves housed in the most luxurious hotels of the prewar era and ferried from hotel grounds to hotel grounds in army trucks. *Lewis N. Wynne Private Collection.*

facility for American pilots, a role it resumed in 1940. The base continues to be operated by the American navy today.

November 2, 1869

Florida Panhandle Votes to Secede: In one of the strangest political alliances in Reconstruction-era Florida, Democrats and Republicans combined to approve a referendum today that called for the secession of Florida lands west of the Apalachicola River and its annexation to the state of Alabama. By a vote of 1,045 to 659, a nearly 2:1 margin, the referendum passed overwhelmingly. Citizens of the region were upset that the state government in Tallahassee would

not support the construction of a railroad from Quincy to Marianna. The region, which had seen bloody fighting between Republicans and Democrats that had resulted in the deaths of more than one hundred men, nevertheless presented a unified front on this issue. The referendum, however, failed to influence officials in the capital, and the proposed railroad was not built until 1883. The 1869 proposal was just one of several similar propositions to be offered at various times in the state's history. Even today there are "secessionist" ideas that occasionally come to the public's attention from the panhandle area. In March 1982, Governor Fob James of Alabama offered Florida $500 million in exchange for the panhandle. Florida governor Bob Graham refused the offer and informed James that his proposal registered a "No Sale" from the Sunshine State.

November 3, 1762

Preliminary Agreement to End Seven Years' War Reached: The preliminary agreements on the Treaty of Paris, which would end the Seven Years' War (the French and Indian War), were signed today. Great Britain had fought a successful war against France and Spain in North America, India and the Caribbean, including the capture of the Spanish port of Havana, Cuba. As a result of the agreements reached in Paris, France surrendered its possessions in North America and India, and Spain transferred the title to Florida in

exchange for the return of Havana. The formal ratification of the treaty did not take place until 1763. Great Britain took possession of Florida and retained control until the end of the American Revolution, when Spain regained ownership as a byproduct of its support of the American cause. During the British period, Florida was divided into East Florida, with its capital at St. Augustine, and West Florida, with its capital at Pensacola. Spain retained the title until the United States took possession in 1821.

November 4, 1927

Ringling Circus Headquarters Moved to Sarasota: John Ringling, owner of the Ringling Brothers, Barnum and Bailey Circus, made Sarasota his winter headquarters today. Ringling, whose winter home, Cà d'Zan, was located there, was one of five brothers who operated traveling circuses from 1870 until their deaths in various years. Slowly acquiring competing circuses, the Ringling Brothers established a total monopoly on the circus industry when, in 1929, the American Circus Corporation was purchased for $1.7 million. With this acquisition, there were no other traveling circuses left in America. John Ringling and his brother Charles were instrumental in the development of Sarasota during the boom era of the 1920s.

John Ringling was a circus mogul who preferred Sarasota over other part of Florida in the 1920s. After building a luxurious mansion on Sarasota Bay, he made the town the winter headquarters for all the traveling circuses in the United States. How? He owned them all. He also built a private art museum to house his collection of old masters. *Lewis N. Wynne Private Collection.*

November 5, 1915

Navy Plane Catapulted from Ship: Pioneering naval aviator Henry C. Mustin became the first person to be launched from the deck of a warship under steam today when his Curtiss Model AB-2 was hurled aloft by a catapult from the deck of the armored cruiser USS *North Carolina*. Mustin, who was the commandant of the newly organized Naval Aeronautic Station in Pensacola, a naval pilot training base, was recognized as navy air pilot no. 3, a designation that was later changed to naval aviator no. 11. He was removed from command, and his designation as a naval aviator was revoked in January 1917 when two cadets were killed during training. Assigned to battleship duty, he later served as commander of the Fleet Air Detachment, Pacific Fleet. Mustin became the assistant chief of the Bureau of Aeronautics in late October 1921, and he was promoted to captain on January 1, 1922. He died on August 23, 1923, from heart problems. In 1990, he was inducted into the Naval Aviation Hall of Honor in Pensacola.

November 6, 1971

War Hero and Florida Politician Dies: World War I hero, governor and U.S. senator Spessard Lindsey Holland died today in Bartow. He graduated from Emory College in 1912 and then attended the University of Florida School

of Law. During World War I, he served as an observer and gunner in aircraft and was credited with shooting down two enemy planes on a single mission, an act for which he was awarded the Distinguished Service Cross. He returned to his law practice in Bartow in 1919, served briefly as the county prosecutor and then was elected judge. In 1929, he formed a law partnership with William F. Bevis, creating a firm that eventually became the international law firm of Holland and Knight. After eight years in the state senate, he was elected governor and was sworn in on January 7, 1941. He was elected to the U.S. Senate in 1946, a position he filled until he left political office in 1971. He was seventy-nine years old when he died.

November 7, 2000

Presidential Election Depends on Florida Votes: For the second time in history, a presidential election was to be decided by disputed election returns from the state of Florida. In the election of 1876, Rutherford B. Hayes and James A. Garfield were neck and neck in votes in the Electoral College when a behind-the-scenes deal was worked out. In the 2000 presidential election, Al Gore and George W. Bush were in a similar position. Based on early exit polls, television networks proclaimed that Gore had won Florida, but early returns of actual votes showed Bush with a substantial lead and the predictions were withdrawn.

The election finally came down to the returns from three counties in the southern part of Florida—Palm Beach, Miami-Dade and Broward. Bush was finally declared the winner, but the Gore camp requested recounts. For the next two weeks, battles were fought in court and the entire world became familiar with the term "hanging chad." A state court ordered a manual recount of disputed ballots be conducted, but that ruling was overturned by the Florida Supreme Court, whose ruling was sustained by the U.S. Supreme Court. There were charges of judicial favoritism when the Supreme Court voted along Republican-Democratic party lines. The election was awarded to Bush, but the controversy still remains.

November 8, 1876

African American Humanitarian Born: Eartha Mary Magdalene White, African American humanitarian and the founder of the Clara White Mission, was born today in Jacksonville. The thirteenth child of former slaves, she was adopted by Clara English White. Eartha White attended schools in Florida and New York. In 1893, upon graduation from the Stanton School in Jacksonville, she moved to New York City for a brief period in order to avoid a yellow fever epidemic. She attended the Madam Hall Beauty School and the National Conservatory of Music and became an opera singer with the Oriental American Opera Company. She sang as a

lyric soprano and traveled with the company throughout the United States and Europe. In 1896, White returned to Florida and graduated from the Florida Baptist Academy. With her adoptive mother, she undertook charitable activities in Jacksonville's African American community. After Clara White died in 1920, Eartha White obtained the closed Globe Theatre Building on West Ashley Street, and operated the facility as the only nonprofit organization serving daily meals to the needy in the city. Eartha White died of heart failure at age ninety-seven in 1974.

November 9, 1868

William H. Gleason Proclaims Himself Governor: William H. Gleason, the lieutenant governor of Florida, proclaimed himself governor today when the Florida legislature adjourned while the senate was still debating the impeachment of the sitting governor, Harrison Reed. Reed refused to surrender his office, and the state adjutant general and the sheriff of Leon County sided with him, surrounding the governor's office with men to prevent Gleason from occupying it. On November 24, the state Supreme Court ruled that Reed was still the lawful governor and that Gleason's claim to the office was spurious. Governor Reed then brought charges against Gleason, charging him with having been ineligible for public office when he was elected as lieutenant governor since he had been a resident of the

state for less than the three years mandated by the state's constitution. Governor Reed prevailed, and Gleason was forced from office on December 14. Following his abbreviated service as lieutenant governor, Gleason moved to Dade County, which he represented in the Florida House of Representatives from 1871 until 1874. Following some financial reverses, Gleason moved his family to Eau Gallie in Brevard County into the building that had been previously constructed as the site for the University of Florida. Gradually, the Gleason fortune was restored, and he gained a great deal of prominence in his new home.

November 10, 1976

Supreme Court Waives Bar Exam for Civil Rights Leader: Today the Florida Supreme Court unanimously ruled that Virgil D. Hawkins be admitted to the practice of law without taking and passing the bar exam. It marked the end of a long and convoluted struggle for Hawkins to gain admission to the legal profession. In April 1949, he and five other African American students applied for admission to the University of Florida School of Law, but they were denied admission because of their race. Hawkins appealed the decision to the state's Supreme Court but did not prevail. Instead, the court ordered the state to build a separate law school for black students at Florida A&M University, which would satisfy the prevailing doctrine of "separate but equal" educational

opportunities. When the U.S. Supreme Court overturned segregation in the 1954 *Brown v. Board of Education* decision, the university was ordered to admit Hawkins as a student, but the university continued to refuse. In 1958, he and the university reached an agreement that Hawkins would withdraw his application for admission and the university would desegregate its graduate and professional programs. In November 1976, the Florida Supreme Court waived a requirement that he take the bar exam before being allowed to practice law in Florida, even though the law school he had attended twenty years earlier was unaccredited.

November 11, 1966

Gemini 12 Launched: Gemini 12 was launched from Cape Canaveral today with James Lovell Jr. and Edwin "Buzz" Aldrin Jr. as the crew. The Gemini 12 flight was the last in the Gemini program and was highlighted by three tethered spacewalks by Aldrin that demonstrated the safety of such walks for astronauts. Lovell and Aldrin also were able to observe and photograph a total eclipse of the sun over South America. In addition, the Gemini 12 capsule docked with an Agena rocket while in orbit. The Gemini 12 spacecraft returned to Earth on November 15 and splashed down in the western Atlantic Ocean. The Gemini program, designed to test equipment and procedures for lunar missions, effectively bridged the gap between the

early and limited Mercury flights and the anticipated Apollo programs, which saw American astronauts become the first humans to walk on the surface of the moon. The first Apollo launch came in 1968.

November 12, 1981

Second Space Shuttle Launched Successfully: The space shuttle *Columbia* was successfully launched today from Cape Canaveral on a mission to test the technology that would be used on future shuttle flights. With rookie astronauts Joe H. Engle and Richard H. Truly as the crew, the *Columbia* was scheduled for a five-day mission, although mechanical failures before the launch threatened to force NASA to scrub the flight. A faulty computer and two of three power units were replaced, and a fuel spill before launch required the replacement of more than three hundred contaminated thermal tiles that protected the shuttle from extreme temperatures during its reentry into the Earth's atmosphere. The mechanical malfunctions continued during and after the shuttle launch. An O-ring that sealed the shuttle's fuel tanks malfunctioned, and although *Columbia* was launched successfully, the same seal would prove disastrous to the 1986 *Challenger*. Once in space, a fuel cell that produced electricity and water failed. With the continuing failures in equipment, NASA ordered the crew to abort the mission and return to Earth after only two days.

November 13, 1934

Eastern Airlines Begins Miami to New York Flights: Today was the first day of Eastern Air Lines' dawn-to-dusk air passenger service between Miami and New York. The introduction of advanced DC-2 aircraft with greater fuel capacity and an extended range eliminated the need for an overnight stay in Jacksonville. The aircraft could carry fourteen passengers in comfort and safety. Eastern Air Lines started in the early 1920s as Pitcairn Aviation. Pitcairn was sold in 1929 to North American Aviation, which soon changed its name to Eastern Air Transport. In 1934, World War I fighter ace Eddie Rickenbacker became the general manager of Eastern, and the airline grew with the addition of new mail and passenger routes. Under the leadership of Rickenbacker, Eastern became the first airline to make a profit on passenger service alone. In 1938, Rickenbacker formed a group of investors and purchased Eastern for $3.5 million. Concentrating on its passenger business, the airline flew more than 141 million passenger miles between 1930 and 1936. Eastern proudly proclaimed that it had flown these miles without a single crash or fatality, but that accomplishment ended when an Eastern DC-2 crashed near Daytona Beach in August 1937.

November 14, 1969

Apollo 12 Races to Moon: Today the Apollo 12 space mission the *Yankee Clipper* was launched from Cape Canaveral and headed for the moon. Charles Conrad Jr., Richard F. Gordon Jr. and Alan F. Bean were tasked with making man's second landing on the lunar surface. During liftoff, the Apollo 12 was struck by lightning, which caused the spacecraft to lose much of its instrumentation. An immediate switch to a backup system brought the instrumentation back on line. Once the craft had reached orbit around the Earth, the crew conducted a thorough check of all systems and reported no permanent damage to any of them. Cleared by NASA officials, the mission proceeded and reached lunar orbit safely. On November 19, Bean and Conrad landed the moon module near an area that had been targeted by several earlier unmanned probes, including the Surveyor 3 that had been launched in 1967. After about thirty-two hours on the moon's surface, Bean and Conrad returned to the mother ship, piloted by Gordon, and the spacecraft headed back to Earth. The Apollo 12 returned to Earth on November 24, 1969, splashing down in the Pacific Ocean near American Samoa.

November 15, 1960

Florida's Population Growth Means Four New Seats in Congress: The 1960 census showed that Florida had 4,951,560 residents and ranked as the tenth-most-populous state in the nation. Migration from other states, especially by retirees, caused a population explosion that gave Florida four additional seats in Congress. By 1980, the state was ranked seventh in population with 9,746,324 residents,

By the beginning of the twentieth century, Florida's economy was largely dependent on tourism. In the first decade of the 1900s, more and more people chose to come to the Sunshine State by automobile and explore on their own. They were called the "Tin Can Tourists" and preferred visiting where there were no hotels or developments. They brought their own supplies and stayed in tents. Automobile tourism was the mainstay of the industry in Florida until the 1980s, when airplane travel began to dominate. *Lewis N. Wynne Private Collection.*

which increased to 12,937,926 in 1990. Florida's growth continued for the next decade, and the population reached 15,982,378 in 2000. Although the state experienced a slight decrease in population in 2005, following two years of multiple hurricanes, population growth resumed soon afterward and reached 18,801,310 residents in 2010.

November 16, 1888

Legendary FSU President Doak Campbell Born: Doak S. Campbell, former president of Florida State University, was born today in Waldron, Arkansas. Campbell received his doctorate from George Peabody College in 1930 and served as the dean of the college's graduate school from 1938 until 1941. He became president of the Florida State College for Women in 1941 and continued in that position after the university became co-ed in 1948. He retired on June 30, 1957. During his presidency, the college experienced a period of accelerated growth largely due to the large number of servicemen who attended specialized classes at the school. After the war, many of these men wanted to return as regular students on the G.I. Bill, which provided critical financial assistance to them. In response to the demands, the Florida legislature renamed the school Florida State University on May 15, 1947, and made it a co-ed university. As president, Campbell was a strong supporter of intercollegiate athletics, and when the university built a

football stadium in 1950, university trustees named it in his honor. A much revered figure on campus, Campbell died on March 23, 1973. He was eighty-four.

November 17, 1856

Former Florida Governor Eaton Dies: John Henry Eaton, the second territorial governor of Florida, died today at his home in Washington. Eaton, who was born on June 18, 1790, in North Carolina, practiced law in Nashville and represented that state in the Senate for eight years. His friend and political ally Andrew Jackson appointed him secretary of war, which immediately thrust him into the center of a major scandal. His wife, Margaret "Peggy" O'Neal, was a former barmaid in a Washington tavern. The wives of some prominent politicians, led by Mrs. John C. Calhoun, considered Peggy to be their social inferior and boycotted official functions she attended. The O'Neal affair seriously damaged the relationship of Jackson and Calhoun, his vice president and presumptive political heir, who refused to force his aristocratic wife to attend such functions. Jackson and Calhoun became bitter political and personal enemies, costing Calhoun Old Hickory's political support. Jackson transferred his favor to Martin Van Buren, who was a widower and avoided any of the controversy surrounding Eaton's wife. After serving as governor of Florida from 1834 until 1836, Eaton served

as American Minister to Spain. His wife was well received at the court of Spain and was a social favorite in London and Paris.

November 18, 1923

First American in Space Born: Alan Shephard, a sometime Brevard County resident and the first American to travel into space in 1961, was born today. He entered the astronaut program after service as a navy flier. He had a storied career as an astronaut, including his 1971 command of the Apollo 14 mission to the moon when he was forty-seven. He made the trip from the command module to the lunar surface and claimed to be the oldest man ever to walk on the moon. While on the moon, he also became the first person to hit a golf ball in outer space, a feat that earned him millions of earthbound admirers. After graduation from the U.S. Naval Academy in 1944, Shepard was assigned to duty on a destroyer during the final months of World War II. After the war, he completed training as a naval aviator and served several tours on aircraft carriers before being selected for astronaut training in NASA's Mercury program in 1959. After the Apollo 14 mission, Shepard became the chief of the Astronaut Office at NASA, a position he held until his retirement in 1974. He became a successful businessman after leaving the space program. He died on July 21, 1998.

November 19, 1969

Apollo 12 Lands on Moon: The Apollo 12 spacecraft, which had been launched on November 14 from Cape Canaveral with its smaller lunar vehicle, Intrepid, aboard. Today, two members of the crew, Alan L. Bean and Charles "Pete" Conrad, landed on the lunar surface, and Richard F. Gordon Jr. remained at the controls of the craft. Bean and Conrad quickly constructed a nuclear-powered scientific station on the surface, which was designed to continuously transmit data about seismic activity, solar winds and lunar magnetic fields to Earth. Conrad, the first of the two Apollo 12 astronauts to step onto the surface, is reported to have said, "Whoopie! Man, that may have been a small one for Neil [Armstrong], but that's a long one for me." Despite the initial problems with the launch, the shuttle continued on its voyage to the moon, completed its mission and returned safely to Earth on November 24.

November 20, 1962

American Blockade of Cuba Ends: The Cuban Missile Crisis, which was started by the discovery of Russian missiles and bombers at bases in Cuba, nearly led to war as the United States demanded the removal of Russian offensive weapons. From October 15 until October 28, it appeared that a nuclear war might happen as the Soviets refused

to remove the missiles. Offensive weapons were placed in Cuba, the Russians argued, to counterbalance the presence of American missiles in Turkey. President John F. Kennedy and his advisors considered bombing the missile bases or invading Cuba to destroy them before deciding to impose a naval blockade against Soviet ships. In Florida, available military bases were quickly flooded by American troops, fully equipped and ready for battle, and many civilian airports were also used to house troops. For thirteen days, the world watched as Russian and American leaders made threats about an imminent "nuclear holocaust." Kennedy held firm with the blockade. With no direct means of communications between the Soviet premier and the American president, diplomats feverishly engaged in back-channel negotiations to find a solution to the crisis. War was averted when the United States agreed to remove its missiles from Turkey and Russia agreed to remove its missiles and bombers from Cuba.

November 21, 1985

Hurricane Kate Hits the Panhandle: Hurricane Kate, a Category 2 storm, struck the Florida panhandle near Port St. Joe today, becoming the sixth hurricane to strike the United States this year. Kate was also the latest hurricane on record to hit the Sunshine State. Formed in the Atlantic Ocean on November 15, the storm struck Cuba on November 19 and then moved

into the Gulf of Mexico before hitting the Florida coast. Hundreds of thousands of residents were evacuated, but the storm did little damage. When Kate struck the Florida panhandle, it destroyed much of the oyster industry along the coast, which caused many people to lose their jobs in the weeks after the storm. After weakening into a tropical storm, Kate headed north through Georgia and exited the United States from North Carolina on November 22. Overall, Kate was responsible for fifteen fatalities and about $700 million in damages in the United States.

November 22, 1966

Steve Spurrier Wins Heisman Trophy: Steve Spurrier, the quarterback for the University of Florida football team, was named the recipient of the Heisman Trophy today. Spurrier became the first athlete in the state to receive this honor. In addition to the Heisman Trophy, he also won the Walter Camp Memorial Trophy in 1966, plus All-American honors in 1965 and 1966. Following his collegiate career, he played professional football for the San Francisco 49ers and the Tampa Bay Buccaneers, although he enjoyed only modest success as a professional. He also coached the U.S. Football League's Tampa Bay Bandits and the National Football League's Washington Redskins, again with only modest success. Spurrier is best known for his career as a college coach at Duke University; the University

of Florida, where he won a national championship in 1996; and the University of South Carolina, which has improved its record each year under his guidance. In 2006, readers of the local *Gainesville Sun* newspaper voted him the honor of being the second-best Gator player ever.

November 23, 1883

Former Governor Broome Dies: James Emilius Broome, the third governor of Florida, died today in Deland. Broome was born in Hamburg, South Carolina, on December 15, 1808. He moved to Tallahassee in 1837 and engaged in the mercantile business until he retired in 1841. Governor Richard Keith Call appointed him to the position of probate judge of Leon County, and he served in that position until 1848. He was elected governor in 1852 as a Democrat and a "states righter" who supported Southern secession from the United States. Broome had to deal with a legislature controlled by the Whig party, which led to his vetoing many of the bills approved by the legislature—so many, in fact, that he was derisively referred to as the "Veto Governor." Among the measures he vetoed was a bill that would have eliminated the state's Supreme Court. After he left office in October 1857, he remained active in politics and served in the state senate from 1860 to 1864. At the end of the Civil War, he left Florida and moved to New York City. On a visit with his son in DeLand, Broome died in 1883.

November 24, 1991

Shuttle Atlantis *Launched on Special Mission*: The space shuttle *Atlantis* lifted off from Cape Canaveral this evening on a special mission for the Defense Department to deploy a secret military satellite. The shuttle was commanded by Frederick D. Gregory and included crew members Terence T. Henricks, James S. Voss, F. Story Musgrave, Thomas J. Hennen and Mario Runco Jr. Originally scheduled for launch on November 19, equipment problems delayed the shuttle liftoff until today. Today's launch was delayed thirteen minutes to allow an orbiting spacecraft to pass overhead and to make additional minor repairs to equipment. Once the shuttle reached orbit, the crew deployed the satellite and performed a number of scientific experiments. Even in orbit, equipment failures continued to plague *Atlantis*, which returned to Earth on December 1, three days short of its planned mission. *Atlantis* was supposed to land at Cape Canaveral on its return but landed at Edwards Air Force Base in California because of ongoing equipment failures.

November 25, 1863

Florida Units Fighting at Chattanooga: Florida units took heavy casualties today in the Battle of Chattanooga as Union general Ulysses S. Grant, the victor at Vicksburg in July, turned his attention to lifting the Confederate siege of the

city. Following their success at the Battle of Chickamauga in September, Southern forces had kept the Union troops bottled up in the river town. In an offensive that began on November 23, Grant's soldiers began to push the Confederates south from the city. First came the victory at Orchard Knob, followed by a Union victory at Lookout Mountain and, finally, a difficult victory at Tunnel Hill. The Battle of Chattanooga was costly for the Confederates, and the Fourth Florida Infantry, which had entered the battle with 172 men, reported that it had 154 killed, wounded or missing. The Florida First Cavalry (Dismounted) listed 200 men ready for duty when the battle started and reported indicated that 167 men were killed, wounded or missing when the fighting ended. Florida's other units, notably the First, Third and Sixth Infantry Regiments were among the last to vacate the Confederate battle lines and retreated only after experiencing similar casualty rates.

November 26, 1902

Florida Historical Society Is Reorganized: Major George R. Fairbanks of Fernandina was elected president of the Florida Historical Society at an organizational meeting in Jacksonville today. Although originally founded in 1856 in St. Augustine, the War Between the States and Reconstruction forced the society into a hiatus. Without a state-funded library, Fairbanks and others realized the need

for the society to "collect, preserve and publicize documents relating to Florida history." Fairbanks had been one of the original founders of the society in 1856. During the Civil War, Union soldiers in St. Augustine plundered the archives of the society, scattering irreplaceable historical documents in the muddy streets of the town to be trampled and destroyed. In his presidential remarks, Fairbanks enunciated the need for a society library, a task that was finally achieved in 1997 when the Library of Florida History opened in Historic Cocoa Village in Brevard County. The Library of Florida History is located in a renovated 1939 WPA-built federal post office.

November 27, 1961

Biscayne College Opens in Miami: Biscayne College, which traces its roots to a university in Havana founded in 1946 by American Augustinians, opened its doors today. Expelled from Cuba by Fidel Castro in 1961, several members of the Augustinian Order made their way to Miami and founded Biscayne College under the leadership of the vice rector of Villanueva. It was accredited in 1968 as a college and slowly began to expand its student population and academic offering. The same year, Biscayne College changed its name to St. Thomas College. The institution earned university status in 1984, when it added a School of Law and ten masters' degree programs. The campus of the

university is located in Miami Gardens and comprises 150 acres. There are several residence halls and dormitories located on campus in addition to academic buildings, a library and several athletic facilities and fields. The mascot for St. Thomas University is the bobcat.

November 28, 1857

Captain John Parkhill Killed: Today, Captain John Parkhill of the Leon Volunteers captured a unique spot in Florida history when he became the last man to be killed in the Third Seminole War in 1857. Parkhill, who had assumed command of the Florida Volunteers on Chokoloskee Island when Colonel St. George-Rogers became ill, was killed as he led his troops on a mission to capture the few remaining Seminole Indians in the Sunshine State and destroy their villages and fields. The war, which had started on December 20, 1855, had proven difficult for the American soldiers, and by November 1857, most military leaders had come to the realization that it would be impossible for them to remove all the Seminoles from Florida. About seven hundred Seminoles remained hidden deep in the Everglades, safe from the army. The confrontation in which Captain Parkhill was killed was the last conflict of the war, which was declared at an end on May 8, 1858. A statue recognizing Captain Parkhill is on the grounds of the capitol in Tallahassee.

November 29, 1963

President Johnson Changes Cape's Name: On November 28, 1963, President Lyndon B. Johnson announced that Cape Canaveral would be renamed Cape Kennedy in memory of President John F. Kennedy, who was assassinated just six days earlier. On November 29, Johnson signed an executive order that decreed that the NASA Launch Operations Center facilities on Merritt Island and Cape Canaveral would be renamed the John F. Kennedy Space Center, NASA. That name change officially took effect on December 20, 1963, and the air force subsequently changed the name of the Cape Canaveral Missile Test Annex to Cape Kennedy Air Force Station in 1964. Floridians were outraged at Johnson's decision and started a ten-year campaign to change the name back to Cape Canaveral, the name that it had held for four hundred years. Congress refused to change the name again. The Florida legislature decided to take the bull by the horns and passed a law—signed by Governor Rueben Askew on May 18, 1973—requiring the name Cape Canaveral to be used on all state documents and maps. When the U.S. Board of Geographic Names followed suit on October 9, 1973, the name was officially restored. The space center complex retained the name John F. Kennedy Space Center.

November 30, 1982

Black Legislators in Florida Organize Caucus: Today, eleven of twelve of Florida's African American legislators met to organize the state's first "Black Caucus." Senator Carrie Meek of Miami was elected to the position of caucus chairperson and Representative John Thomas of Jacksonville was elected vice-chairperson. Meek was a native of Tallahassee and graduated from Florida A&M University in 1946. She later attended the University of Michigan and received her master's degree from that institution in 1948. She moved to Miami in 1961 after teaching at Bethune-Cookman University and FAMU. She was elected to the state house of representatives in 1978 and served until 1982, the year she became the first African American woman elected to the state senate. In 1992, she was elected to the U.S. House of Representatives and retired from that body in 2003. She was succeeded by her son, Kendrick Meek. John Thomas represented the Seventeenth District in the Florida House of Representatives. The purpose of the Black Caucus was to increase the power of the small group of African American legislators in the legislature.

DECEMBER

December 1, 1845

First U.S. Senators from Florida Claim Seats: David Levy Yulee and James D. Westcott Jr. took their seats in the Senate today as the first senators from Florida. Yulee was from St. Augustine, and Westcott was from Tallahassee. David Levy Yulee won the long term of office, which ended on March 3, 1851, while Westcott's short term expired on March 3, 1849. Yulee would later be elected for a full term that ran from 1855 until he resigned in 1861. Westcott would become the attorney general of Florida in 1868. Yulee, who had previously served as the representative from Florida in the twenty-seventh, twenty-eighth and twenty-ninth Congresses, was a large landowner and entrepreneur. He was the moving force behind the success of the Florida Railroad, the first cross-peninsula railroad that ran from Fernandina on the Atlantic Coast to Cedar Key on the Gulf of Mexico. The railroad

opened in 1860 but was almost immediately shut down after the beginning of the War Between the States.

December 2, 1839

Reid Takes Office as Territorial Governor: Robert Raymond Reid, the fourth territorial governor of Florida, took office today. Reid was born in Prince William Parish, South Carolina, on September 8, 1789. He was educated in Augusta, Georgia, and remained in the city to practice law. At age twenty-seven, Reid became a Superior Court judge before being elected as an at-large member of the House of Representatives in three successive Congresses from 1819 until 1823. In May 1832, President Andrew Jackson appointed him to the position of federal judge for East Florida. Reid continued in this office until President Martin Van Buren appointed him to the governor's office. Reid had presided over the Constitutional Convention at St. Joseph before his appointment as governor some six years before statehood. He was an advocate of vigorously prosecuting the Second Seminole War. Reid died in Leon County in 1841, a victim of a yellow fever epidemic. His daughter and granddaughter were also victims of the same epidemic.

December 3, 1838

Constitutional Convention Meets in North Florida: Florida's first constitutional convention opened today at St. Joseph in north Florida. Fifty-six representatives from Florida's twenty counties gathered to write a constitution in anticipation of statehood. Chaired by Robert Raymond Reid, the convention stayed in session until January 11, 1839. Although the efforts of the convention delegates were six years premature, the document they drafted became the basis of the state's first constitution in 1845. St. Joseph was a growing boomtown and one of the wealthiest communities in the Florida territory when it was chosen to host the convention. The town was considered to be an ideal location for the very rich to vacation, and promoters had developed elaborate plans to turn the area into a vast vacation play land. Their dreams were shattered in 1841 when a yellow fever epidemic decimated the population, dropping it from thousands to fewer than five hundred people in just a few months. Just as the town was recovering from the epidemic, it was devastated by a hurricane in 1844. Though a few people remained, the town withered and died. A new town, Port St. Joe, never regained the favor of the wealthy and remained small until the early 1900s.

December 4, 1765

Zepaniah Kingsley Born: Zepaniah Kingsley Jr., a controversial slave owner and trader during the British, last Spanish and territorial periods of Florida's history, was born today in Bristol, England, the second of eight children of a London Quaker and a Scottish woman. His father moved the family to South Carolina in 1770, and Zepaniah was left behind in London to be educated. A Loyalist during the American Revolution, the elder Kingsley sought the safety of Canada in 1782. The younger Kingsley purchased a plantation near present-day Jacksonville and began to cultivate it with slave labor. A benevolent slave owner, he married four slave women, but Anna Madgigine Jai was his principal wife. Kingsley entrusted her with the operation of the plantation during his absences. He fathered nine mixed-race children with his wives, educated them and made arrangements to give them his property on his death. Kingsley became involved in politics when control of Florida passed from Spain to the United States in 1821 and tried unsuccessfully to persuade the new territorial government to maintain the special status of the free black population that had flourished under Spanish rule. When the Americans adopted the harsh restrictions on slavery found in southern states, particularly laws that forbade interracial marriage, Kingsley relocated his large family to Haiti between 1835 and 1837. After his death, his estate in Florida was the subject of dispute between his widow Anna Jai and other members of Kingsley's family.

December 5, 1918

Florida House Rejects Women's Suffrage: Today the Florida House of Representatives failed to approve the women's suffrage amendment. The Women's Suffrage Association in Florida was formed in Tampa in January 1893 and was affiliated with the National American Woman Suffrage Association led by Susan B. Anthony. The Florida group, while never large in numbers, was supported by a number of men, including several state legislators who tried to secure the

Women who remained at home or were not directly employed in war industries also contributed to the war effort by volunteering their time and energy doing such tasks as rolling bandages, knitting socks or other endeavors that were labor intensive, but which could be done in small groups or at home. *Camp Gordon Johnston Museum, Carrabelle.*

enactment of suffrage legislation. Despite the ratification of a suffrage amendment to the U.S. Constitution in 1920, the Florida legislature didn't get around to approving the amendment until May 13, 1969.

December 6, 1947

President Truman Dedicates Everglades National Park: President Harry S. Truman dedicated the Everglades National Park today. Since the late 1800s, efforts had been made by private enterprise and by the federal government to drain portions of the Everglades for commercial and development purposes. Environmentalists worked to protect and preserve the fragile environment, and in 1916, the Royal Palm State Park was created. In 1928, the Florida legislature established a commission to study the formation of a protected area of the Everglades, and the commission, on May 30, 1934, persuaded the U.S. House of Representatives to authorize the creation of a new national park. Ernest F. Coe, a former developer, and Senator Spessard Holland worked with Florida naturalists to secure 1.3 million acres for the park, and John Pennekamp, the editor of the *Miami Herald*, worked to secure funding from the legislature.

December 7, 1941

Japanese Planes Attack Pearl Harbor: On December 7, 1941, Floridians were shocked to learn that Japanese planes had attacked Pearl Harbor and knew America would soon be at war. Because Florida had a warm climate and lots of vacant land, it was ideal for building training bases. Three million trainees for military service were sent to the Sunshine State.

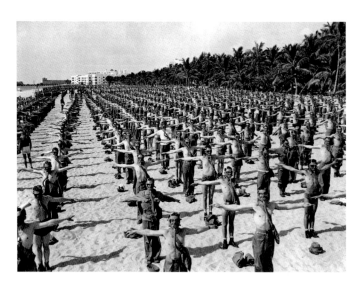

Instead of bathing beauties and frolicking tourists, Miami Beach was a gigantic physical training field for these scantily clad servicemen in 1942. While there was no threat of a gas attack, the soldiers were encouraged to become familiar with how their gas masks functioned. *Lewis N. Wynne Private Collection.*

More than 170 military installations were built, including forty new airfields for training pilots. To handle the influx of recruits quickly, the military took over many large hotels and resorts. Some of the hotels were used for barracks, and others became makeshift hospitals.

December 8, 1891

Reconstruction Governor Stearns Dies: Marcellus Lovejoy Stearns, the eleventh governor of Florida died today in Palatine Bridge, New York. Stearns, who served from March 18, 1874, until January 2, 1877, presided over the end of Reconstruction in the state. Stearns was born in Maine, in 1839. He enrolled at Waterville (now Colby) College, but left college to join the Union army in 1861. After Stearns lost an arm at the Battle of Winchester, he transferred to the Freedman's Bureau and was stationed at Quincy, Florida. In 1868, he served in the constitutional convention and was elected to the state house of representatives from 1868 until 1872 and was elected Speaker in 1869. That same year, Stearns was appointed the U.S. surveyor general for Florida by Ulysses S. Grant. In 1872, Stearns was elected lieutenant governor and became governor upon the death of Ossian Bingley Hart. Defeated in his bid for election to a regular term, he left Florida to accept an appointment as U.S. commissioner at Hot Springs, Arkansas, a position he held until 1880.

December 9, 1985

Floridians Appalled at Reagan's Iran-Contra Scandal: Polls released today showed most Floridians among Americans who thought President Ronald Reagan lied about his knowledge of the Iran-Contra scandal. Reagan's public approval rating dropped from 67 to 46 percent as a result of the investigation by special prosecutor Lawrence Walsh and the televised congressional hearings on the matter. Walsh discovered that some senior officials of the Reagan administration secretly facilitated the sale of arms to Iran, which had been embargoed by Congress, in the hope that they would secure the release of several hostages held by Iran and that the money would allow U.S. intelligence agencies to secretly fund the Nicaraguan Contras, an act prohibited by the Boland Amendment. Reagan denied any knowledge of the events, although Lieutenant Colonel Oliver North testified that he had witnessed the destruction of the only existing copy of Reagan's official approval of the deal by John Poindexter, the president's national security advisor. Fourteen administration officials were indicted for violating the law, and eleven of the fourteen were convicted. While some of the individuals had their convictions overturned on appeal, the remaining individuals were pardoned during the presidency of George H.W. Bush, who was vice president at the time of the Iran-Contra affair.

December 10, 1941

Colin P. Kelly Becomes American Hero: Colin Purdie Kelly Jr. was killed today when his airplane was shot down by Japanese Zero fighters in the Philippines. Kelly was born in Madison in 1915 and graduated from high school in 1932. He went to West Point in 1933 and graduated in 1937. Opting to become a pilot, he was assigned to a B-17 bomber group and sent to the Philippines. After the attack on Pearl Harbor, another large force of Japanese ships attacked the Philippines in preparation for a land invasion. This morning, Kelly took off from Clark Field on a mission against the Japanese fleet. After hitting the cruiser *Natori* with his bombs, he turned his bomber toward his home base. During the return flight, the bomber came under attack by Zeros. Kelly stayed at the controls of the badly damaged aircraft so that crew members could bail out. Just as he and his co-pilot were making their escape, the plane exploded, and both men were ejected. Lieutenant Donald Robins, the co-pilot, was able use his parachute and survived. Kelly, however, failed to open his chute and hit the ground. He was posthumously awarded the Distinguished Service Cross for his bravery.

December 11, 1942

Florida Goes to War: Still reeling from the shock of the Japanese sneak attack on Pearl Harbor and Japanese attacks on other American bases in the Pacific, Floridians began the arduous task of gearing up for a world war. During the next five years, Florida became home to many military bases and war industries, including several shipyards. The state also constructed 1,560 miles of new highways to facilitate military travel and experienced a population growth of almost one million new residents.

Tampa became a major shipbuilding city during World War II. The TASCO dry docks, shown here, built mostly Liberty ships, but early in the war, they produced more than thirty concrete freighters. Concrete was used because the supply of steel was not sufficient to meet the needs of shipbuilders. *Lewis N. Wynne Private Collection.*

December 12, 1998

Lawton Chiles Dies in Governor's Mansion: Governor Lawton Chiles, who was born on April 3, 1930, in Lakeland, died today of an apparent heart attack while exercising in the gym at the executive mansion in Tallahassee. Chiles, a graduate of the University of Florida, first entered politics as a member of the state house of representatives and later served in the state senate. Largely unknown around the state, he decided to walk from Key West to Pensacola to focus attention on his bid for the U.S. Senate in 1970. Newspapers kept up with the progress of his walk and labeled him "Walkin' Lawton," a nickname that stuck. He won the election and two more after that. He decided to run for governor in 1990 against the unpopular incumbent, Bob Martinez, and won by an impressive 13 percent margin. During his first term, he led recovery efforts after the state had been hit by Hurricane Andrew in 1992. In 1994, he ran for reelection against Jeb Bush and squeaked to victory by only sixty-four thousand votes. In his second term, Chiles emphasized educational reforms for the state's schools. Lieutenant Governor Buddy McKay was sworn in as governor to serve out the remaining twenty-three days of Chile's term.

December 13, 1977

Legislator Fined and Reprimanded for Conduct: State senator Ralph R. Poston Sr. of Miami was reprimanded and fined $500 today by the Florida Senate, which met in a special session. Poston was charged with violating laws and senate rules by using his public office to solicit business for his construction company. Poston was informed he would not be allowed to take his seat in the senate until he paid the fine, which he promptly did. Senator Poston was a native Miamian who started Poston Steel Company at the end of World War II. He continued to expand his company, which eventually was involved in the construction of many large public buildings and hotels in the Miami area, such as the Eden Roc hotel, the South Beach Pier and the Miami Federal Building. A major contributor to Florida political candidates and causes, he became a successful politician in his own right.

December 14, 1896

Don Vicente Martínez-Ybor Dies: Vicente Martínez-Ybor, a Spanish immigrant to the United States who became a noted cigar manufacturer first in Cuba, then Key West and finally in Tampa, died today in that city. Martínez-Ybor was perhaps best known for founding the cigar-manufacturing town of Ybor City in 1885, which was

annexed into Tampa in 1887. Ybor City and West Tampa, another cigar factory town, became major factors in the growth of Tampa into one of the largest cities in the state. The Tampa area became the center for cigar production in the world. Martínez-Ybor's brand of *Príncipe de Gales* cigars was considered to be among the finest cigars produced in America. In addition to his cigar factories, Martínez-Ybor invested in companies that sold gasoline, street pavers and fire insurance. A strong supporter of the Ybor City community, he built houses for his workers, employed doctors to treat them and even converted one of his factory buildings into a theater to entertain them. When Martínez-Ybor died in 1896, much of Tampa closed down so people could attend his funeral. He has been honored with a statue in Ybor City.

December 15, 1903

Newspaper Publisher Nelson Poynter Born: Nelson Poynter, an American newspaper publisher, was born in Indiana today in 1903. His family moved to Florida nine years later when his father bought the *St. Petersburg Times*. After high school, Nelson got his undergraduate degree from Indiana University and completed his master's degree at Yale in 1927. After working various newspaper jobs across the country, he joined his father at the *Times* and became

an editor in 1939, a position he filled until his father's death in 1953. He had bought stock in the company that owned the newspaper from his father over the years, and when his father died, Nelson was appointed president of the Times Publishing Company. In 1954, he established the Poynter Fund, which made generous contributions to the journalism programs at his alma maters. Along with his wife, Henrietta, he co-founded the *Congressional Quarterly*. He also founded the Modern Media Institute, which became the Poynter Institute after his death. The institute was gifted with all his stock in the publishing company, and in 1996, the Nelson Poynter Memorial Library was opened on the campus of the University of South Florida–St. Petersburg. The *Congressional Quarterly* was sold by the Times Publishing Company in 2009, and the *St. Petersburg Times* was renamed the *Tampa Bay Times* in 2012. Nelson Poynter has been universally recognized as one of the dominant forces in American journalism.

December 16, 1950

Truman Proclaims National Emergency: Floridians, like other Americans, were taken by surprise when President Harry S. Truman proclaimed a state of emergency today and called for Americans to prepare for a war against Chinese forces on the Korean Peninsula. The United

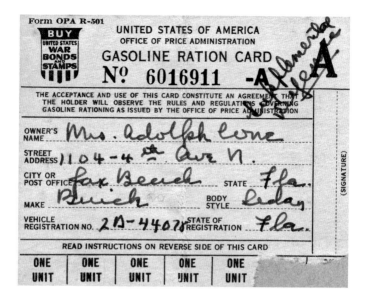

Form OPA R-501

BUY UNITED STATES WAR BONDS AND STAMPS

UNITED STATES OF AMERICA
OFFICE OF PRICE ADMINISTRATION

GASOLINE RATION CARD
Nº 6016911 -A

THE ACCEPTANCE AND USE OF THIS CARD CONSTITUTE AN AGREEMENT THAT THE HOLDER WILL OBSERVE THE RULES AND REGULATIONS GOVERNING GASOLINE RATIONING AS ISSUED BY THE OFFICE OF PRICE ADMINISTRATION

OWNER'S NAME *Mrs. Adolph Cone*

STREET ADDRESS *1104-4th Ave N.*

CITY OR POST OFFICE *Fax Beach* STATE *Fla.*

MAKE *Buick* BODY STYLE *Sedan*

VEHICLE REGISTRATION NO. *2A-44078* STATE OF REGISTRATION *Fla.*

READ INSTRUCTIONS ON REVERSE SIDE OF THIS CARD

| ONE UNIT | ONE UNIT | ONE UNIT | ONE UNIT | ONE UNIT |

Americans became used to a strictly regulated program of rationing foodstuffs and essential items like gasoline during World War II. Everyone became familiar with terms like "quota," "points" and "stamps." During the Korean War, some rationing was in place but soon was phased out. This gas rationing card was highly prized and carefully protected during the war. *Camp Blanding Infantry Museum.*

States had entered the fighting in Korea in June 1950 at the head of a United Nations force after North Korea had overrun virtually all of South Korea. He stressed that "the military, naval, air and civilian defenses of this country be strengthened as speedily as possible."

December 17, 1885

Arbor Day Comes to the Sunshine State: On this day, the first Arbor Day was celebrated in the Sunshine State when members of the Southern Forestry Congress and representatives of the U.S. Department of Agriculture planted several trees along the shores of Lake DeFuniak in the Florida panhandle. The decision to inaugurate Arbor Day in Florida came as a result of a three-day meeting of the Southern Forestry Congress, organized by the Florida Chautauqua Association and supported by Governor Edward Aylesworth Perry. Delegates to the Congress assembled in the 2,500-seat Chautauqua Tabernacle to discuss ways to preserve southern forests while getting the maximum economic benefits from them. One theme that delegates came back to again and again was the need to constantly replenish the available supply of trees by replanting. Governor Perry was so impressed with the idea, he promised to get the legislature to formally approve an annual Arbor Day, which it did.

December 18, 1865

Slavery Officially Ended: Today, Secretary of State William Seward issued a statement verifying the ratification of the Thirteenth Amendment to the U.S. Constitution eight months after the end of the Civil War. President Abraham

Lincoln worked to get the amendment through Congress, although he had issued the Emancipation Proclamation in 1863, which stated that "all persons held as slaves within any State, or designated part of a State, the people whereof shall then be in rebellion against the United States, shall be then, thenceforward, and forever free." However, Lincoln knew that to legally end slavery, a constitutional amendment would be needed. The Thirteenth Amendment passed in the Senate in April 1864 and the House in January 1865. It was ratified by the necessary number of states by December 6, 1865. Florida ratified the amendment on December 28, 1865, after it was already ratified by twenty-seven of thirty-six states. The state of Mississippi, however, did not ratify the amendment until February 7, 2013, when it finally officially certified an earlier approval on March 16, 1995. Mississippi officials explained that the late completion of the ratification process was due to "an oversight."

December 19, 1971

Railroad Strike Settled: The nearly decade-long strike against the Florida East Coast Railroad, which started on January 23, 1963, was settled in federal court today. Workers received a 37 percent pay raise, and the unions representing them received $1.5 million in damages. The strike began just two years after a controlling interest in the FEC Railway had been purchased by the du Pont Trust by way of the St.

Joe Company. Negotiations with the nonoperating unions began in January 1963, and the failure of the FEC to reach an agreement led to prolonged work stoppages and picket lines around FEC properties. The operating unions, which primarily consisted of train crews, honored the picket lines. Ball responded to the strike by hiring scab workers to run the railroad. He used the strike to justify ending the FEC's passenger service, which consistently lost money, and to install different kinds of automation that reduced the number of workers needed to operate the railroad. During the strike, violence erupted as strikers used bombs and shootings to discourage the scabs from continuing to work for the railroad. Federal intervention was needed to end the violence. Despite the overall settlement, minor conflicts between the railroad and the unions continued until 1977.

December 20, 1865

Walker Becomes Governor: David Shelby Walker, Florida's eighth governor, took office today in Tallahassee. Born in Kentucky in May 1815, he moved to Leon County, Florida, as a young man. Walker was a member of the state senate in the first legislature after statehood had been granted in 1845. He was elected as a member of the lower house in 1848. From 1849 until 1854, he served as the register of Public Lands and the state superintendent of Public Instruction. He was also elected

the mayor of Tallahassee and, in 1860, became a justice on the state Supreme Court, a position he held until he became governor. Although Walker opposed secession, he supported Florida when it left the Union. Walker's administration had the difficult task of restoring civil government during Reconstruction. After his tenure as governor, he returned to the practice of law in 1868 and was appointed Circuit Court judge in 1876, a position he held until his death in 1891.

December 21, 1915

Dade County Goes Dry: Citizens of Dade County hotly debated the question of the county's liquor sales in 1915. Residents of the city of Miami were in favor of making liquor readily available because they thought it would bring more tourists to the city, but rural residents opposed liquor on moral grounds. In a special election, voters were asked whether Dade County would prohibit alcohol sales. By a

Opposite: Floridians were caught in a dilemma in the 1920s. Many supported the idea of Prohibition as a philosophical and moral matter but disagreed with its practicality. Liquor was the lifeblood of the land boom of the 1920s, and being practical people, Floridians joined the ranks of bootleggers and rumrunners to supply the craving for booze. *Burgert Brothers Collection, Tampa Public Library.*

vote of 1,138 to 635, voters approved the outlawing of liquor sales. Dade County entered the ranks of the "dry" counties. Despite the referendum and the imposition of national Prohibition, "hooch" was readily available to Miamians as bootleggers established networks to supply illicit liquor.

December 22, 1943

Nazi Prisoners Riot at Camp Blanding: German prisoners fought today at Camp Blanding as pro-Nazi prisoners who had been captured in North Africa attacked prisoners who

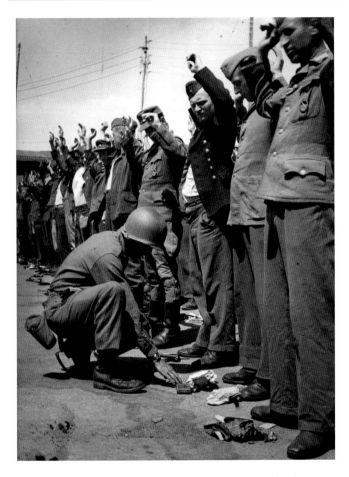

German and Italian POWs, captured in North Africa in 1942–43, were sent to a number of American military bases for incarceration. Many of the earlier POWs were ardent Nazis and frequently clashed with later arrivals, who were mostly draftees in the German army. After the Italian surrender in 1943, Italian POWs became trustees and were placed under minimal supervision. *Camp Blanding Infantry Museum.*

had been captured later and were draftees, not committed Nazis. This was the second fight between prisoner groups at the camp. In November, an earlier riot had been broken up, but the hatred between ardent Nazis and German draftees continued to dominate relations. Camp Blanding was a major POW holding facility in Florida and eventually housed around ten thousand POWs. A network of more than twenty branch camps were established in the Sunshine State, and POWs were put to work harvesting sugar, vegetables and citrus.

December 23, 1817

Luis Aury Surrenders Amelia Island: Officers of the "Republic of the Floridas" headed by Luis Aury, a French mercenary, surrendered Amelia Island to American troops today. The U.S. flag was the fourth to fly over Amelia Island in a six-month period. Though he claimed to be Mexican, Aury was born in Paris and served in the French navy before becoming a mercenary. He followed Gregor MacGregor, a freebooter,

Following page: Fernandina would be an important military installation for the American army. During the Spanish-American War it was the headquarters of General Fitzhugh Lee, who had been a Confederate general in the Civil War and was called into active service during the Spanish-American War. He, along with General Joseph Wheeler who was also a former Confederate, highlighted the claim that the war was a means of reuniting North and South permanently. *Tampa Bay History Center.*

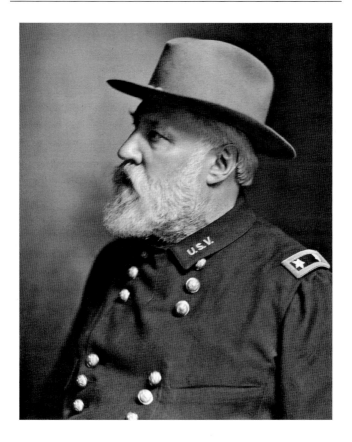

who had taken Amelia Island with the backing of American businessmen. When MacGregor ran out of money for men and munitions, he left. Aury sailed into the port of Fernandina and claimed the island in the name of Mexico, but he was soon forced to surrender it to American troops.

December 24, 1956

Supreme Court Outlaws Segregated Buses in Tallahassee: On May 26, 1956, two students from Florida Agricultural and Mechanical University, Wilhelmina Jakes and Carrie Patterson, sat down in the "whites-only" section of a segregated bus in the city of Tallahassee. When they refused to move to the rear of the bus, the driver pulled into a service station and called the police. Tallahassee police arrested Jakes and Patterson, charging them with "placing themselves in a position to incite a riot." The arrests of the students triggered a campus-wide bus boycott, a movement that soon spread throughout the African American population of the city. Reverend C.K. Steele and others created the Inter-Civic Council to manage the boycott and organize car pools, which soon drew the ire of city leaders, who had them arrested for operating a taxi business without a license. The bus company was soon forced to stop its operation because of the loss of revenue. The strike continued despite an investigation by the notorious Johns Committee, the conviction of strike leaders for minor offenses and the opposition of the KKK. On December 24, the U.S. Supreme Court issued a judgment in a similar case from Montgomery, Alabama, in which segregated forms of public transportation were declared illegal. Although it would take several months to achieve, an end to segregated seating on Tallahassee buses came by the middle of 1957.

December 25, 1951

Civil Rights Leaders Killed by Christmas Bombing: Civil rights activists Harry T. and Harriette V. Moore were killed in their home at Mims when a bomb exploded under the house. Harry Moore, a school administrator in Brevard County and the president of the NAACP in Florida, and Harriette V. Moore, a schoolteacher, lost their jobs in the county when they advocated an end to educational segregation and for equal pay for African American teachers. The most immediate, though unproven, cause for the bombing was thought to be a Ku Klux Klan response to a series of letters Harry Moore wrote to state and federal officials calling for an investigation into the deaths of black prisoners in Lake County who were shot by Sheriff Willis V. McCall. Moore and other African American leaders had called the shootings murder. No charges were ever made in the case, although a 2006 investigation by the state named four individuals who were members of the Klan as being responsible for the murders. None of the men ever faced trial.

December 26, 1972

Harry Truman Dies: Harry S. Truman, a sometime resident of Key West, died this morning in a Kansas City hospital. He was eighty-eight years old. Truman, who maintained

a vacation retreat in Key West during his presidency, became president after Franklin Delano Roosevelt's death 1945. By November 1946, President Truman had finished nineteen months in office, having successfully directed the end of World War II, and was physically exhausted. His doctor ordered a warm vacation, so Truman arrived in Key West and took up residence in the old commandant's quarters at the submarine base. As he was leaving, he promised to return whenever he felt the need for rest. His second vacation came in March 1947, and this became the pattern for additional visits every November–December and every February–March. Truman spent 175 days of his presidency at the Little White House in Key West, and after he left office, he returned several times and stayed at various other places. On January 1, 1987, the Little White House was deeded to the State of Florida, which spent almost one million dollars restoring the house to its 1949 appearance. In 1991, the house opened as a state historic site and museum.

December 27, 1968

Apollo 8 Returns to Earth: Frank Borman, William Anders and James A. Lovell returned to Earth safely today aboard Apollo 8 after completing ten orbits around the moon. Launched from Cape Kennedy on December 21, the American astronauts were the first humans to

perform such a feat as Apollo 8 became the first manned spacecraft to leave Earth's orbit. The three astronauts also became the first humans to see the Earth in its entirety, the first to see the far side of the moon and the first humans to witness an "Earthrise." Apollo 8 took three days to reach an orbit around the moon, which it orbited ten times in twenty hours. The crew appeared on a live telecast on Christmas Eve, which was the most watched television program ever at the time. The success of the Apollo 8 mission was critical to achieving NASA's goal of putting a man on the moon before the end of the decade of the 1960s.

December 28, 1979

Ohio State Football Coach Assaults Opposing Player: Floridians were shocked today when legendary coach Woody Hayes of Ohio State University punched Clemson University player Charlie Bauman after he intercepted a pass during the last minute of play in the Gator Bowl game in Jacksonville. Ohio State University lost the game 17–15. OSU president Harold Enarson said, "There is not a university in this country that would permit a coach to physically assault a college athlete." Enarson fired Hayes the very next day. Hayes had a history of fighting, and over the years, he had attacked one of his own players, a network cameraman and a sportswriter and almost

came to blows with Iowa's athletic director. Despite his aggressive temperament, Hayes was a winning coach and led his Ohio State teams to a 205-61-10 record, including three consensus national championships in 1954, 1957 and 1968, plus two other shared national titles in 1961 and 1970. Hayes was a three-time winner of the College Football Coach of the Year award. After he was dismissed as head coach, he remained at Ohio State as a professor of military history. He died on March 12, 1987.

December 29, 1824

Walton County Created by Territorial Council: Walton County, named for General George Walton, was established today. Walton served as the secretary of West Florida during the governorship of Andrew Jackson (1821–22) and as the secretary of East and West Florida from 1822 until 1826. Walton was the son of George Walton, a signer of the Declaration of Independence. The county seat of Walton County is DeFuniak Springs, which gained notoriety as the home of one of the state's more controversial governors, Sidney J. Catts. Walton County opposed secession in 1861, but after the end of the Civil War, the first memorial to Confederate war dead was erected on the lawn of the county courthouse. Originally established as a "final destination resort," DeFuniak Springs was known as the intellectual capital of Florida

when the Chautauqua Movement selected it as its winter headquarters. Eventually, the town was home to two colleges, a technical school and a private high school. In 1886, the organizational meeting for the Florida Education Association, a teachers' union, was held in DeFuniak Springs. The FEA is still active today. The town also claims the oldest extant library in the state.

December 30, 1961

President Kennedy Addresses Bay of Pigs Veterans: President John F. Kennedy today addressed 1,100 Cuban survivors of the ill-fated Bay of Pigs invasion, along with 40,000 spectators, in Miami's Orange Bowl. Kennedy, who had taken office on January 20, inherited a CIA plan to launch an invasion of Cuba using Cuban exiles trained and funded by the United States. The purpose of the invasion was to overthrow the revolutionary government of Fidel Castro. Brigade 2506 was trained in Mexico and supported by eight surplus World War II B-26 bombers. The invasion force assembled in Guatemala and left by boat for Cuba on April 13. On April 15, the bombers attacked Cuban airfields and returned to the United States. On April 16, the invasion force landed at the Bay of Pigs and quickly overwhelmed the local Cuban militia. By April 20, however, the Cuban militia, led by Fidel Castro, had forced the invaders to surrender, effectively

ending the invasion. The failure of the invasion was a black eye for American relations in Latin America and a public relations success for the Castro government. Most political analysts credit the failed invasion with creating the Cuban Missile Crisis of 1962 and the close Cuba-Russia alliance.

December 31, 1973

Florida Tourism Threatened by Gas Shortage: Florida tourism officials predicted dire consequences for the state's tourist industry as gas rationing followed the Arab oil embargo that started in October. Americans were limited to about eight gallons a week, and officials feared that the number of tourists in the Sunshine State would be extremely low in 1974. Despite their fears, tourism did not suffer greatly from the embargo, though more came

Following page: Tourism in the Sunshine State had depended on people using their automobiles to arrive in Florida and to make their way from attraction to attraction. Since the 1920s, automobiles had been essential to a thriving tourist industry. Anything that threatened the use of automobiles by individuals threatened the economy of the state. Tourist frequently gathered at state parks to meet friends or to make new one. *Burgert Brothers Collection, Tampa Public Library.*

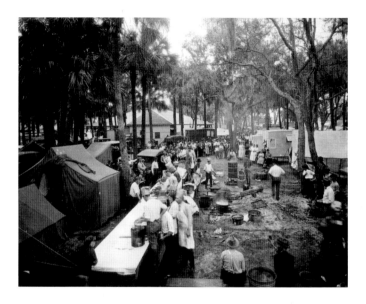

by airplanes instead of automobiles. Americans learned to live with odd/even day gasoline purchases at higher prices and a fifty-five-mile-per-hour speed limit. The embargo ended in March 1974, and tourism increased to new levels by the end of 1974.

BIBLIOGRAPHY

Billinger, Robert D. *Hitler's Soldiers in the Sunshine State: German POWS in Florida.* Gainesville: University Press of Florida, 2000.

Knetsch, Joe, and Nick Wynne. *Florida in the Spanish-American War.* Charleston, SC: The History Press, 2011.

Moorhead, Richard, and Nick Wynne. *Golf in Florida, 1886–1950.* Charleston, SC: Arcadia Publishing, 2008.

Pearce, George F. *Pensacola during the Civil War: A Thorn in the Side of the Confederacy.* Gainesville: University Press of Florida, 2000.

Tebeau, Charlton W., and William Marina. *A History of Florida.* 3rd ed. Miami, FL: University of Miami, 1999.

Wynne, Lewis N., and Robert A. Taylor. *Florida in the Civil War.* Charleston, SC: Arcadia Publishing, 2001.

———. *This War So Horrible: The Civil War Diary of Hiram Smith Williams, 40th Alabama Confederate Pioneer.* Tuscaloosa: University of Alabama Press, 1993.

Wynne, Nick, and Joe Crankshaw. *Florida Civil War Blockades: Battling for the Coast*. Charleston, SC: The History Press, 2011.

Wynne, Nick, and Joseph Knetsch. *Florida in the Great Depression: Desperation and Defiance*. Charleston, SC: The History Press, 2012.

Wynne, Nick, and Richard Moorhead. *Florida in World War II: Floating Fortress*. Charleston, SC: The History Press, 2010.

————. *Paradise for Sale: Florida's Booms and Busts*. Charleston, SC: The History Press, 2010.

ABOUT THE AUTHOR

Athree-time graduate of the University of Georgia, Nick Wynne is the executive director emeritus of the Florida Historical Society. In retirement, Nick writes fiction and history books. An avid photograph collector, he is active on several history sites on Facebook. In addition to his writing, Nick is also a "much in demand" speaker on Florida history topics. He lives in Rockledge, Florida, with his wife and two freethinking cats in a beautifully restored 1925 Mediterranean Revival home, a product of Florida's great building boom.